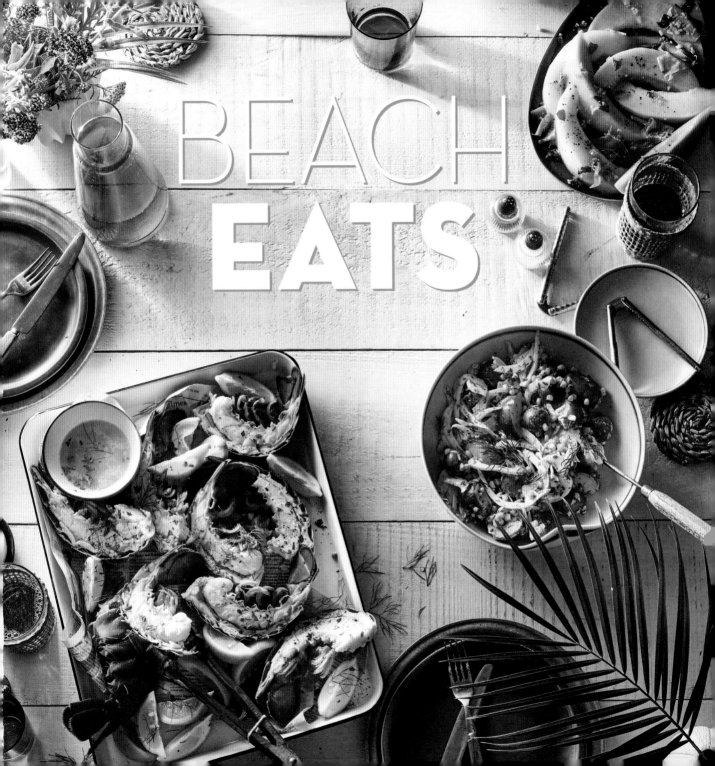

BEACH
EATS

BEACH

FAVORITE SURFSIDE RECIPES
FOR EVERY OCCASION

EATS

iPg

PRODUCED BY IPG
814 North Franklin Street
Chicago, Illinois 60610

ISBN 978-1-9573-1724-3

**PRODUCED BY BLUELINE CREATIVE
GROUP, LLC**
Visit: bluelinecreativegroup.com
Writer/Producer: Katherine Cobbs
Designer/Illustrator: Matt Ryan
Copyeditor: Donna Ingram
Indexer: Carol Roberts

**FOOD PHOTOGRAPHY & RECIPES BY
DOTDASH MEREDITH FOOD STUDIOS**
Studio Photo Direction: Paden Reich
Photographers: Antonis Achilleos, Caitlin
Bensel, and Greg Dupree; **Food Stylists:**
Margaret Monroe Dickey, Anna S. Hampton,
Katelyn Hardwick, and Tina Bell Stamos;
Prop Stylists: Cindy Barr, Missy Crawford,
Mary Clayton Carl Jones, and Christine Keely;
Recipe Developers: Katie Barreira, Robin
Bashinsky, Meredith L. Butcher, Mary Claire
Britton, Katherine Cobbs, Adam Doige, Mark
Driscoll, Paige Grandjean, Emily Nabors Hall,
Adam Hickman, Darcy Lenz, Robby Melvin,
Karen Shroeder-Rankin, Julia Rutland, Sarah
Schneider, and Deb Wise

**SCENIC PHOTOGRAPHY
BY GETTY IMAGES**
Pg 5: Ildo Frazao, Pg 9-10: the_burtons,
Pg 13-14: dogayusufdokdok, Pg 22-23:
mgstudyo, Pg 30-31: spooh, Pg 42-43: Yanick
Folly/AFP, Pg 64-65: David Neil Madden, Pg
72-73: krisanapong detraphiphat, Pg 78-79:
Meinzahn, Pg 92-93: Javier Ghersi, Pg 108-109:
Glenn Ross Images, Pg 122-123: KenWiedemann,
Pg 134-135: haveseen, Pg 150-151: Mike Brinson,
Pg 160-161: Jaeyun Jang/EyeEm, 174-175:
M Swiet Productions, Pg 184-185: Tim Rue/
Bloomberg, Pg 194-195: Tan Dao Duy, Pg
210-211: Tony Heff/WSL, Pg 222-223: Bruce
Yuanyue Bi, Pg 226-227: Michal Lotocki/EyeEm,
Pg 242-243: Pavel1964, Pg 248-249: Marie
LaFauci, Pg 254-255: Peter Unger, Pg 260-261:
Bertlmann, Pg 276-277: Grant Faint

For syndication or international licensing
requests, email syndication.generic@
dotdashmdp.com
For reprint and reuse permission, email mmc.
permissions@dotdashmdp.com

First Edition 2023
Printed in China
10 9 8 7 6 5 4 3 2 1

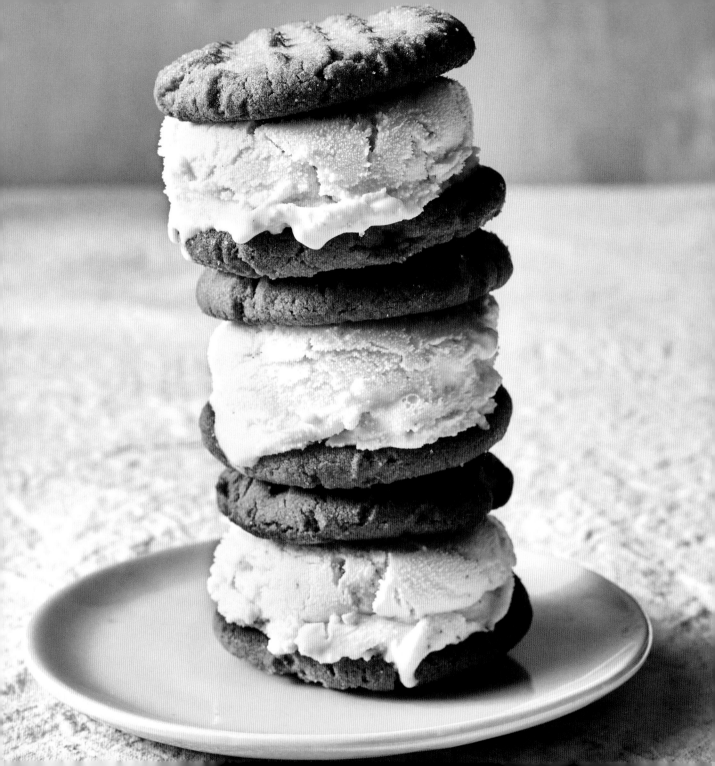

CONTENTS

INTRODUCTION

The beach is an anticipated gathering place for vacationers, an inspiring place to live for lucky locals, and a magical spot for dreamers far from sea breezes and ocean waves. Seaside destinations are idyllic places for families and friends to come together, relax, and make memories and *Beach Eats* helps you do it deliciously.

This stunning cookbook is your tantalizing recipe roadmap for creating deliciously memorable meals that take their cue from the coast. Enjoy over 175 recipes for every course under the sun and easy, breezy, seasonal menus for the wave of occasions life serves up.

The vibrant flavors of Miami's South Beach come to life in a cultural mashup of mouthwatering recipes like minty Mojitos, a taco spin on the classic Cuban sandwich, creamy grilled avocados, and tart citrus flan. Greek-style small plate nibbles of a Mediterranean Meze menu transport cocktail hour tastebuds to Santorini. Dive into a Fruits de Mer menu with delicacies like oysters on the half shell, lobsters with drawn butter, peel-and-eat shrimp with cocktail sauce, and grilled clams swimming in savory pot liquor. And keep the good times rolling with a tropical take on a Vegetable Plate Supper, eye-opening Coastal Coffee Hour, and sweet Sundae Social. The beautiful scenic photography woven throughout the book will keep you dreaming, planning, and craving your next seaside adventure and coastal feast.

I hope you enjoy this much-anticipated cookbook—the first from Coastal Living to be released in almost two decades. It is the perfect companion to the popular Coastal Living *Beach Cocktails* book. May *Beach Eats* inspire you to cook, entertain, travel, and celebrate the many wonders of the coast.

KATHERINE COBBS
Editor

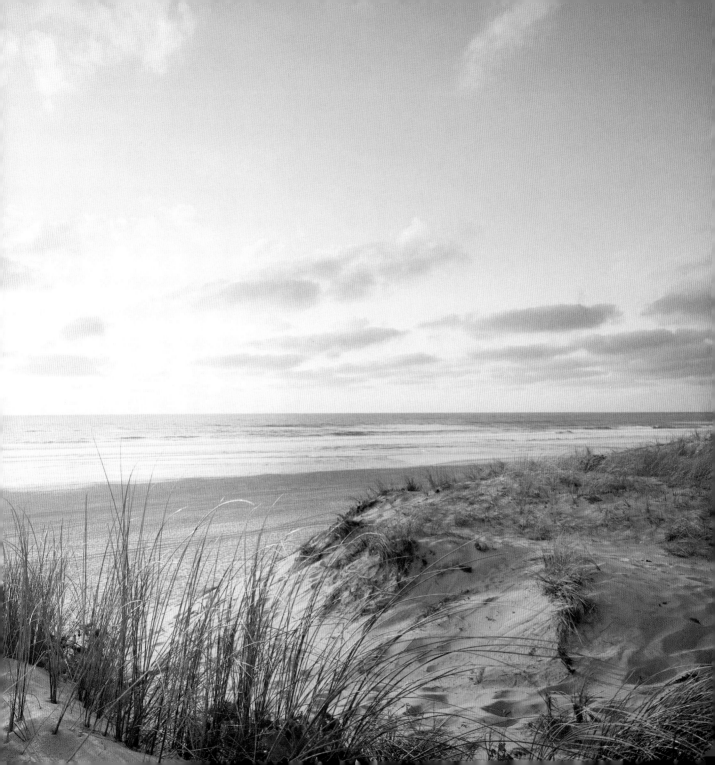

01.
CABANA BAR

SUBLIME SIPS
AND NIBBLES
INSPIRED BY
EXOTIC SURFSIDE
LOCALES

TANGERINE-ELDERFLOWER SPRITZER
WITH CHAMPAGNE ICE CUBES

The refreshing tang of tangerine is complemented by notes of sweet nectar in the elderflower liqueur, which makes this effervescent sipper taste like summertime in a glass.

1 (750-milliliter) bottle Champagne or Prosecco

4 cups (32 ounces) cold seltzer water

2 cups (16 ounces) fresh tangerine juice (from about 12 tangerines)

¼ cup (2 ounces) elderflower liqueur (such as St-Germain)

Tangerine slices

1. Pour the Champagne into each compartment of 2 ice-cube trays, and freeze until almost set, at least 6 hours. (Cubes will not be completely firm.)

2. Combine the seltzer water, tangerine juice, and liqueur in a pitcher, stirring to combine. Divide the Champagne ice cubes among 6 cocktail glasses, and top with the tangerine juice mixture and a tangerine slice.

CRAB RANGOON CHEESE BALL

All the yumminess of the deep-fried dumplings of your neighborhood Chinese restaurant get folded into this creamy seafood appetizer—no deep-fryer required.

1 pound fresh lump crabmeat, drained and picked over

4 ounces mascarpone cheese

1½ (8-ounce) packages cream cheese, softened

3 garlic cloves, minced (about 1 tablespoon)

½ cup chopped scallions (about 10 scallions)

2 tablespoons sweet chili sauce (such as Mae Ploy)

1 teaspoon kosher salt

⅓ cup toasted white sesame seeds

⅓ cup black sesame seeds

Wonton chips

Stir together the crabmeat, mascarpone, cream cheese, garlic, scallions, chili sauce, and salt in a large bowl until combined. Stir together the white and black sesame seeds; spread in an even layer on a large plate. Gently shape the crab mixture into a ball, and carefully roll in the sesame seeds until covered. Place on a serving plate; chill, uncovered, until set, about 30 minutes. Serve with the wonton chips.

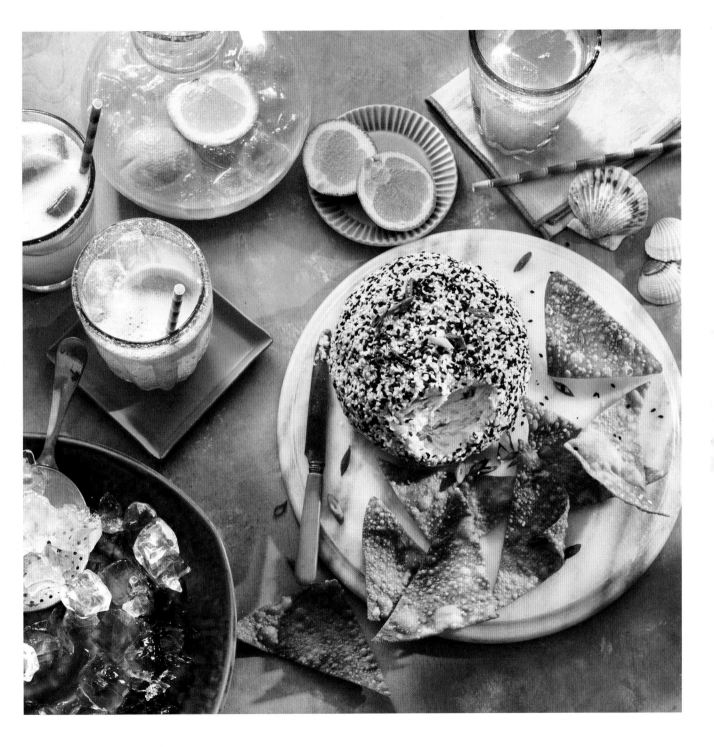

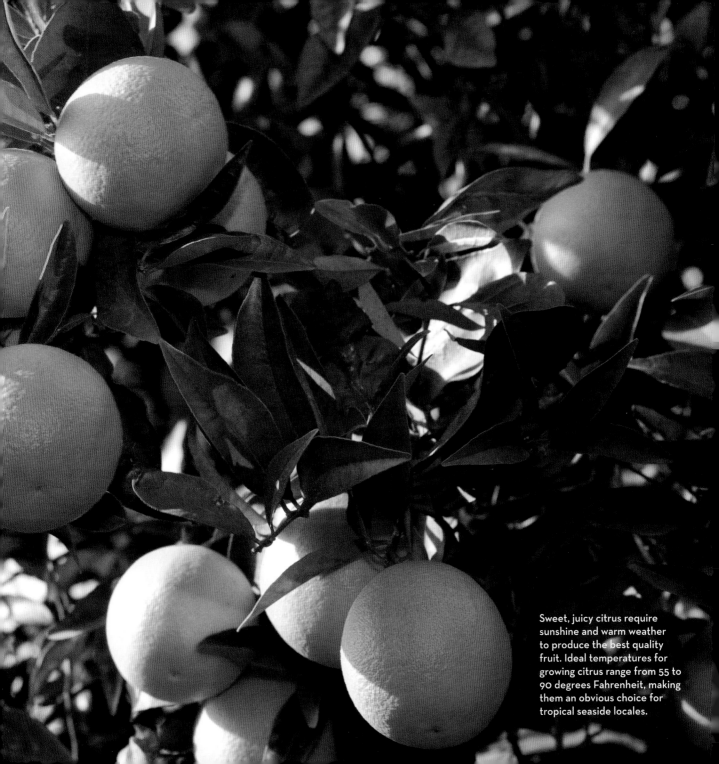

Sweet, juicy citrus require sunshine and warm weather to produce the best quality fruit. Ideal temperatures for growing citrus range from 55 to 90 degrees Fahrenheit, making them an obvious choice for tropical seaside locales.

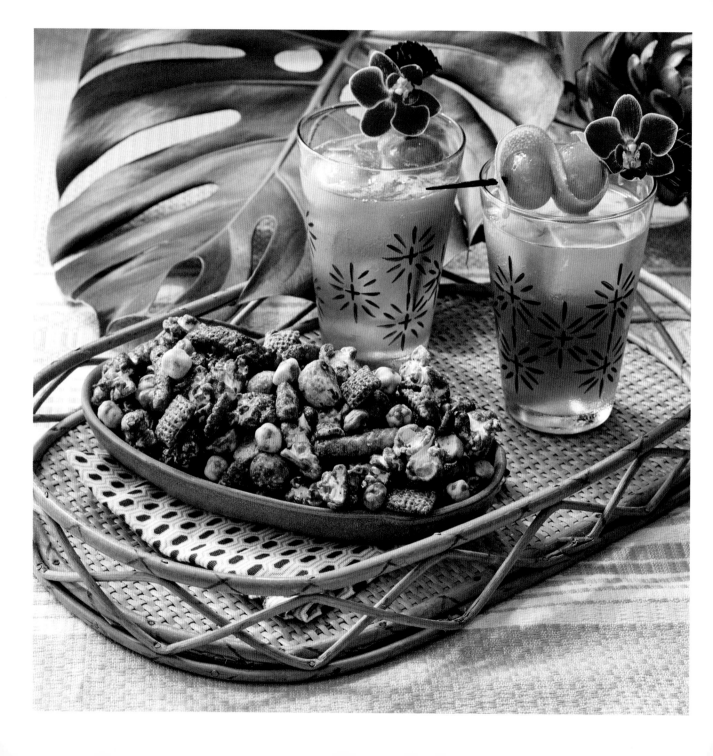

CANDIED-KUMQUAT MANHATTAN

With its edible sweet rind and tart pulp, the entire kumquat can be eaten raw, candied, or cooked. For a change of pace, try muddling a fresh kumquat with ice in the bottom of an ice-filled cocktail shaker before adding the spirits, and then strain it into a glass with ice. Store-bought candied kumquats are called for here. They add a welcome sweetness that can be bumped up further with the addition of a little of the syrup from the jar.

¼ cup (2 ounces) rye whiskey

2 tablespoons (1 ounce) water

1 tablespoon (½ ounce) sweet vermouth

2 dashes of orange bitters

3 whole candied kumquats (available on amazon.com)

Stir together the whiskey, water, vermouth, and bitters in a cocktail shaker filled with ice; cover and shake vigorously until thoroughly chilled, about 30 seconds. Strain into a chilled cocktail glass filled with ice, and garnish with a skewer of candied kumquats. (For a sweeter drink, stir in 1 teaspoon kumquat syrup.)

TOGARASHI-SPICED SNACK MIX

Togarashi seasoning is a traditional Japanese spice blend made from ground togarashi chilies, sesame, orange zest, and ginger. The bold flavors make this snack mix a challenge to stop eating.

5 cups rice cereal squares (such as Rice Chex)

3 cups popped popcorn

2 cups regular shrimp cracker fries (such as Nongshim)

1 cup macadamia nuts

¾ cup packed light brown sugar

6 tablespoons (3 ounces) salted butter

3 tablespoons light corn syrup

2 tablespoons soy sauce

1 tablespoon nanami togarashi (such as S&B)

1 teaspoon kosher salt

1 teaspoon baking soda

1½ cups wasabi peas (from 1 [4.23-ounce] package)

1. Preheat the oven to 300°F. Combine the cereal, popcorn, shrimp cracker fries, and macadamia nuts in a large bowl.

2. Cook the sugar, butter, syrup, and soy sauce in a small saucepan over medium, stirring occasionally, until the mixture comes to a boil, 3 to 4 minutes. Reduce the heat to medium-low, and cook, stirring often, until the sugar is completely dissolved, 1 to 2 minutes. Remove from the heat, and quickly stir in the togarashi, salt, and baking soda. Pour the syrup mixture over the popcorn mixture, stirring gently until well coated.

3. Spread the popcorn in a single layer on a parchment paper–lined rimmed baking sheet. Bake at 300°F until lightly golden, 25 to 30 minutes, stirring after 15 minutes. Transfer the baking sheet to a wire rack to cool. Pour the mixture into a medium serving bowl, and stir in the peas. Serve immediately, or store in an airtight container up to 3 days.

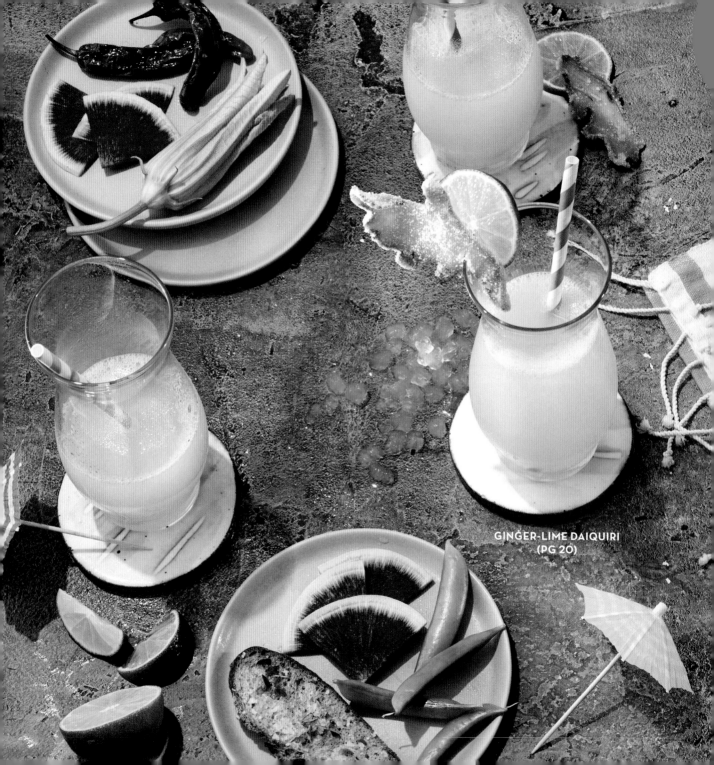

GINGER-LIME DAIQUIRI
(PG 20)

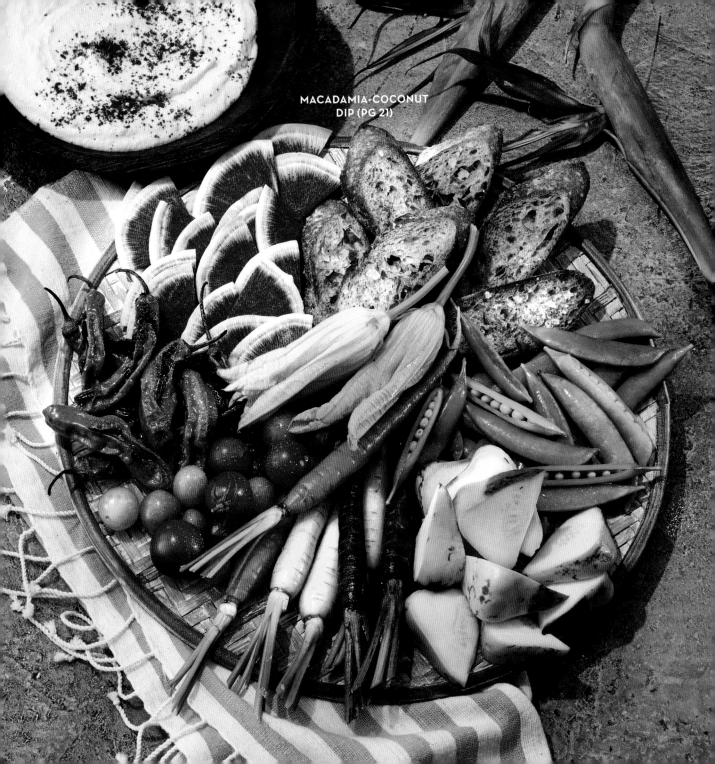

MACADAMIA-COCONUT
DIP (PG 21)

GINGER-LIME DAIQUIRI

This is a less boozy version of the classic Hemingway favorite, only sweetened with a ginger-spiked syrup for a dose of sweetness with a distinctive kick.

¼ cup (2 ounces) light rum

2 tablespoons (1 ounce) fresh lime juice (from 2 limes)

1 tablespoon (½ ounce) Ginger Simple Syrup (recipe follows)

Lime slice

Combine the rum, lime juice, and simple syrup in a cocktail shaker filled with ice. Cover and shake vigorously for 30 seconds. Strain into a chilled glass with a lime slice.

GINGER SIMPLE SYRUP

1 cup granulated sugar

8 ounces (1 cup) water

2 tablespoons chopped peeled fresh ginger

Combine the sugar, water, and ginger in a small saucepan over medium-high. Cook, stirring often, until the sugar dissolves and mixture comes to a simmer, 2 to 3 minutes. Remove from the heat; cover and let mixture steep 15 minutes. Discard the ginger. Cool the simple syrup to room temperature before using, about 30 minutes. (Leave the ginger in the syrup as it cools for stronger ginger flavor.) Store in an airtight container in the refrigerator for up to 2 weeks. **Makes 1¼ cups**

VARIATION

SIMPLE SYRUP To make plain Simple Syrup, omit the chopped peeled fresh ginger and cook the sugar and water mixture until the sugar dissolves completely.

GET THE "RUMDOWN" ON THIS SPIRIT OF THE SEA

British and American navies offered rum rations to sailors because water didn't keep well during long voyages. Pirate ships, on the other hand, were notorious for rum drinking and often easily commandeered because crews were too drunk to fight. Rums come in many forms—from light to dark, and spiced or flavored. A good rule of thumb is to use less expensive rum in fruity cocktails and recipes and save the pricey, aged kinds for sipping. Here's a handy primer.

LIGHT Often called white or silver, light rum has a subtle flavor and is filtered to remove any color acquired during aging. It is a good choice for mixed cocktails.

GOLDEN Its medium body and amber color come from aging in wooden casks (cheaper versions add caramel coloring instead). Enjoy this rum in cocktails or for sipping.

DARK Also called black rum, this full-flavored, heavy-bodied spirit has distinct caramel and molasses overtones. Less expensive versions are used in cooking, while top-shelf selections are often enjoyed straight up.

SPICED This rum with added vanilla, ginger, cloves, allspice, or cinnamon is good in mixed drinks and tiki cocktails.

FLAVORED Light rum that is infused with citrus, tropical fruit, berry, or vanilla flavorings is a good choice for mixing into cocktails or sipping on the rocks.

MACADAMIA-COCONUT DIP

If you like hummus, you will love this island spin that swaps ground macadamia nuts blended with coconut cream for the usual chickpeas and sesame tahini. Though native to Australia, macadamia nuts are a cash crop of Hawaii. It takes half a dozen years for a grafted tree to begin producing nuts.

1 (5-inch) French baguette, split lengthwise

1 cup toasted macadamia nuts

1 large garlic clove

½ cup olive oil

½ cup solidified coconut cream from chilled, canned coconut milk

2 tablespoons fresh lime juice (from 1 lime)

2 teaspoons kosher salt

½ teaspoon Aleppo pepper

Assorted vegetables (such as sugar snap peas, carrots, radishes, endive, cucumber, and cherry tomatoes)

Scoop out the bread from each baguette half to equal about 2 cups, discarding the bread shell. Place the bread with water to cover in a bowl to soak 1 minute. Squeeze excess water from the bread. Process the bread, nuts, and garlic in a food processor until finely chopped. Add the oil, solidified coconut cream, lime juice, and salt; process until smooth. Transfer to a large serving bowl. Sprinkle with the Aleppo pepper, and serve with the assorted vegetables.

The tropical coconut palm provides sustenance and a canopy to escape the heat. The nuts can be fashioned into utensils and containers. The coir fiber that covers its exterior can be used as garden mulch and organic mattress stuffing. And the palm leaves are woven into hats, mats, and decorative items for the home.

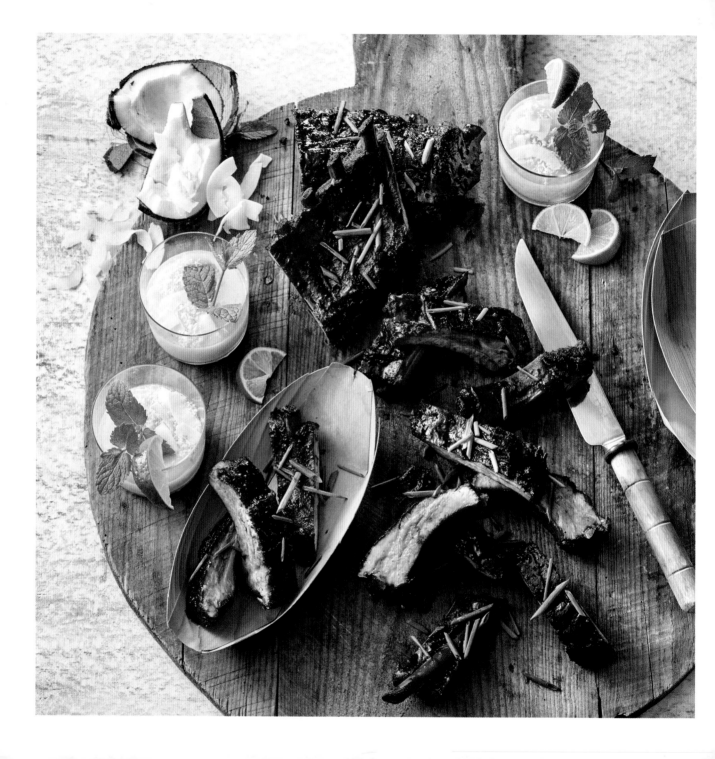

COCONUT MOJO

If a piña colada and mojito collided, this creamy refresher would be the sublime result. This delectable drink has all the elements of a tropical tipple: muddled citrus, white rum, coconut rum, coconut cream, and a touch of brown sugar. Gild the lily with a cocktail umbrella because this drink screams, "It's a beach holiday!"

6 fresh mint leaves

3 lime wedges

1 teaspoon brown sugar

2½ tablespoons (1¼ ounces) Mount Gay white rum

1 tablespoon (½ ounce) Malibu coconut rum

2 tablespoons (1 ounce) cream of coconut

1 cup (8 ounces) chilled club soda

Garnish: lime wedge, fresh mint leaves and grated coconut

Muddle the mint leaves, lime wedges, and brown sugar in the bottom of a cocktail shaker. Add the white rum, coconut rum, and cream of coconut. Fill the cocktail shaker with ice, and stir vigorously to chill. Strain the mixture into a tall glass, and top with club soda. Garnish as desired.

CHAR SIU BABY BACK RIBS

Cantonese char siu sauce typically relies on sherry or rice wine, but dark rum delivers mouthwatering results here.

¾ cup hoisin sauce

½ cup (4 ounces) dark rum

½ cup soy sauce

¼ cup honey

3 tablespoons sambal oelek (ground fresh chile paste)

2 tablespoons dark sesame oil

2 tablespoons minced fresh ginger

2 teaspoons minced fresh garlic

2 teaspoons Chinese five spice powder

2 teaspoons onion powder

2 teaspoons red liquid food coloring

2 (2-pound) slabs baby back pork ribs

1½ teaspoons kosher salt

½ teaspoon black pepper

Chopped fresh chives

1. Whisk together the first 11 ingredients in a medium bowl, reserving ¼ cup.

2. Pat slabs dry with paper towels. Remove thin membrane from the back of each slab. Place the ribs in a large ziplock plastic bag, cutting if needed. Add the hoisin mixture, seal, and rub to coat. Chill at least 4 hours or overnight.

3. Prepare a charcoal grill to medium-high (about 450°F), by piling charcoal on 1 side of grill and leaving the other empty. (For a gas grill, light only 1 side.) Remove the ribs from the bag; discard marinade. Sprinkle with salt and pepper. Place on the unlit side of the grill, stacking 1 on top of the other. Grill, covered, 40 minutes. Rotate slabs, moving bottom slab to top; grill, covered, 40 minutes. Rotate again; grill, covered, 40 minutes.

4. Decrease temperature to medium (350° to 450°F); place slabs side by side on unlit side. Baste with reserved sauce. Grill, covered, 30 minutes, basting occasionally. Remove and let stand 10 minutes before cutting. Cut slabs into individual ribs. Sprinkle with chives; serve immediately.

THAI CUCUMBER COLLINS

Putting this drink with its rum-and-lime juice base in the same category as the classic sparkling Collins cocktail comprised of lemon juice, sugar, and gin is an admitted stretch. So imagine that the traditional tipple went on a Southeast Asian adventure and picked up a few flavorful friends along the way, including lemongrass, mint, and cucumber. We think this far-flung fresh take on the Collins is destined to be a new classic.

4 fresh mint leaves

3 sugar cubes

2 (¼-inch) cucumber slices

1 teaspoon grated (on a Microplane) lemongrass

6 tablespoons (3 ounces) fresh-pressed cucumber juice

¼ cup (2 ounces) white rum

2 tablespoons (1 ounce) fresh lime juice

6 tablespoons (3 ounces) club soda

Garnish: cucumber slices and fresh mint leaves

Muddle the mint leaves, sugar cubes, cucumber slices, and lemongrass in a cocktail shaker. Add the cucumber juice, white rum, and lime juice. Swirl to combine. Add ice, cover and shake vigorously until thoroughly chilled, about 30 seconds. Strain into an ice-filled Collins glass. Top with the club soda. Garnish as desired.

GRILLED SHISHITO PEPPERS

Typically milder than Padrons, another popular pepper for panfrying, Shishitos are devoured seeds and all. They are delicious stuffed, sautéed, or tempura-dipped and fried. If this variety is not available at your market, turn to Padrons, or even jalapeños if you like a spicy kick.

1 pound Shishito peppers

2 tablespoons olive oil

Sea salt

Preheat a grill to medium-high (about 450°F). Brush the peppers with the olive oil, and sprinkle with the sea salt. Grill, turning occasionally, until skin slightly blisters, 5 to 7 minutes. Sprinkle with additional sea salt, if desired.

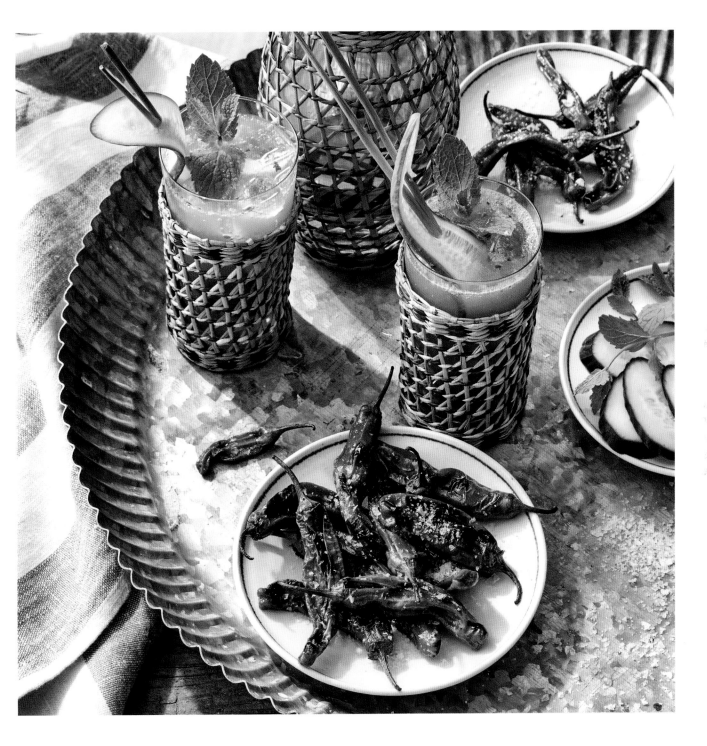

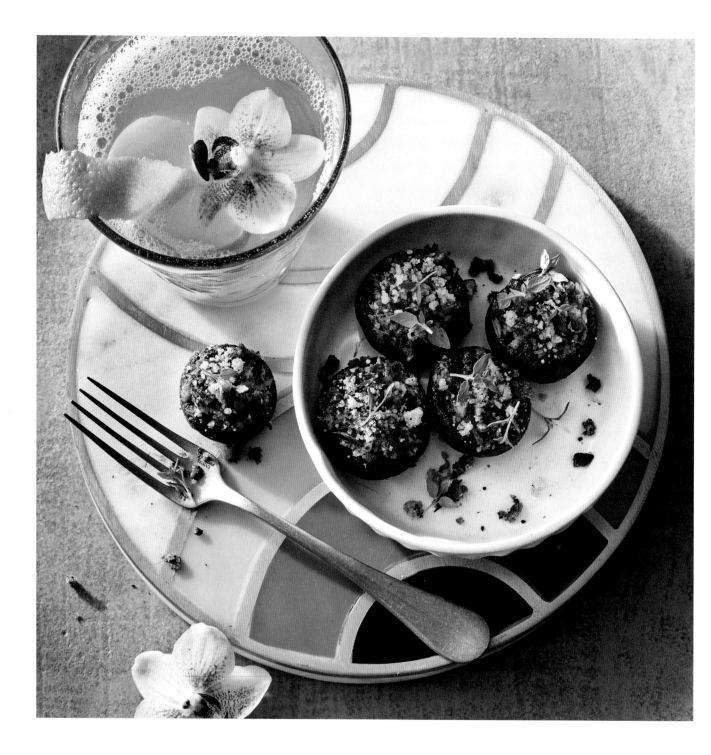

MY SHERRY AMOUR

Perfect for warm weather sipping, this cocktail is a pleasing marriage of sweet, tart, and bitter.

5 tablespoons (2½ ounces) Lillet Blanc

2 tablespoons (1 ounce) fino sherry

1½ tablespoons simple syrup

1 tablespoon fresh lemon juice

Dash of orange bitters

Garnish: orange peel

Fill a rocks glass with crushed ice. Add the Lillet Blanc, fino sherry, simple syrup, fresh lemon juice, and a dash of orange bitters; mix well. Garnish as desired.

GOAT CHEESE-STUFFED MUSHROOMS

A favorite party popper for as long as cocktail hour has been a predinner pastime, these cheesy stuffed mushrooms get their pleasing crunch from finely chopped pecans.

24 large fresh mushrooms

1 tablespoon olive oil

⅓ cup minced scallions

½ cup freshly grated Parmesan cheese

½ cup soft breadcrumbs

⅓ cup minced toasted pecans

2 tablespoons minced fresh thyme

½ teaspoon freshly ground black pepper

2 ounces goat cheese (½ cup)

1. Preheat the broiler. Clean the mushrooms with damp paper towels. Remove the stems, reserving them for another use.

2. Sauté the mushroom caps in 1 tablespoon hot olive oil in a large skillet over medium-high 5 minutes. Remove from the skillet, and drain on paper towels. Add the scallions to the skillet; sauté over medium-high until tender. Remove from the heat; stir in ⅓ cup of the Parmesan cheese and the next 4 ingredients. Set aside.

3. Crumble the goat cheese evenly into the mushroom caps. Spoon the breadcrumb mixture into the mushroom caps over the goat cheese. Sprinkle with the remaining Parmesan cheese. Arrange the mushrooms on the rack of a broiler pan coated with cooking spray. Broil 5½ inches from the heat until lightly browned, 2 to 3 minutes.

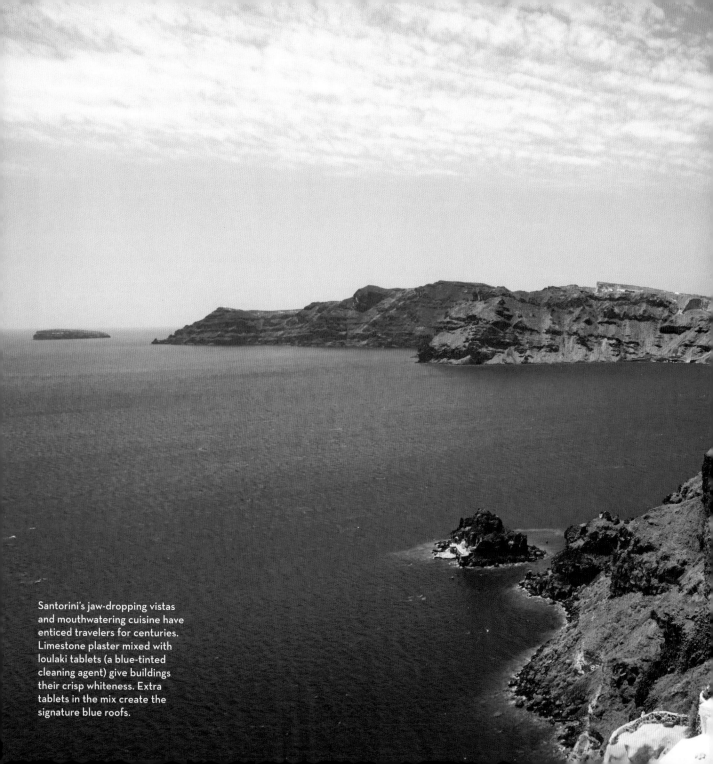

Santorini's jaw-dropping vistas and mouthwatering cuisine have enticed travelers for centuries. Limestone plaster mixed with loulaki tablets (a blue-tinted cleaning agent) give buildings their crisp whiteness. Extra tablets in the mix create the signature blue roofs.

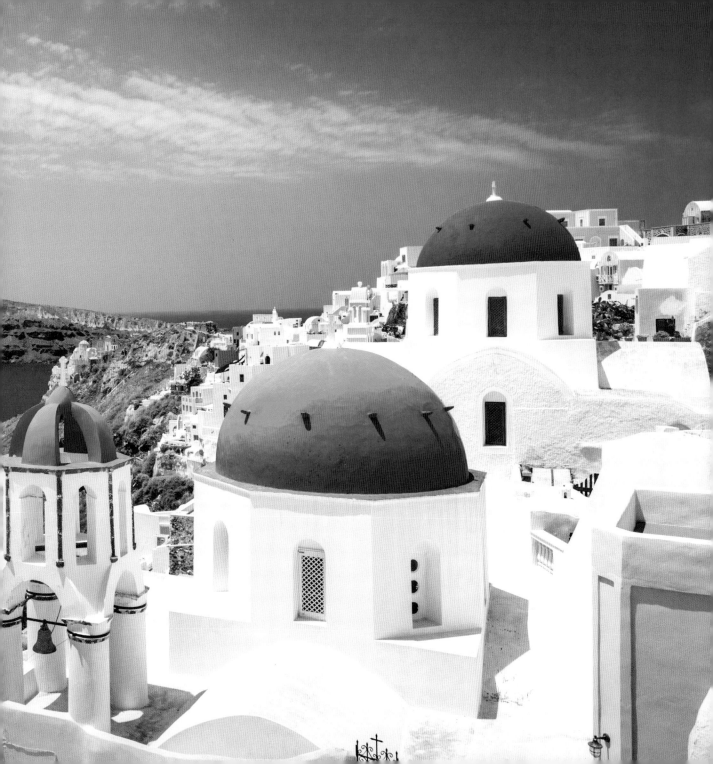

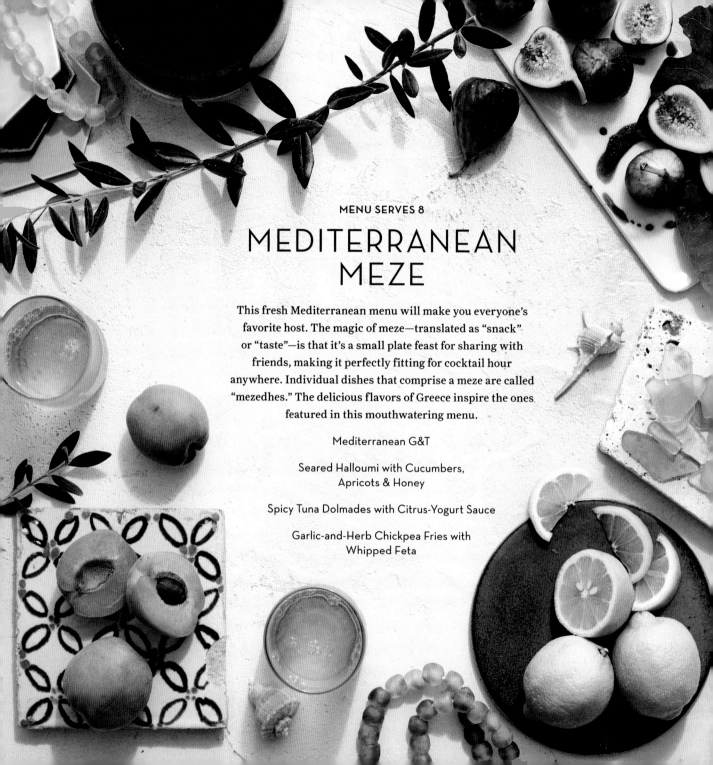

MEDITERRANEAN MEZE

This fresh Mediterranean menu will make you everyone's favorite host. The magic of meze—translated as "snack" or "taste"—is that it's a small plate feast for sharing with friends, making it perfectly fitting for cocktail hour anywhere. Individual dishes that comprise a meze are called "mezedhes." The delicious flavors of Greece inspire the ones featured in this mouthwatering menu.

Mediterranean G&T

Seared Halloumi with Cucumbers, Apricots & Honey

Spicy Tuna Dolmades with Citrus-Yogurt Sauce

Garlic-and-Herb Chickpea Fries with Whipped Feta

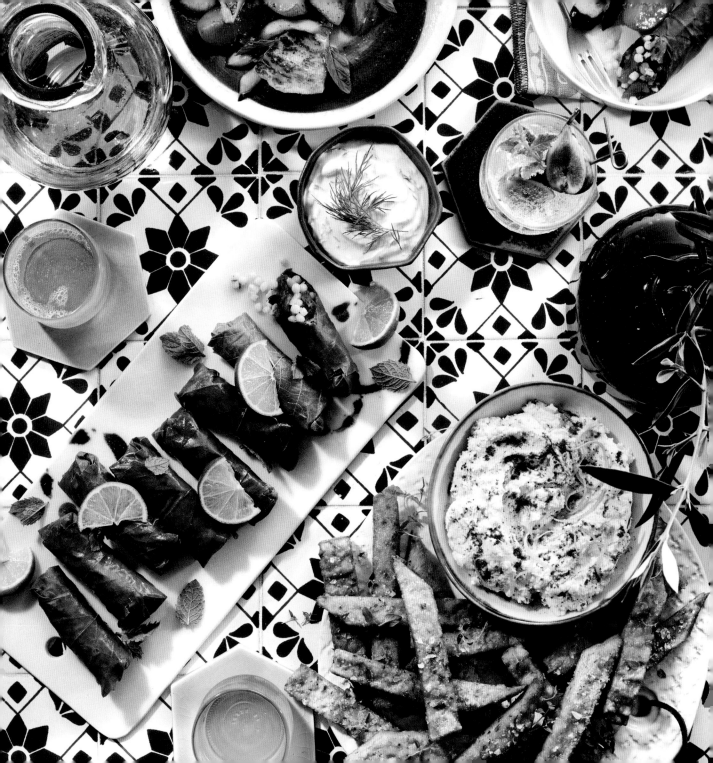

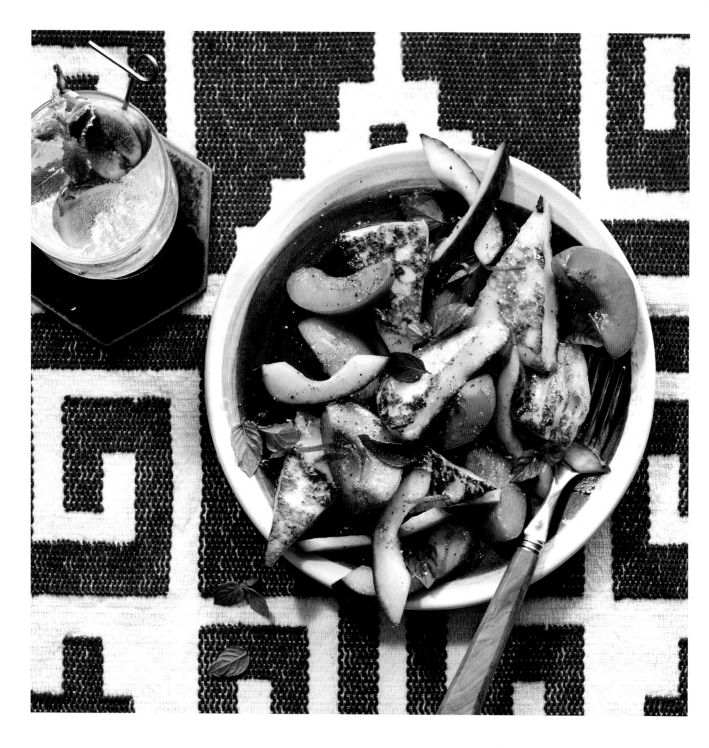

MEDITERRANEAN G&T

Gin genius Simon Ford (Ford's Gin) crafts this silky spirit from globe-spanning ingredients as far flung as Romania and Morocco.

½ cup (4 ounces) Mediterranean tonic (such as Fever-Tree)

6 tablespoons (3 ounces) gin

1 tablespoon (½ ounce) white port

2 dashes of orange bitters

1 fresh mint sprig

Garnish: persimmon or fig slice

Stir together the tonic, gin, port, and orange bitters in a Collins glass. Firmly clap 1 mint sprig between your palms to release the herb's aromatic and flavorful oils. Add the sprig to the glass, and swirl in the drink for 10 seconds. Discard the mint sprig. Add ice to the glass, and garnish as desired.

SEARED HALLOUMI
WITH CUCUMBERS, APRICOTS & HONEY

Halloumi is a mild Cypriot cheese with seemingly magical qualities. It can be cooked without melting or losing its shape, while taking on caramelized goodness. Searing the halloumi in butter instead of olive oil gives the cheese a rich, nutty flavor that balances its natural salinity.

½ cup packed fresh mint leaves, chopped

1 English cucumber (about 11 ounces), seeded and thinly sliced on an angle

8 apricots, seeded and quartered

¼ cup extra-virgin olive oil

3 tablespoons Champagne vinegar

2 teaspoons honey

1 teaspoon lime zest plus 3 tablespoons fresh juice (from 2 limes)

½ teaspoon kosher salt

¼ teaspoon black pepper

2 (8.8-ounce) packages halloumi cheese

4 tablespoons (2 ounces) unsalted butter

1. Combine the mint, cucumber, and apricots in a medium bowl; set aside.

2. Whisk together the olive oil, vinegar, honey, lime zest and juice in a small bowl. Whisk in the salt and pepper; set aside.

3. Cut the halloumi into 4 (½-inch-thick) slabs. Cut each slab diagonally into 2 triangles.

4. Melt 2 tablespoons of the butter in a large skillet over medium-high. Add half of the cheese triangles in a single layer; cook until browned, 2 to 3 minutes per side. Transfer the cheese to a serving platter. Repeat with the remaining butter and cheese.

5. Toss the cucumber mixture with the dressing. Spoon over the halloumi, and serve immediately.

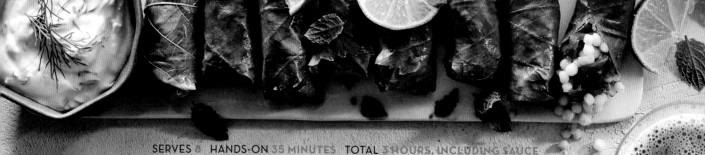

SPICY TUNA DOLMADES
WITH CITRUS-YOGURT SAUCE

Trade the Japanese nori wrappers and sticky rice for grape leaves and couscous in this decidedly Mediterranean spin on the spicy tuna roll.

16 grape leaves (from 1 [16-ounce] jar)

3 cups chicken stock

10 ounces fresh tuna, cut into ½-inch pieces

1 cup uncooked Israeli couscous, cooked according to package directions (about 2 cups)

1 small yellow onion, minced (about 1 cup)

3 garlic cloves, minced (about 1 tablespoon)

1 serrano chile, minced

⅓ cup chopped fresh flat-leaf parsley

⅓ cup chopped fresh mint leaves

2 tablespoons fresh lime juice (from 1 lime)

¼ teaspoon curry powder

1½ teaspoons kosher salt

2 tablespoons extra-virgin olive oil

Citrus-Yogurt Sauce (recipe follows)

1. Rinse the grape leaves under cold water and place in a large bowl. Cover the leaves with cold water; let stand for 15 minutes. Drain and carefully separate the grape leaves. Remove and discard the stems.

2. Place the leaves in a large saucepan, and add the chicken stock, making sure leaves are covered with the stock. Bring to a simmer over medium. Cover and cook until tender, 15 to 20 minutes. Drain and set aside to cool completely.

3. Gently stir together the tuna, couscous, onion, garlic, serrano, parsley, mint, lime juice, curry powder, salt, and olive oil in a large bowl.

4. Place the grape leaves, vein side up, on a work surface. Spoon 1 to 1½ tablespoons of the tuna mixture (depending on the size of the leaf) on the center of the bottom half of each leaf. Fold up the stem end of the leaf to cover the mixture; fold in the sides, and roll up tightly.

5. Place the dolmades on a platter, and cover with plastic wrap. Refrigerate for 2 hours and up to 8 hours. Serve cold or at room temperature with the Citrus-Yogurt Sauce.

CITRUS-YOGURT SAUCE

1 cup plain whole-milk Greek yogurt

1 teaspoon lemon zest plus 2 teaspoons fresh juice (from 1 lemon)

1 teaspoon lime zest plus 2 teaspoons fresh juice (from 1 lime)

1 teaspoon honey

½ teaspoon kosher salt

1 teaspoon chopped fresh dill

Stir together the yogurt, lemon zest and juice, lime zest and juice, honey, and salt in a small bowl. Sprinkle with the fresh dill, and serve immediately. **Makes 1 cup**

GARLIC-AND-HERB CHICKPEA FRIES
WITH WHIPPED FETA

You may say "goodbye" to French fries after tasting these protein-packed fries made with chickpea flour, garlic, and herbs. One dunk in the Whipped Feta may make you say "adieu" to ketchup too.

2 tablespoons extra-virgin olive oil

1 small white onion, minced (about ¾ cup)

4 garlic cloves, minced (about 4 teaspoons)

2 teaspoons fresh thyme leaves

2 teaspoons chopped fresh oregano

4 cups water

2 cups (about 6½ ounces) fine chickpea (garbanzo bean) flour

2¼ teaspoons kosher salt

Canola oil

½ cup (about 2⅛ ounces) all-purpose flour

¼ teaspoon black pepper

Whipped Feta (recipe follows)

1. Grease a 13- x 9-inch baking pan. Heat the olive oil in a saucepan over medium. Add the onion, garlic, thyme, and oregano and cook until tender, about 6 minutes. Add the water and boil over high. Whisk in the chickpea flour until smooth. Reduce heat to medium-low; cook, whisking constantly, until thick, about 6 minutes. Stir in 2 teaspoons salt. Spread the mixture in the pan; press plastic wrap on surface. Refrigerate until firm, about 4 hours.

2. Pour the canola oil in a Dutch oven to a depth of 2 inches; heat over high to 350°F. Cut the chickpea mixture into 4- x ¾-inch strips; pat dry with paper towels. Stir together the all-purpose flour, pepper, and remaining ¼ teaspoon salt, and lightly dust the strips. Fry in batches until golden, about 8 minutes. Drain on paper towels. Serve with the Whipped Feta.

WHIPPED FETA

8 ounces feta cheese, crumbled

4 ounces cream cheese, softened

¼ cup heavy cream

2 tablespoons extra-virgin olive oil

1 teaspoon lemon zest plus 1 tablespoon fresh juice (from 1 lemon)

1 teaspoon za'atar

Place the feta in a food processor, and pulse 5 times. Add the cream cheese, heavy cream, olive oil, lemon zest, and lemon juice; process until smooth and fluffy. Garnish with za'atar. **Makes 2 cups**

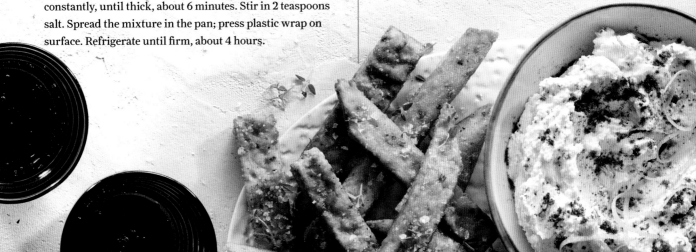

NUI NUI

Modern-day Tiki "archaeologist" Beachbum Barry cracked the code for this drink after deciphering what "spices number two" and "spices number four" were in the recipes in Don the Beachcomber's little black books (owner Donn Beach was notoriously secretive) kept at his tiki bar. The secret? He used a mixture of allspice, vanilla and cinnamon to infuse the sugar syrup.

CINNAMON & VANILLA SIMPLE SYRUPS

2 (3-inch) cinnamon sticks
2 cups granulated sugar
2 cups water
½ vanilla bean, split lengthwise

COCKTAIL

3 tablespoons (1½ ounces) gold rum
1 tablespoon (½ ounce) demerara rum
1 tablespoon (½ ounce) fresh lime juice (from 1 lime)
1 tablespoon (½ ounce) fresh orange juice (from 1 orange)
1½ teaspoons (¼ ounce) allspice dram or Tuaca spiced liqueur
1½ teaspoons (¼ ounce) Cinnamon Simple Syrup (recipe follows)
1½ teaspoons (¼ ounce) Vanilla Simple Syrup (recipe follows)
Dash of Angostura bitters
Garnish: cinnamon stick, lemon peel strip and orange peel strip

1. PREPARE THE CINNAMON AND VANILLA SIMPLE SYRUPS: Combine the cinnamon sticks, 1 cup of the granulated sugar, and 1 cup of the water in a small saucepan. Scrape the seeds from inside the vanilla bean half into a separate small saucepan; add the scraped vanilla bean pod and remaining 1 cup sugar and water. Place each saucepan over medium-high, and bring the contents to a simmer, stirring occasionally until the sugar is dissolved, about 1 minute. Remove the saucepans from the heat, and let the mixtures cool to room temperature, about 30 minutes. Remove and discard the cinnamon sticks and vanilla bean from the syrups. Refrigerate the syrups in separate airtight containers for up to 2 weeks.

2. PREPARE THE COCKTAIL: Fill a tall Collins glass with ice, gold rum, demerara rum, lime juice, orange juice, allspice dram, Cinnamon and Vanilla Simple Syrups, and bitters, stirring to combine. Garnish as desired. Serve immediately.

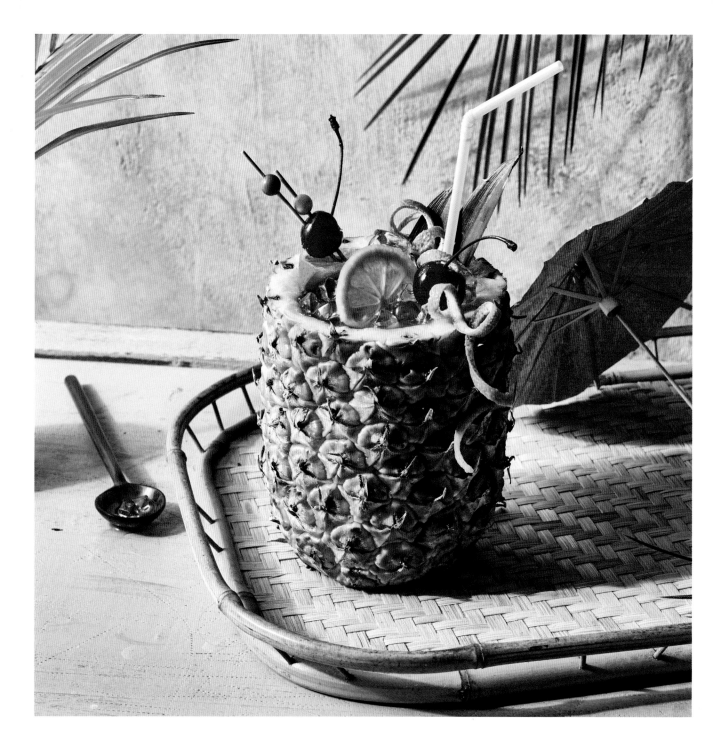

CHIEF LAPU-LAPU

Though named for a fierce Filipino warrior chief, this blended rum drink is more fruity than feisty.

⅓ cup (3 ounces) fresh orange juice (from 1 or 2 oranges)

¼ cup (2 ounces) fresh lemon juice (from 1 or 2 lemons)

3 tablespoons (1½ ounces) dark rum

3 tablespoons (1½ ounces) light rum

2 tablespoons (1 ounce) simple syrup

1½ tablespoons (¾ ounce) grenadine

1 fresh pineapple, trimmed and hollowed out

Garnish: lemon wheel, lime wedge, marashino cherries and orange twist

Fill a cocktail shaker with ice; add the orange juice, lemon juice, dark rum, light rum, simple syrup, and grenadine. Cover and shake vigorously until thoroughly chilled, about 15 seconds. Strain into the hollowed-out pineapple. Garnish as desired and serve with a straw.

A new crop of pineapples are piled in the field before being gathered to take to market. It takes 15 to 20 months from planting until the fruit is mature enough to harvest.

EDAMAME-AVOCADO HUMMUS

Sesame paste gives this variation on hummus a familiar flavor, but shelled soybeans, or edamame, stand in for the usual chickpeas. At the same time, avocado lends a silkiness that gives this riff a lighter texture than the classic. Serve this with rice crackers instead of the usual pita chips.

2 cups refrigerated shelled edamame (1 [9-ounce] container)
½ cup loosely packed fresh cilantro leaves (from 1 bunch)
¼ cup olive oil
¼ cup tahini (sesame paste)
¼ cup fresh lime juice (from 3 limes)
1 tablespoon toasted sesame oil
½ tablespoon Sriracha chili sauce
1 teaspoon kosher salt
1 teaspoon grated fresh ginger
1 medium-size ripe avocado, peeled (about 6 ounces)
1 teaspoon white sesame seeds
1 teaspoon black sesame seeds
Assorted vegetables (such as sugar snap peas, carrots, radishes, endive, cucumber, and cherry tomatoes)

Process the edamame, cilantro, olive oil, tahini, lime juice, sesame oil, Sriracha, salt, ginger, and avocado in a food processor until smooth. Transfer the mixture to a large serving bowl. Sprinkle with the sesame seeds, and serve with the assorted vegetables.

HOW TO GET THE MOST JUICE FROM A LIME: Microwave the lime for 20 seconds, and then let it cool. Roll it across the counter a couple of times with your palm, then cut in half and squeeze.

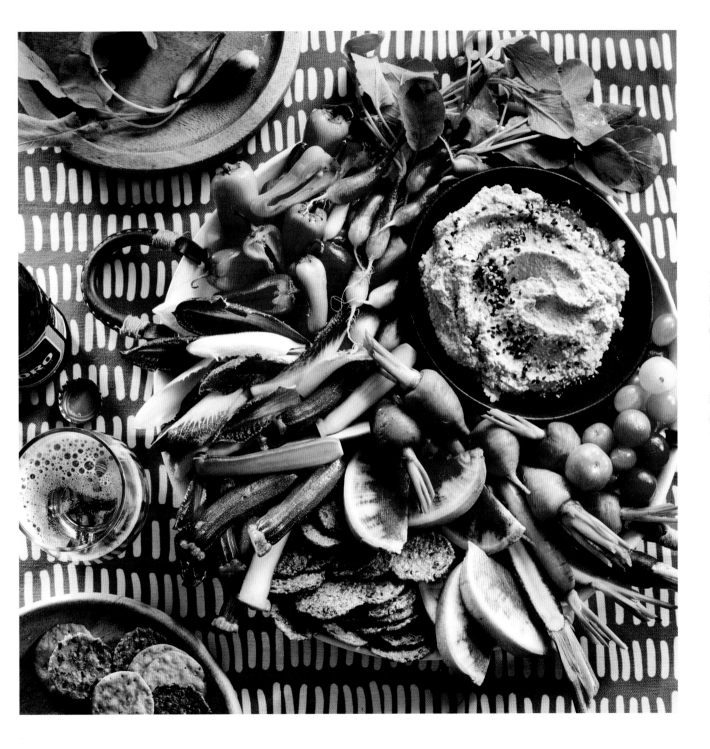

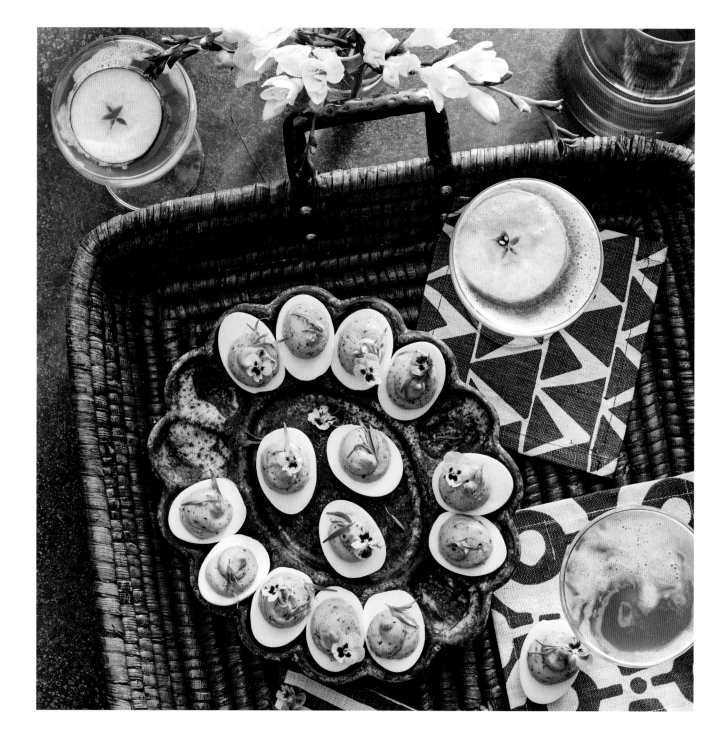

LILLET MISS SUNSHINE

A blend of citrus liqueur and Bordeaux wines, Lillet is a popular aperitif in France. It's delicious for layering in spirited cocktails like this juicy bourbon-apple combo.

¼ cup (2 ounces) bourbon

2 tablespoons (1 ounce) apple cider

2 tablespoons (1 ounce) ginger syrup

¼ cup (2 ounces) apple kombucha

1 apple slices

Combine the bourbon, apple cider, and ginger syrup in a cocktail shaker filled with ice. Cover and shake vigorously until thoroughly chilled, about 30 seconds. Strain into 2 chilled coupe glasses. Top each drink with apple kombucha, and an apple slice. Serve immediately.

GREEN GODDESS DEVILED EGGS

The verdant filling for these deviled eggs is packed with herbaceous goodness from green goddess dressing and creamy avocado.

6 large eggs

½ medium-size ripe avocado

¼ cup chopped fresh tarragon

¼ cup chopped fresh flat-leaf parsley

3 tablespoons apple cider vinegar

3 tablespoons mayonnaise

¼ teaspoon kosher salt

⅛ teaspoon black pepper

2 anchovy fillets

Garnish: tarragon leaves and pansy blossoms

1. Bring a large saucepan of water to a boil over high. Carefully add the eggs with a slotted spoon. Cook exactly 9 minutes; remove the eggs with a slotted spoon. Immediately plunge them into a bowl of ice water. Let stand 15 minutes. Peel the eggs, and halve lengthwise. Separate the yolks from whites, reserving both.

2. Process the yolks, avocado, tarragon, parsley, vinegar, mayonnaise, salt, pepper, and anchovies in a food processor until smooth, about 1 minute. Spoon or pipe the filling into the egg white halves. Garnish as desired.

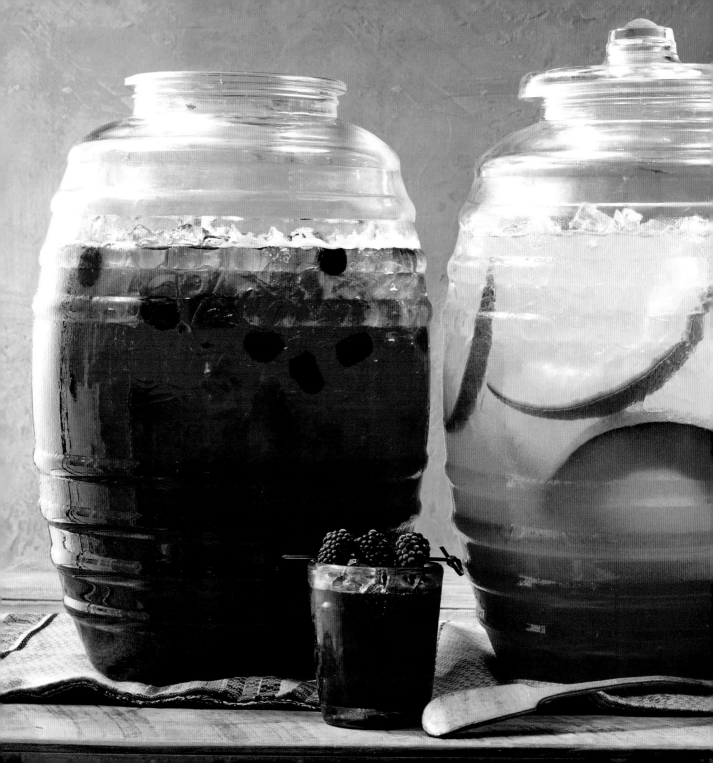

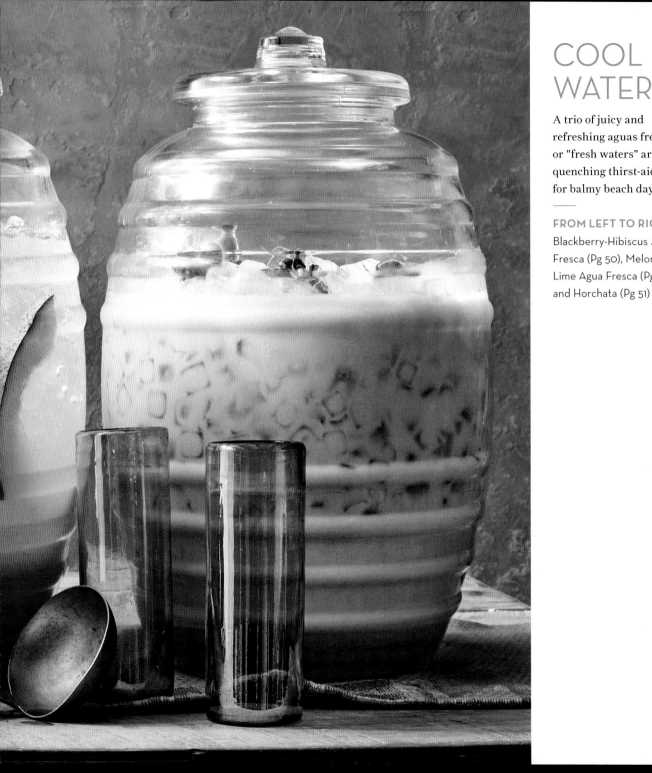

COOL WATERS

A trio of juicy and refreshing aguas frescas or "fresh waters" are a quenching thirst-aid kit for balmy beach days.

FROM LEFT TO RIGHT: Blackberry-Hibiscus Agua Fresca (Pg 50), Melon-Lime Agua Fresca (Pg 50), and Horchata (Pg 51)

BLACKBERRY-HIBISCUS AGUA FRESCA

The addition of blackberries to the traditional Agua de Jamaica made with hibiscus flowers gives the tart drink a dose of sweetness and boosts its deep ruby hue.

3 cups (24 ounces) boiling water

8 hibiscus flower tea bags (such as The Republic of Tea)

3 cups (about 18 ounces) fresh blackberries

2 cups (16 ounces) cold water

¼ cup (2 ounces) honey

Garnish: fresh blackberries

1. Combine the boiling water and hibiscus-flower tea bags; stir once, and steep 10 minutes. Pour through a fine wire-mesh strainer into a pitcher to equal 2 cups hibiscus tea. (Do not squeeze the tea bags.)

2. Process the blackberries in a food processor until smooth, about 30 seconds, stopping to scrape down the sides if needed. Pour through a fine wire-mesh strainer, stirring and pressing with a spatula. Discard seeds and solids.

3. Stir together the hibiscus tea, cold water, honey, and the berry puree in a pitcher; serve over ice. Garnish as desired.

MELON-LIME AGUA FRESCA

Sour lime and sweet melon are a popular agua fresca combo. Serve this in a salt-rimmed glass to enhance the flavors if you wish.

1 medium-size, very ripe cantaloupe (about 4 pounds), peeled, seeded, and coarsely chopped

3 cups (24 ounces) cold water

¾ cup (6 ounces) simple syrup

½ cup (4 ounces) lime juice (from about 3 large limes)

Process the cantaloupe in a food processor until smooth, 30 to 40 seconds, stopping to scrape down sides as needed. Pour through a fine wire-mesh strainer into a measuring cup, stirring and pressing gently with a spatula. Discard seeds and solids. Stir together the cold water, simple syrup, lime juice, and 2½ cups of the melon puree in a large pitcher. (Reserve any remaining melon puree for another use.) Serve over ice.

HORCHATA

With origins in Africa, this blend of rice and nut or seed milks found its way to Spain and then on to the New World. Traditionally steeped with cassia or cinnamon, sometimes other flavorings like vanilla or clove are added.

1½ cups uncooked basmati rice

1½ cups whole blanched almonds

1 cup granulated sugar

1 teaspoon ground cinnamon

3 (2-inch) lemon peel strips

48 ounces (6 cups) boiling water

Ground cinnamon

1. Place the uncooked basmati rice, blanched almonds, sugar, 1 teaspoon cinnamon, and lemon peel strips in a large glass bowl. Pour the boiling water over the mixture in the bowl, and cool until room temperature, about 1 hour. Cover and chill 12 hours or overnight.

2. Transfer the mixture to a blender; process until smooth. (If using a high-powered blender, blend on medium speed to avoid overprocessing the rice.) Pour through a fine wire-mesh strainer lined with a single layer of cheesecloth into a 1½- to 2-quart pitcher; press gently with a spoon to extract the puree and discard the solids. Chill until ready to serve (up to 4 hours).

3. Serve over ice with a sprinkle of ground cinnamon.

SPARKLING MATCHA MINT COCKTAIL

Floral honey, fresh herbs, and vibrant green tea powder add earthiness to this effervescent springtime sipper.

½ cup (4 ounces) hot water

3 teaspoons matcha powder

3 teaspoons honey

8 fresh mint leaves

1 cup (8 ounces) dry Champagne

Garnish: mint sprigs

1. Whisk together the first 3 ingredients in a small bowl until the matcha powder dissolves. Let cool completely.

2. Muddle the mint leaves in the bottom of a cocktail shaker. Add the matcha mixture, and fill the shaker with ice. Cover and shake until thoroughly chilled, about 30 seconds. Strain into 2 Champagne flutes. Top with the Champagne. Garnish as desired.

BENNE WAFERS

A Lowcountry, South Carolina, staple, these crisp sesame cookies are delicious with afternoon tea or as an after-dinner digestif.

½ cup (2⅛ ounces) all-purpose flour

¼ teaspoon kosher salt

⅛ teaspoon baking soda

1 cup packed light brown sugar

¼ cup (2 ounces) butter, softened

1 large egg

1 teaspoon fresh lemon juice

½ teaspoon vanilla extract

1 cup toasted sesame seeds

1. Preheat the oven to 350°F. Line 2 baking sheets with parchment paper. Combine the first 3 ingredients; set aside.

2. Beat the sugar and butter with a mixer at medium speed until light and fluffy. Add the egg, and mix until well blended. Add the flour mixture, and mix until well blended. Stir in the lemon juice, vanilla, and sesame seeds. Drop by tablespoonfuls onto the prepared baking sheets.

3. Bake at 350°F until lightly golden, 8 minutes. Cool slightly on the baking sheets; remove to wire racks to cool completely. Store in an airtight container until ready to serve.

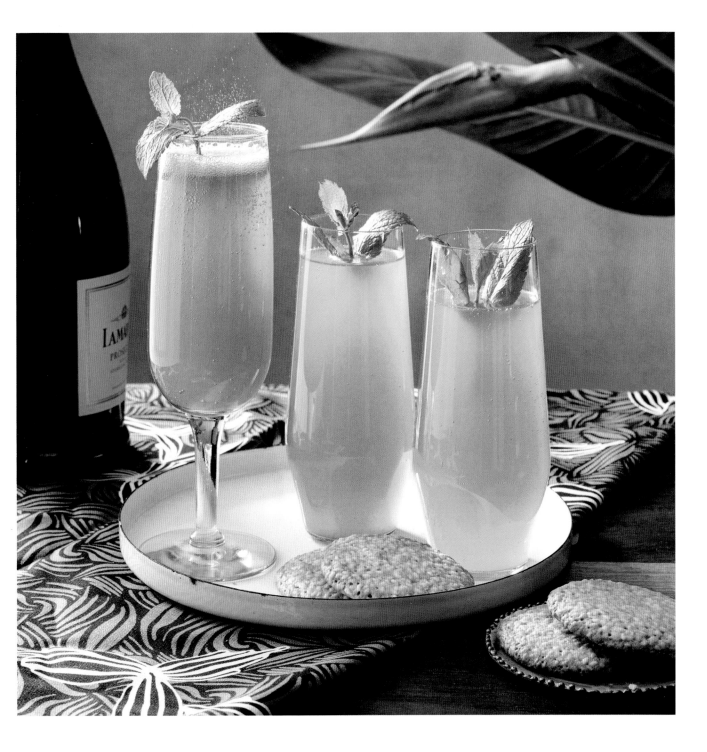

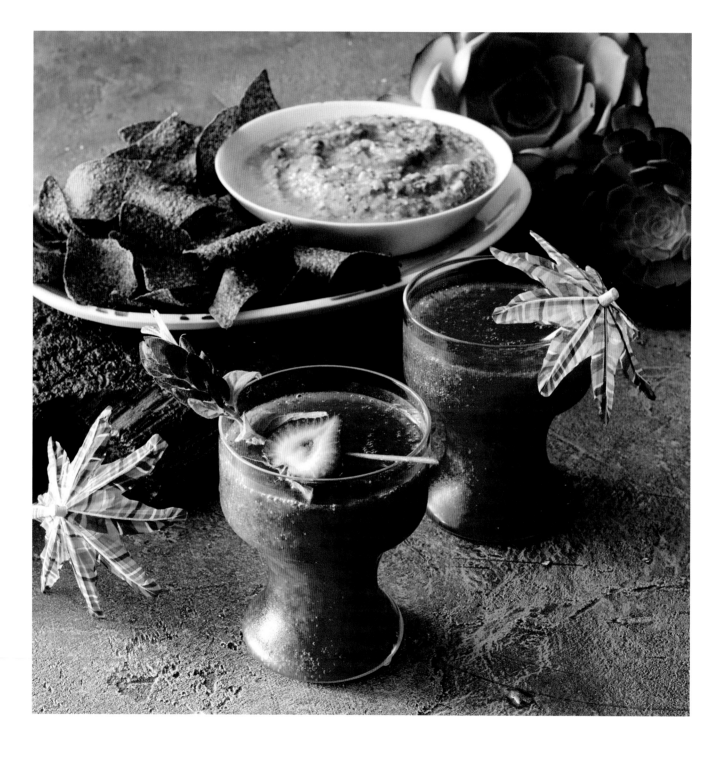

STRAWBERRY CAIPIRINHAS

Fresh strawberries can't help but make Brazil's traditional Caipirinha of sugar, muddled limes, and cachaça (a sugarcane spirit) blush.

4 cups hulled and halved fresh strawberries (about 1½ pounds whole strawberries)

3 cups ice cubes

¾ cup (6 ounces) simple syrup

½ cup (4 ounces) cachaça

3 tablespoons (1½ ounces) fresh lime juice (from about 2 limes)

Garnish: lime wedges and halved strawberries

Process the strawberries, ice cubes, simple syrup, cachaça, and lime juice in a blender until smooth and blended, about 1 minute, stopping to scrape down the sides as needed. Pour into chilled glasses, and garnish as desired.

AVOCADO SALSA VERDE

Rich, ripe avocado gives a silky texture to classic salsa verde brimming with the bold flavors of spicy chiles, garlic, and lime juice.

1 to 1¼ pounds tomatillos (about 10)

¼ sweet onion, chopped

2 garlic cloves

1 serrano chile or jalapeño chile, seeded and chopped

½ cup fresh cilantro

2 tablespoons fresh lime juice

1 avocado, chopped

1½ teaspoons kosher salt

Tortilla chips

Peel the husks from the tomatillos, and rinse with cool water until they no longer feel sticky. Cut into chunks, and place in a food processor with the onion, garlic, and serrano chile; process until the mixture is finely chopped. Add the cilantro and lime juice; process until very finely chopped. Add the avocado and salt; pulse until blended. Serve with the tortilla chips.

BOOZY ALMOND HOT CHOCOLATE

Rich hot cocoa get an infusion of amaretto liqueur to create this decadent, warming cocktail.

3 cups whole milk
1½ cups heavy cream
¾ cup amaretto liqueur
¼ cup honey
3 ounces chopped milk chocolate
⅛ teaspoon kosher salt
Toasted sliced almonds

Combine the milk and 1 cup heavy cream in a small saucepan; bring to a simmer over medium. Remove from the heat. Whisk in the amaretto, honey, chocolate, and salt. Keep warm. Beat the remaining ½ cup heavy cream in a chilled bowl with a whisk until soft peaks form. Serve the hot chocolate topped with the whipped cream and toasted sliced almonds.

BROWNED BUTTER-CHOCOLATE CHUNK COOKIES
WITH FLAKE SALT

This elevated take on the classic chocolate chip cookie is a perfect afternoon pick-me-up or nightcap nibble.

¾ cup granulated sugar
⅔ cup packed brown sugar
1 teaspoon instant coffee granules
1 cup (8 ounces) unsalted butter
1½ teaspoons vanilla extract
1¼ teaspoons flake salt
2 large eggs
1 large egg yolk
2⅓ cups (about 10.5 ounces) all-purpose flour
3 tablespoons cornstarch
1½ teaspoons baking powder
¼ teaspoon baking soda
8 ounces semisweet chocolate, chopped into chunks

1. Combine the sugars and coffee granules in the bowl of a stand mixer. Melt the butter over medium-high until it bubbles and begins to brown, 3 to 4 minutes. Add it to sugar mixture; beat at medium-low for 2 minutes. Beat in the vanilla, ¾ teaspoon salt, eggs and egg yolk to combine.

2. Whisk flour, cornstarch, baking powder, and baking soda in a medium bowl. Add flour mixture to sugar mixture; beat at low speed to combine. Stir in chocolate. Refrigerate at least 1 hour.

3. Preheat the oven to 350°F. Line 2 large baking sheets with parchment paper.

4. Scoop half of dough into 16 balls and place 8 balls onto each prepared baking sheet. Bake at 350°F 8 minutes. Rotate pans; bake until edges are golden brown, 6 to 7 more minutes. Sprinkle tops with ¼ teaspoon salt. Cool on baking sheets 5 minutes. Transfer to wire racks to cool completely. Repeat with remaining dough and salt.

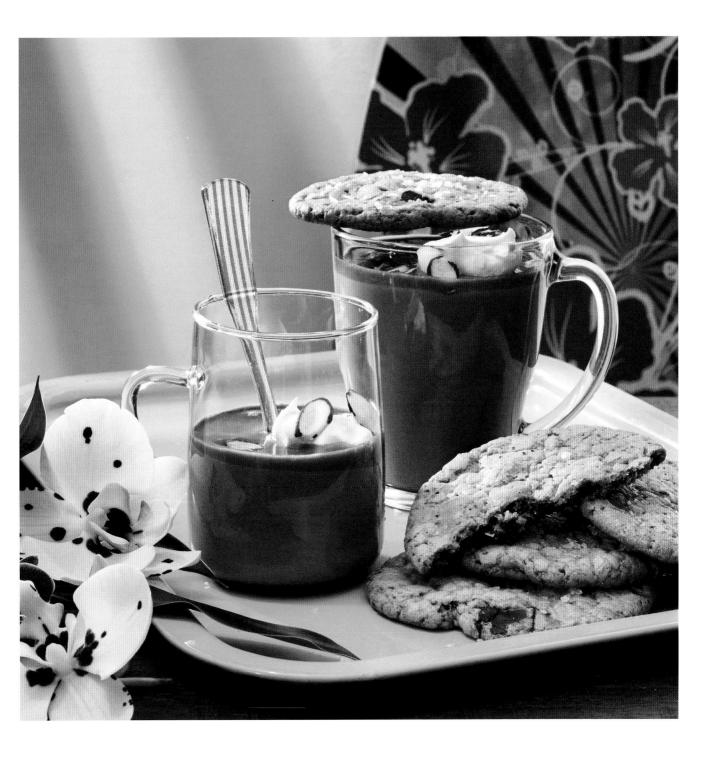

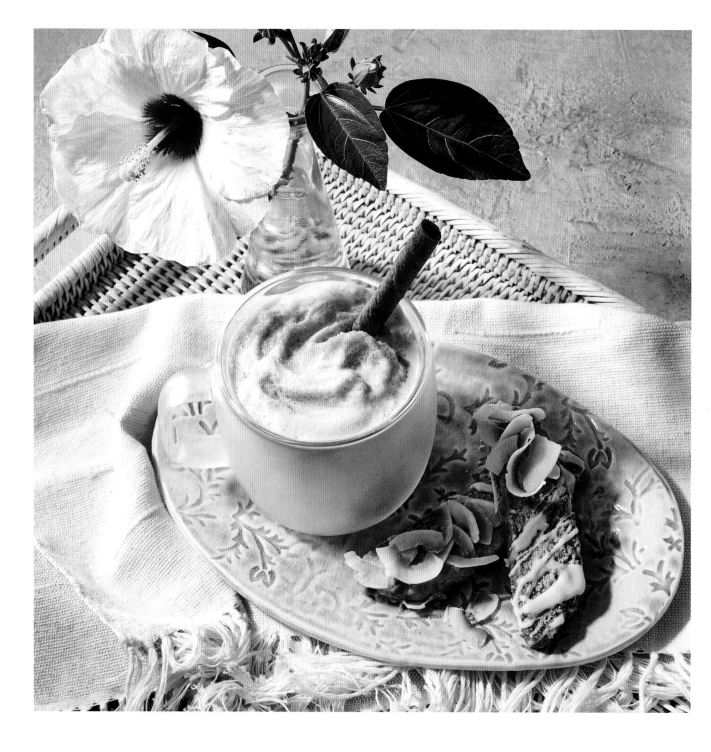

SPIKED VIETNAMESE COFFEE FRAPPE

Known as *cà phê sua dá* in Vietnamese, this cold, creamy eye-opener is made from coffee concentrate or espresso, crushed ice, and sweetened condensed milk. Kahlúa is a spirited embellishment.

8 ounces (1 cup) cold coffee concentrate or brewed espresso

4 ounces (½ cup) sweetened condensed milk

4 ounces (½ cup) coffee liqueur (such as Kahlúa)

3 cups ice cubes

Rolled cookie "straws" (such as Pirouline)

Process the coffee concentrate or brewed espresso, sweetened condensed milk, coffee liqueur, and 3 cups ice cubes in a blender on high speed until smooth and blended, 30 to 45 seconds. Pour evenly into 4 chilled glasses, and serve with a cookie straw.

COCO-ALMOND BISCOTTI

Enjoy this tropical biscotti with your morning espresso.

1 cup granulated sugar

2½ cups unsweetened coconut flakes, lightly toasted

3 cups (13.5 ounces) all-purpose flour

1 teaspoon baking powder

½ teaspoon baking soda

½ teaspoon kosher salt

3 large eggs

½ cup (4 ounces) unsalted butter, melted

1½ teaspoons vanilla extract

1 cup slivered toasted almonds

4 teaspoons coconut milk

1 cup powdered sugar

1. Preheat the oven to 350°F. Line a baking sheet with parchment paper.

2. Combine the sugar and 1 cup of the coconut in the bowl of a food processor; process until finely ground. Combine the coconut mixture, flour, baking powder, baking soda, and salt in the bowl of a stand mixer fitted with the paddle attachment. Whisk the eggs in a small bowl. Remove 1 tablespoon beaten egg and mix with 1 tablespoon water in a small bowl; set aside. Add the butter, remaining eggs, and vanilla to the flour mixture; mix at low speed until just combined. Add the almonds and ½ cup of the coconut flakes; mix until just combined.

3. Divide the dough into 2 (8- x 4-inch) loaves on the prepared baking sheet. Brush loaves with the egg wash. Bake at 350°F until lightly browned, about 35 minutes. Let stand 15 minutes.

4. Reduce the oven temperature to 325°F. Cut each loaf crosswise into 16 (½-inch) slices. Arrange the slices, cut sides down, on the prepared baking sheet. Bake until lightly browned, 25 more minutes. Let cool completely.

5. Whisk together the coconut milk and powdered sugar in a medium bowl until smooth. Spread over one-third of each biscotti; sprinkle with remaining 1 cup coconut flakes.

02.
BEACHSIDE GRILL

JAMAICAN JERK CHICKEN WINGS
WITH CILANTRO-LIME RANCH

From merely hot to downright incendiary, this Caribbean seasoning gets its kick from a blend of bold ingredients like chiles, thyme, cinnamon, garlic, and nutmeg. Sprinkle on meat or vegetables. Here the heat is tamed with a cool, creamy spin on Ranch dressing.

CHICKEN

- ½ cup chopped scallions (about 10 scallions)
- 3 tablespoons dark brown sugar
- ½ ounce fresh ginger, sliced (about 1 [2-inch] piece)
- 1 tablespoon kosher salt
- 1 teaspoon ground allspice
- 1 teaspoon ground cinnamon
- ½ teaspoon ground cloves
- ¼ teaspoon ground nutmeg
- 4 garlic cloves
- 2 Scotch bonnet chiles, chopped
- ¼ cup fresh lime juice (from 2 limes)
- ¼ cup canola oil
- 3 pounds chicken drumettes

SAUCE

- 1 cup sour cream
- ¼ cup whole buttermilk
- 2 tablespoons chopped fresh cilantro
- 1 teaspoon lime zest plus 2 tablespoons fresh juice (from 1 lime)
- 1 teaspoon kosher salt

1. PREPARE THE CHICKEN: Combine the scallions, brown sugar, ginger, salt, allspice, cinnamon, cloves, nutmeg, garlic, and chiles in a mini food processor. Process until a smooth paste forms, about 2 minutes. Transfer to a large bowl, and add the lime juice, oil, and drumettes; toss to coat. Cover and chill 4 hours or up to overnight.

2. Heat a charcoal grill to medium-high (about 450°F). Place the drumettes on oiled grate, and grill, covered and turning often, until cooked through and well charred, about 30 minutes.

3. PREPARE THE SAUCE: Stir together all the sauce ingredients in a bowl; serve with the wings.

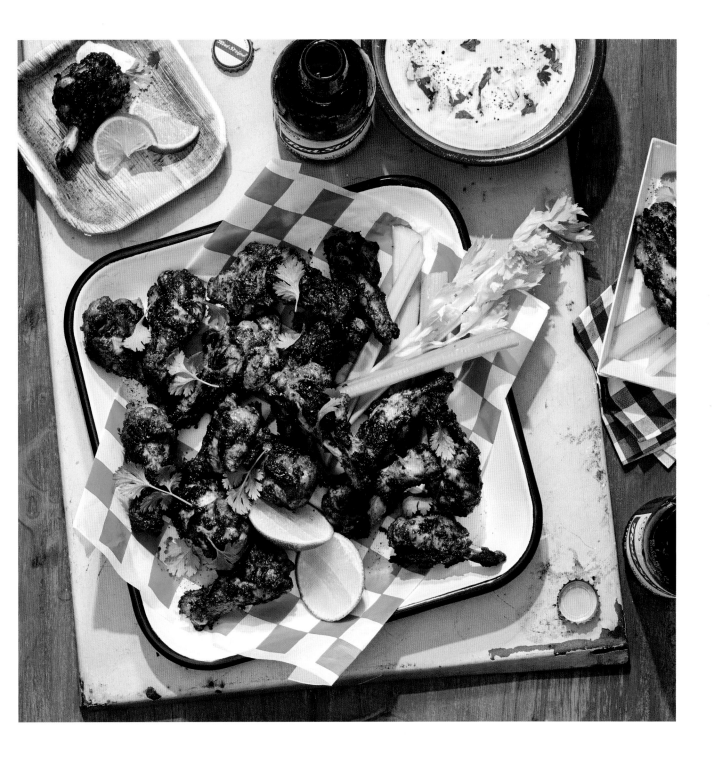

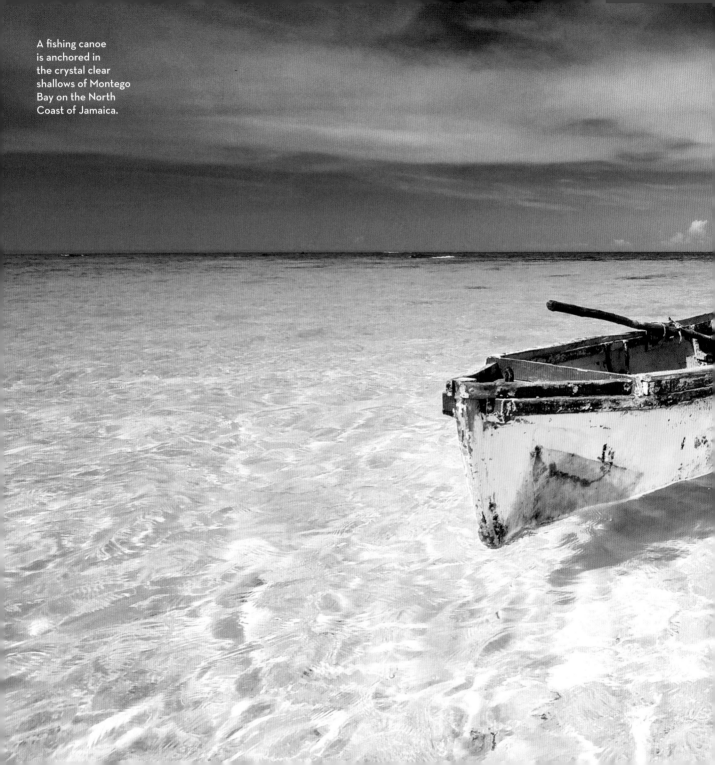

A fishing canoe is anchored in the crystal clear shallows of Montego Bay on the North Coast of Jamaica.

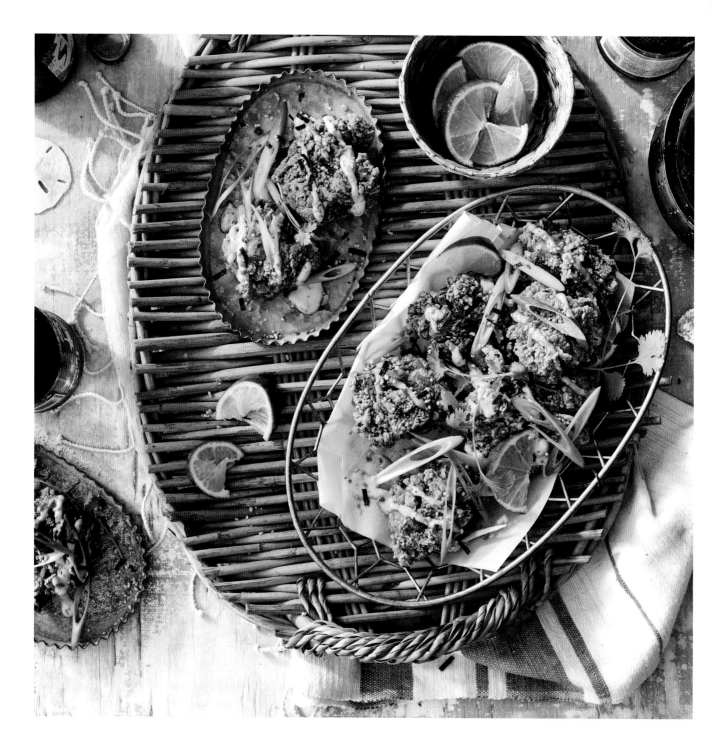

SHOYU FRIED CHICKEN
WITH MOCHIKO BATTER

Shoyu chicken is a Hawaiian plate-lunch favorite that consists of chicken marinated or simmered in shoyu (a variety of soy sauce), garlic, sugar, and other spices.

1 (13.5-ounce) can coconut milk, well shaken and stirred

½ cup shoyu sauce (soy sauce)

2 pounds boneless, skinless chicken thighs, cut into 2-inch pieces

1 cup (about 5 ounces) mochiko flour (sweet rice flour)

¼ cup cornstarch

2 tablespoons sesame seeds

1 tablespoon granulated sugar

2 teaspoons garlic powder

2 teaspoons ground ginger

1 teaspoon kosher salt

½ teaspoon black pepper

½ cup mayonnaise

2 tablespoons sambal oelek (ground fresh chile paste)

1 teaspoon fresh lime juice (from 1 lime)

Peanut oil

½ cup loosely packed fresh cilantro leaves

¼ cup thinly sliced scallions (from 2 scallions)

Dash of furikake (see note)

1. Whisk together the coconut milk and shoyu in a large bowl. Add the chicken pieces, stirring until coated and submerged. Cover and chill 4 hours or overnight.

2. Stir together the mochiko flour, cornstarch, sesame seeds, sugar, garlic powder, ginger, salt, and pepper in a large bowl. Set aside.

3. Whisk together the mayonnaise, sambal oelek, and lime juice in a small bowl. Cover and chill.

4. Pour the peanut oil to a depth of 2 inches in a large Dutch oven over medium-high, and heat to 360°F. Using tongs, remove the chicken pieces from the marinade, letting excess liquid drip off, and dredge in the mochiko mixture. Cook the chicken, in batches, in the hot oil until crispy and cooked through, about 6 to 7 minutes. Place on a plate lined with paper towels. Sprinkle with the cilantro leaves, scallions, and furikake; drizzle with about 1½ tablespoons of the mayonnaise-sambal sauce, and serve with the remaining sauce on the side.

NOTE: A dried blend of seaweed, sesame seeds, fish flakes, salt, and other seasonings, *furikake* (which literally translates to "sprinkle over') is often served on rice or sushi rolls, and in party mix.

CRISPY CHICKEN
WITH LEMON, PARSLEY, & OLIVE OIL

Who doesn't love crispy fried chicken? What sets this recipe apart is using mustard instead of beaten egg to get the breading to adhere. The result is crunchy and super flavorful.

2½ ounces sourdough bread (about 3 slices), torn into smaller pieces

4 (6-ounce) boneless, skinless chicken breasts

¾ teaspoon kosher salt

½ teaspoon black pepper

1 tablespoon coarse-grained Dijon mustard

¾ cup extra-virgin olive oil

2 tablespoons fresh lemon juice (from 1 lemon)

2 tablespoons chopped fresh parsley

4 cups mixed baby greens

1. Process the bread in a food processor 1 minute or to coarse crumbs. Transfer the breadcrumbs to a large plate.

2. Place the chicken between 2 sheets of plastic wrap; pound to an even thickness. Sprinkle with ½ teaspoon of the salt and ¼ teaspoon of the pepper. Brush each chicken breast with the mustard, and roll in the breadcrumbs to coat.

3. Heat ½ cup of the oil in a large nonstick skillet over medium until hot. Add the chicken, and cook 7 minutes on each side or until golden brown and a thermometer inserted in thickest portion registers 160°F.

4. Meanwhile, combine the lemon juice, parsley, remaining ¼ teaspoon salt and ¼ teaspoon pepper in a small bowl. Slowly whisk in the remaining ¼ cup olive oil.

5. Place 1 chicken breast half on each of 4 plates; top evenly with the parsley mixture. Serve immediately with the mixed greens.

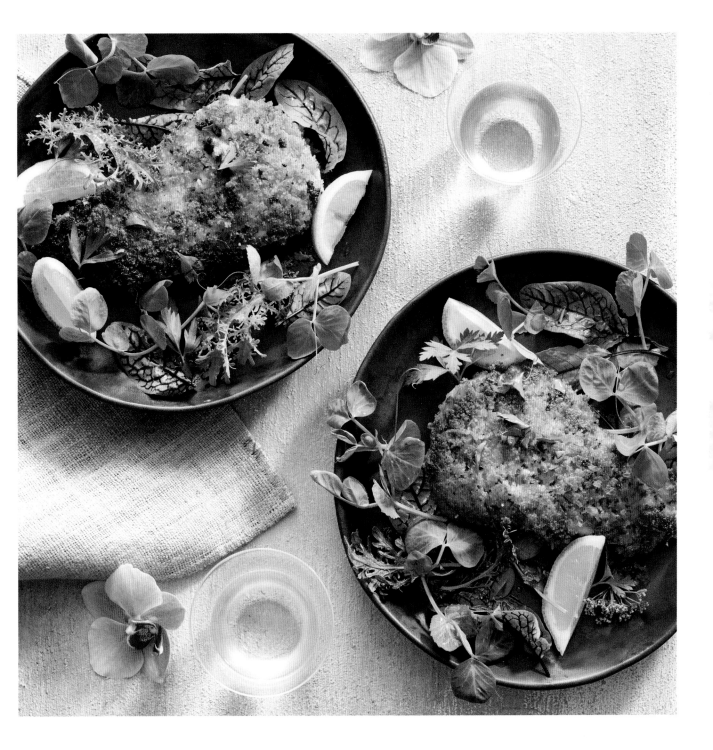

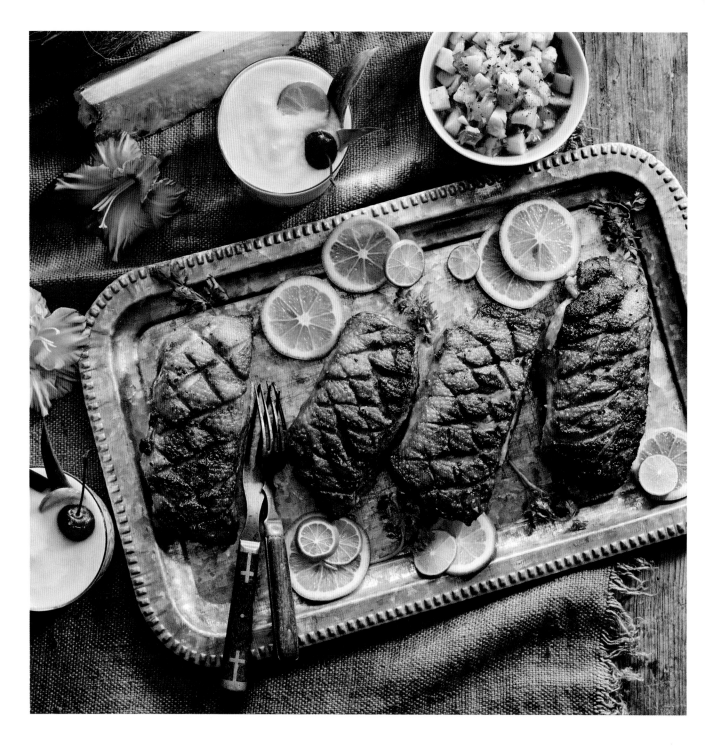

GRILLED DUCK BREAST
WITH MANGO CHUTNEY

Duck breast has an affinity for brightly flavored fruits like citrus—orange is a classic. Tart-sweet mango offers a similar complementary flavor that cuts through the richness of the meat.

4 (6-ounce) boneless duck breasts

¼ teaspoon kosher salt

¼ teaspoon freshly ground black pepper

Mango Chutney (recipe follows)

1. Preheat grill to medium-high (about 450°F). Score the skin of the breasts in a crosshatch pattern; season with the salt and pepper. Grill 4 minutes per side or until desired degree of doneness.

2. Transfer the duck to a serving platter, and cover with foil. Let stand 10 minutes before slicing. Serve with the Mango Chutney.

MANGO CHUTNEY

1 tablespoon canola oil

1 shallot, minced

1 small onion, minced

4 ripe mangoes, diced (see note)

¼ cup apple cider vinegar

¼ cup packed brown sugar

¼ teaspoon kosher salt

¼ teaspoon freshly ground black pepper

⅛ teaspoon ground cardamom

Heat the oil in a large Dutch oven over medium-high. Add the shallot and onion; sauté 3 minutes or until tender. Add the mangoes, vinegar, and sugar. Bring to a boil, reduce heat, and simmer 20 minutes or until the liquid evaporates. Stir in the salt, pepper, and cardamom. **Makes 3 cups**

NOTE: Most mangoes turn red or golden when ripe, but to avoid mushiness, select fruit that yields to gentle pressure and has a sweet aroma at the stem end. Cutting a crosshatch pattern into the flesh of a mango half before turning it inside out makes cubing the fruit super easy.

A kaleidoscope of colorful produce beckons shoppers at a floating market in Bangkok, Thailand.

GRILLED PORK TENDERLOINS
WITH GREEN APPLE-CUCUMBER SALSA

Take delicious pork tenderloin from strictly standard to totally scrumptious. You can substitute equal amounts of ground cumin and black pepper in this recipe, but toasting and grinding your own fresh whole spices adds an exceptional flavor to the meat.

1 tablespoon whole cumin seeds

1 teaspoon whole black peppercorns

2 (1-pound) pork tenderloins

2 tablespoons chopped fresh mint

2 minced garlic cloves

½ teaspoon kosher salt

Green Apple-Cucumber Salsa (recipe follows)

1. Toast the cumin seeds and peppercorns in a small dry skillet over medium, shaking skillet often, 3 minutes or until spices are fragrant. Transfer to a plate to cool, and crush spices with a mortar and pestle. (You can also transfer the spices to a ziplock plastic bag, seal it, and crush the spices with a meat mallet or rolling pin.) Set aside ½ teaspoon spice mixture for the salsa.

2. Sprinkle the tenderloins with the remaining spice mixture, mint, and garlic, pressing to adhere. Cover and chill up to 8 hours.

3. Preheat a grill to medium-high (about 450°F). Sprinkle the pork with salt. Grill, covered, turning every 5 to 6 minutes for 18 to 20 minutes, or until a thermometer registers 145°F and the pork is slightly pink in the center.

4. Place the tenderloins on a cutting board and loosely cover with foil; let stand 10 minutes. Cut into slices, and serve with the Green Apple-Cucumber Salsa.

GREEN APPLE-CUCUMBER SALSA

½ teaspoon reserved spice mixture from Grilled Pork Tenderloins

2 Granny Smith apples, cored and chopped

½ large English cucumber, peeled and chopped

3 tablespoons diced red onion

2 tablespoons chopped fresh mint

1 tablespoon light brown sugar

1 jalapeño chile, seeded and minced

2 tablespoons fresh lime juice

1 tablespoons olive oil

¼ teaspoon kosher salt

¼ cup toasted slivered almonds

Combine the spice mixture, apples, cucumber, onion, mint, brown sugar, jalapeño, lime juice, olive oil, and salt in a bowl. Stir in the almonds just before serving. **Makes 4 cups**

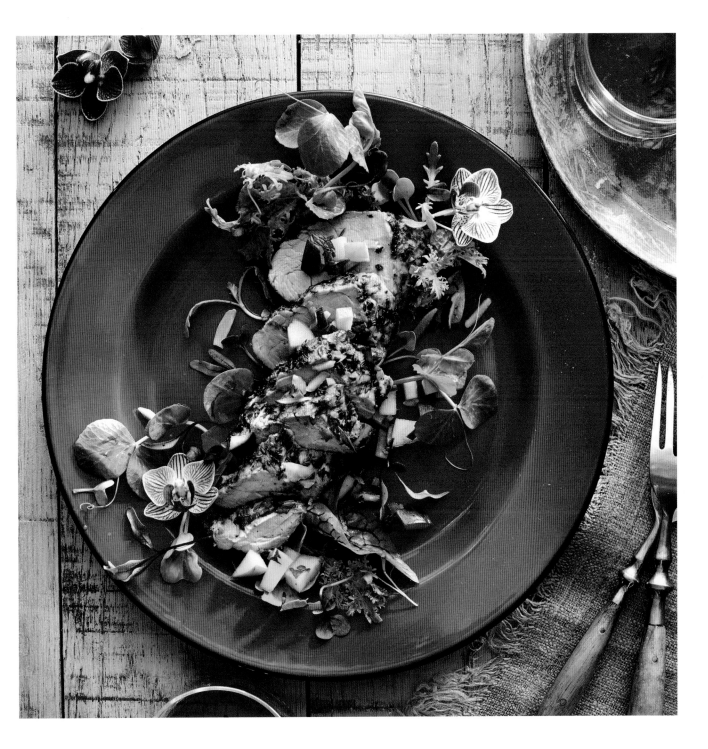

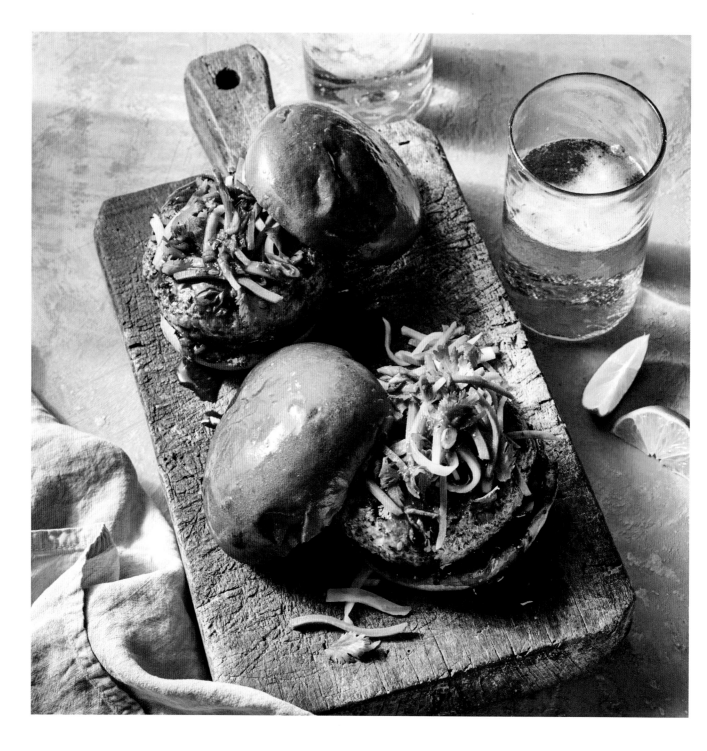

HOISIN PORK BURGERS
WITH PICKLED VEGETABLES

Sweet-meets-spicy in Chinese hoisin sauce, which is made from soybeans, garlic, molasses, vinegar, and a touch of sesame. It's a delicious match for pork.

1½ tablespoons granulated sugar

¼ cup plus 2 tablespoons rice wine vinegar

3 tablespoons water

1 cup thinly shaved carrot

1 cup thinly shaved daikon radish

½ cup fresh cilantro leaves

2 tablespoons hoisin sauce

1 tablespoon soy sauce

1 tablespoon finely chopped scallion

2 teaspoons minced fresh ginger

1 teaspoon minced garlic

1 pound ground pork

1 tablespoon butter, melted

½ teaspoon kosher salt

½ teaspoon freshly ground black pepper

Cooking spray

4 hamburger buns, split horizontally

1. Combine the sugar with ¼ cup of the vinegar and 3 tablespoons water in a medium microwave-safe bowl. Microwave on HIGH for 2 minutes or until bubbling. Add the carrot and radish; toss to combine. Let stand 15 minutes; drain well. Stir in the cilantro.

2. Meanwhile, combine the hoisin sauce, next 4 ingredients, and remaining 2 tablespoons vinegar in a small microwave-safe bowl. Microwave on HIGH for 1 minute.

3. Place 3 tablespoons of the hoisin mixture in a medium bowl. Add the pork, butter, salt, and pepper; mix gently to combine. Divide the mixture into 4 equal portions; gently shape each portion into a ½-inch-thick patty. Lightly coat patties with cooking spray.

4. Preheat grill or grill pan to medium-high (about 450°F); coat with cooking spray. Grill the patties 5 minutes per side, or until a thermometer registers 160°F and the pork is cooked through. Remove the patties from the grill; grill the buns, cut sides down, 1 minute, or until lightly toasted. Remove the buns from the grill, and spread a of the hoisin mixture on each of the bottom buns and then top with the pork patties. Spread the remaining hoisin mixture on the patties and top with the pickled vegetables and bun tops.

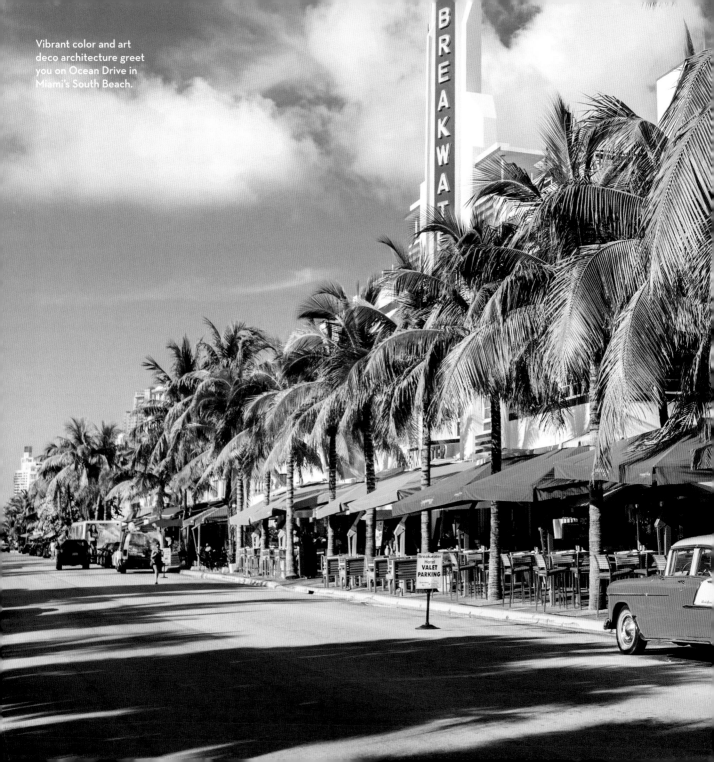

Vibrant color and art
deco architecture greet
you on Ocean Drive in
Miami's South Beach.

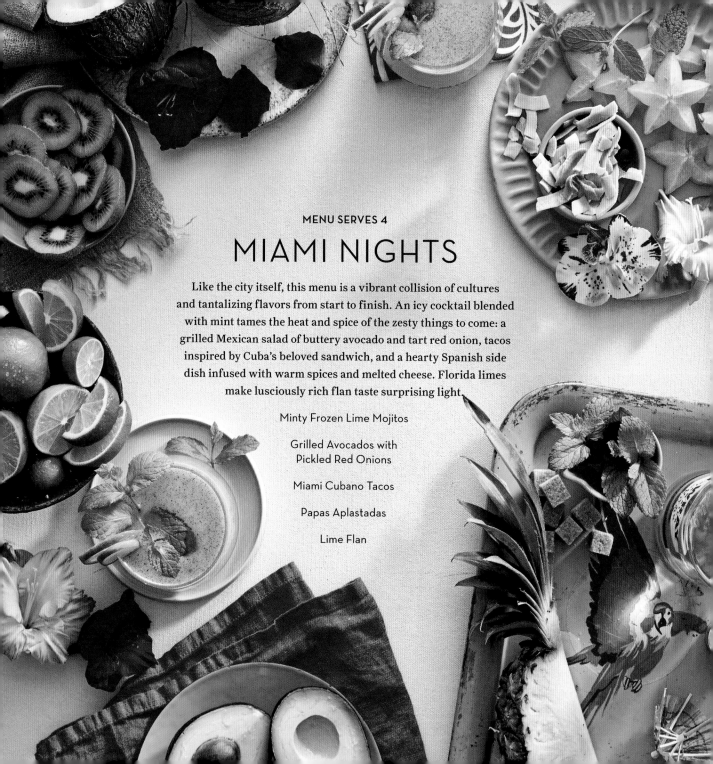

MENU SERVES 4

MIAMI NIGHTS

Like the city itself, this menu is a vibrant collision of cultures and tantalizing flavors from start to finish. An icy cocktail blended with mint tames the heat and spice of the zesty things to come: a grilled Mexican salad of buttery avocado and tart red onion, tacos inspired by Cuba's beloved sandwich, and a hearty Spanish side dish infused with warm spices and melted cheese. Florida limes make lusciously rich flan taste surprising light.

Minty Frozen Lime Mojitos

Grilled Avocados with
Pickled Red Onions

Miami Cubano Tacos

Papas Aplastadas

Lime Flan

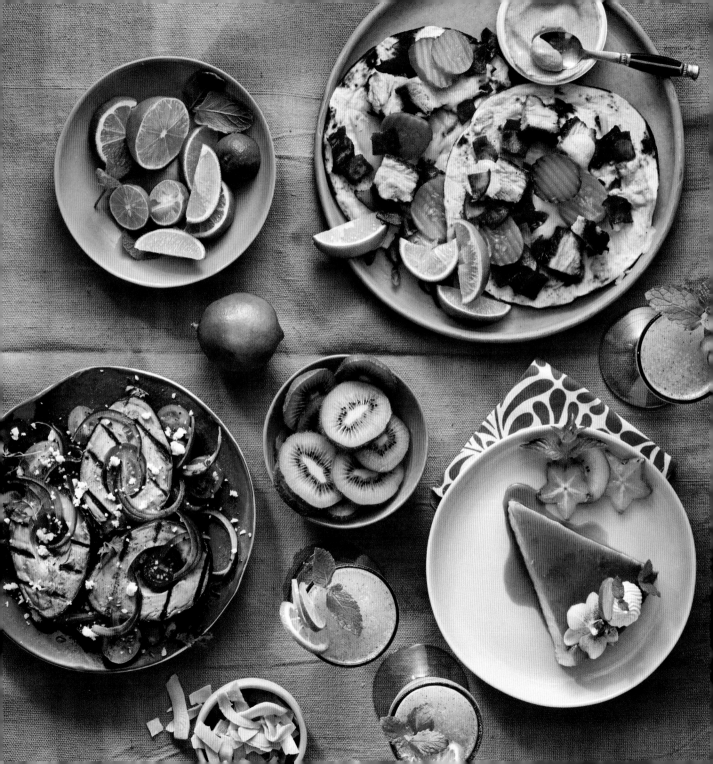

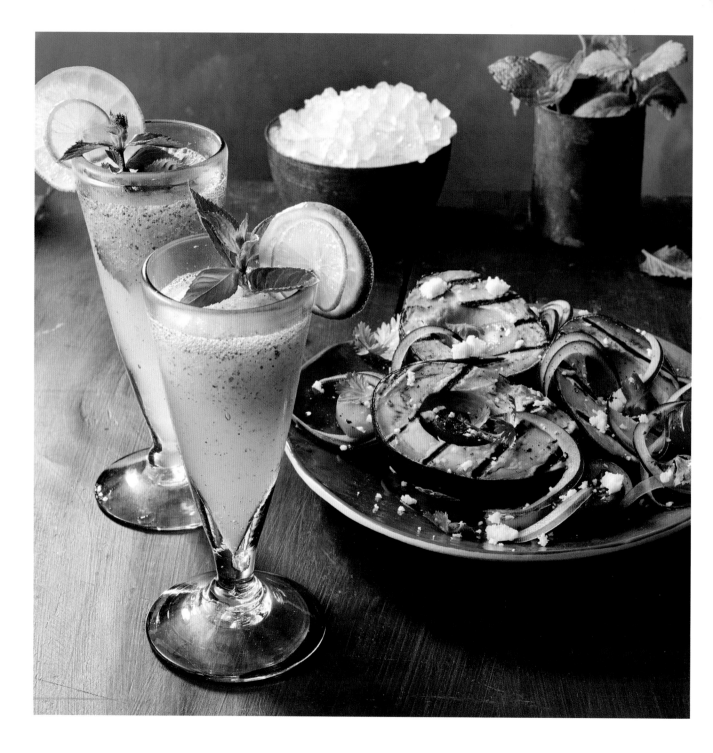

MINTY FROZEN LIME MOJITOS

These gorgeous lime slushes include Key lime-flavored rum, frozen limeade mix, and a swirl of fresh mint.

1 (6-ounce) container frozen limeade concentrate

¾ cup Key lime-flavored (or other light) rum

⅓ cup fresh mint leaves

Garnish: fresh mint sprigs and lime slices

Combine the limeade concentrate, rum, and fresh mint leaves in a blender. Fill to the 5-cup mark with cracked ice. Blend until smooth. Garnish as desired.

NOTE: Substitute water for the rum in this recipe if you or your guests prefer a tamer refresher.

GRILLED AVOCADOS
WITH PICKLED RED ONIONS

If you haven't tried an avocado kissed by the grill, you've missed out. The fruit soaks up the smoky flavor and the heat enhances its creaminess. The method helps slightly underripe avocados morph into buttery perfection.

3 firm, ripe avocados, peeled and halved

3 tablespoons olive oil

3 tablespoons fresh lime juice (from 2 limes)

1½ teaspoons kosher salt

½ teaspoon black pepper

12 ounces multicolored cherry tomatoes, halved

¼ cup fresh cilantro leaves

1½ ounces Cotija cheese, crumbled (about ⅓ cup)

½ cup Pickled Red Onions (recipe follows)

1. Preheat a grill to medium (350° to 450°F). Brush the avocado halves with 1 tablespoon each of olive oil and lime juice. Sprinkle with 1 teaspoon salt and ¼ teaspoon pepper. Grill uncovered, cut side down, until edges char, 5 to 7 minutes.

2. Mix the tomatoes, cilantro, remaining olive oil, lime juice, ½ teaspoon salt, and ¼ teaspoon pepper in a bowl.

3. Place the grilled avocado halves, cut side up, on a platter. Top with the tomato mixture, Cotija, and Pickled Red Onions.

PICKLED RED ONIONS

1 cup hot water

½ cup red wine vinegar

1 tablespoon granulated sugar

1½ teaspoons kosher salt

1 red onion, thinly sliced

Stir together the first 4 ingredients until sugar dissolves. Toss the onion slices in a bowl with the vinegar mixture and cover. Chill 1 hour or overnight. **Makes 1½ cups**

MIAMI CUBANO TACOS

Only Mexico can claim to be the taco's true home, but now this versatile handheld street food is beloved the world over. Here the Cuban sandwich swaps its crusty cloak for a warm tortilla cradle.

PORK BELLY

1 (3-pound) skinless pork belly

2 tablespoons kosher salt

2 tablespoons granulated sugar

1 tablespoon chipotle chile powder

1 tablespoon ground coriander

2 teaspoons orange zest

SPICY MUSTARD SAUCE

½ cup yellow mustard

1 cup sour cream

2 tablespoons extra-virgin olive oil

1 tablespoon white wine vinegar

¾ to 1 teaspoon cayenne pepper

ADDITIONAL INGREDIENTS

6 ounces Swiss cheese, shredded (about 1½ cups)

16 (6-inch) flour tortillas, warmed

10 ounces thinly sliced smoked deli ham, chopped and warmed

½ cup dill pickle slices

1. **PREPARE THE PORK BELLY:** Place the pork belly on a rimmed baking sheet. Stir together the salt, sugar, chile powder, ground coriander, and orange zest in a small bowl. Rub the mixture all over the pork; discard any remaining mixture. Wrap the pork belly with plastic wrap, and chill at least 6 hours but no longer than 24 hours.

2. Preheat the oven to 450°F. Unwrap the pork, and place, fat side up, on a lightly greased wire rack. Place the rack on a baking sheet, and bake at 450°F until golden brown and crispy, about 45 minutes.

3. Reduce the oven temperature to 250°F, and cook the pork until tender when pierced with a fork, 45 minutes to 1 hour. Cool to room temperature, about 20 minutes. Cover with plastic wrap, and chill until firm, 45 minutes to 1 hour.

4. **PREPARE THE SPICY MUSTARD SAUCE:** Whisk together the mustard, sour cream, olive oil, vinegar, and cayenne pepper in a small bowl until well combined. Set aside.

5. Cut the pork into ½-inch-thick slices. Heat the pork in a large skillet over medium until warmed through, 3 to 5 minutes per side.

6. Divide the Swiss cheese among the tortillas. Top with the deli ham and hot pork belly slices (about 3 ounces pork belly per taco). Drizzle each with 1½ tablespoons of the mustard sauce, and top each with ½ tablespoon of the pickles. Serve immediately.

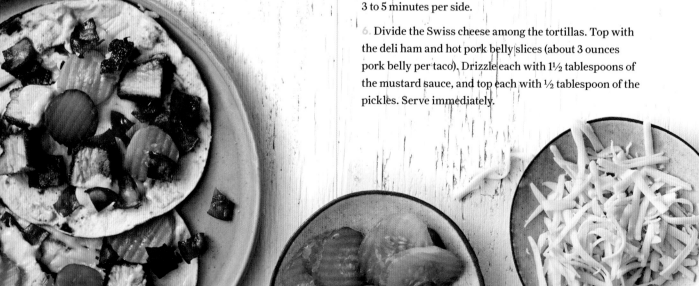

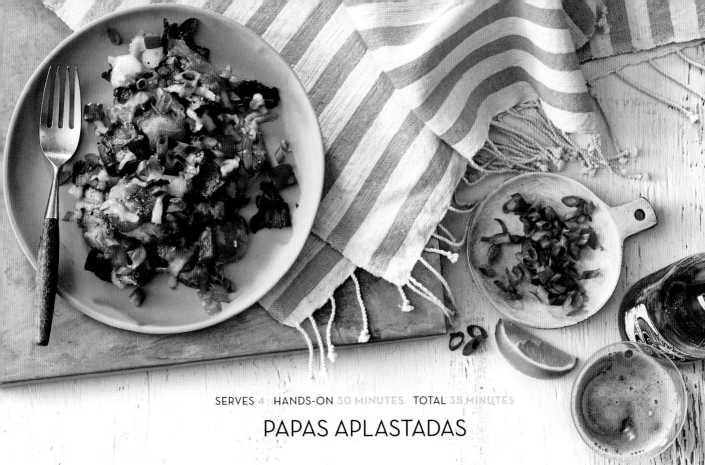

PAPAS APLASTADAS

The classic Spanish side of crushed potatoes gets gussied up with aromatics, spices, and lots of cheese in this hearty crowd-pleaser.

- 15 small red potatoes, unpeeled
- 4 bacon slices, chopped
- 1 cup chopped green bell pepper
- 3 garlic cloves, minced
- 3 tablespoons olive oil
- 1½ teaspoons ground cumin
- ½ teaspoon kosher salt
- ½ teaspoon freshly ground black pepper
- ¾ cup chopped scallions
- ½ cup shredded sharp Cheddar cheese (about 2 ounces)
- ½ cup shredded Monterey Jack cheese (about 2 ounces)

1. Boil the potatoes in lightly salted water 15 minutes or until tender; drain and cool slightly.

2. Cook the bacon in a medium skillet over medium-high 3 minutes or until crisp. Remove the bacon, reserving the drippings in the skillet. Add the bell pepper to the skillet; sauté 4 minutes or until tender. Add the garlic, cook 1 minute more. Turn off heat.

3. Preheat the broiler. Place the cooled potatoes on a lightly greased jelly-roll pan. Using the palm of your hand or the smooth side of a meat mallet, crush the potatoes (just enough to break them open). Drizzle with the olive oil, and sprinkle with the cumin, salt, and pepper. Top with the bacon, cooked bell pepper and garlic, scallions, and cheeses. Broil 5 minutes or until the cheese melts.

LIME FLAN

The creamy, custard dessert is popular throughout Latin America and Spain. Swap the lime zest and juice for orange or grapefruit for a change of taste. Make extra caramel for drizzling at serving time, if you wish.

1 cup granulated sugar
3 cups whipping cream
1 tablespoon vanilla extract
6 large eggs
2 large egg yolks
2 cups granulated sugar
½ cup sweetened
 condensed milk
1 (3-ounce) package cream
 cheese, softened
1 tablespoon lime zest
¼ cup fresh lime juice
Sweetened whipped cream
Garnish: lime wedges,
 mint sprigs and orchid
 blossoms

1. Preheat the oven to 350°F. Sprinkle 1 cup sugar in a medium skillet. Place the pan over medium, and cook, while shaking the pan, until the sugar melts into a light golden brown syrup. Carefully pour the syrup into a 10- x 2½-inch springform pan, tilting to coat the bottom and sides; set aside.

2. Place the whipping cream and vanilla in a large bowl. Process the eggs and egg yolks with the next 5 ingredients in a blender until smooth, stopping to scrape down sides (do not overprocess). Stir the egg mixture into the cream mixture.

3. Pour the custard over the caramelized sugar in the pan, and place in a large roasting pan on the oven rack. Add hot water to the roasting pan to a depth of 1 inch.

4. Bake, uncovered, at 350°F until a knife inserted off center comes out almost clean, 1 hour and 15 minutes. Remove the pan from the water. Cool 1 hour on a wire rack. Cover and chill at least 8 hours.

5. Remove the sides of the springform pan and carefully invert the flan onto a serving plate. Cut it into serving pieces and top with the sweetened whipped cream. Garnish as desired.

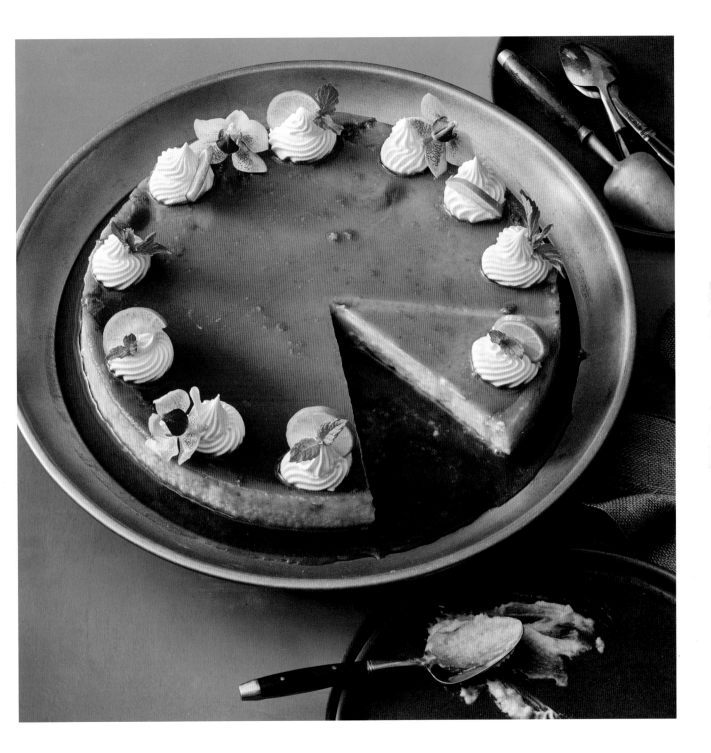

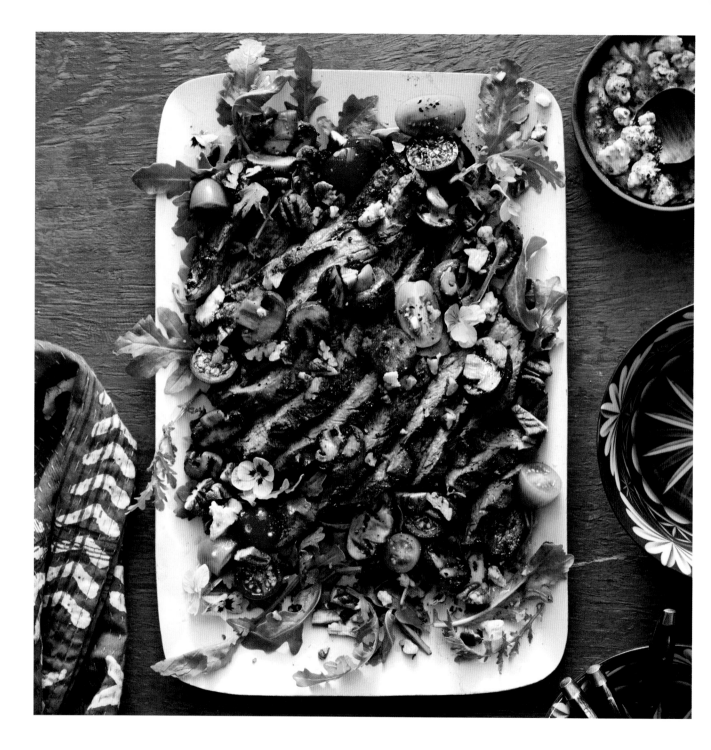

GRILLED PORTOBELLO-FLANK STEAK
WITH ARUGULA & BLUE CHEESE VINAIGRETTE

The secret to this recipe is the marinade, which gives both the mushrooms and steak uncommon depth of flavor. Blue cheese and toasted pecans take the salad over the top.

2 garlic cloves, minced

2 teaspoons granulated sugar

1/3 cup Champagne vinegar

1 tablespoon Dijon mustard

1 teaspoon hot pepper sauce

2/3 cup extra-virgin olive oil

1/4 teaspoon kosher salt

1/4 teaspoon coarsely ground black pepper

1 (8-ounce) package baby portobello mushrooms, halved

12 to 16 ounces flank steak

1/4 cup crumbled blue cheese (about 1 ounce)

8 cups lightly packed baby arugula

1 cup grape tomatoes, halved

1/2 cup toasted pecans, coarsely chopped

1. Whisk together the first 5 ingredients in a small bowl. Gradually whisk in the olive oil; stir in the salt and pepper. Pour 1/3 cup of the vinaigrette into a ziplock plastic bag. Add the mushrooms and steak, turning to coat; seal and chill for 1 1/2 hours. Stir the blue cheese into the remaining vinaigrette. Cover and chill until ready to serve.

2. Preheat a grill to medium-high (about 450°F). Remove the mushrooms and steak from the bag, discarding the marinade. grill the steak 4 to 6 minutes per side (for medium-rare) or until desired degree of doneness. Let stand 5 minutes. Grill the mushrooms 3 to 4 minutes or until tender. Slice the steak across the grain.

3. Place the arugula on a serving platter. Top the arugula with the mushrooms, steak, tomatoes, and toasted pecans. Drizzle with the vinaigrette.

ESPRESSO-RUBBED SKIRT STEAK
WITH PINEAPPLE CHIMICHURRI

Perfectly tender, juicy steak gets a kick of flavor with Argentinian chimichurri, a mouthwatering herb sauce traditionally served with churrasco, or skirt steak. This riff on the sauce incorporates juicy pineapple into the mix.

3 tablespoons chili powder

2 to 3 teaspoons espresso powder or very finely ground coffee

1 tablespoon dark brown sugar

2 teaspoons kosher salt

1 teaspoon coarsely ground black pepper

1 teaspoon garlic powder

1 (1¼- to 1½-pound) skirt steak or flank steak

3 red, yellow, or orange bell peppers, cut into thick strips

Pineapple Chimichurri (recipe follows)

1. Preheat grill to high (450° to 550°F). Combine the first 6 ingredients and rub over both sides of steak.

2. Grill the steak and peppers 4 to 6 minutes per side (for medium-rare), or until desired degree of doneness. Let the steak rest 10 minutes before slicing. Serve steak and peppers with the Pineapple Chimichurri.

PINEAPPLE CHIMICHURRI

¾ cup fresh flat-leaf parsley

½ cup fresh cilantro leaves

4 garlic cloves, coarsely chopped

½ cup extra-virgin olive oil

⅓ cup red wine vinegar

¾ teaspoon kosher salt

¾ teaspoon coarsely ground black pepper

½ peeled and cored pineapple, coarsely chopped

Process the first 7 ingredients in a food processor for 30 seconds or until finely chopped. Add the pineapple; pulse until coarsely chopped. **Makes 1¾ cups**

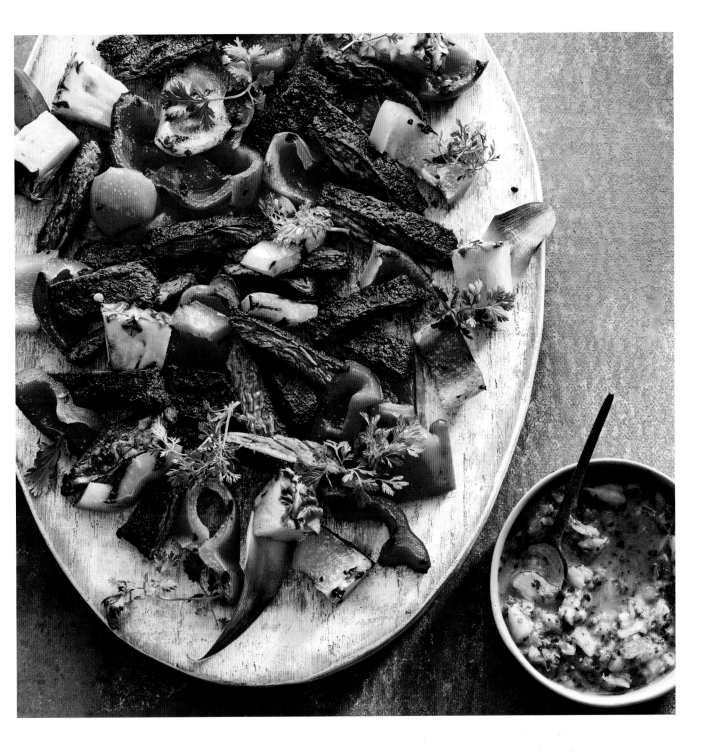

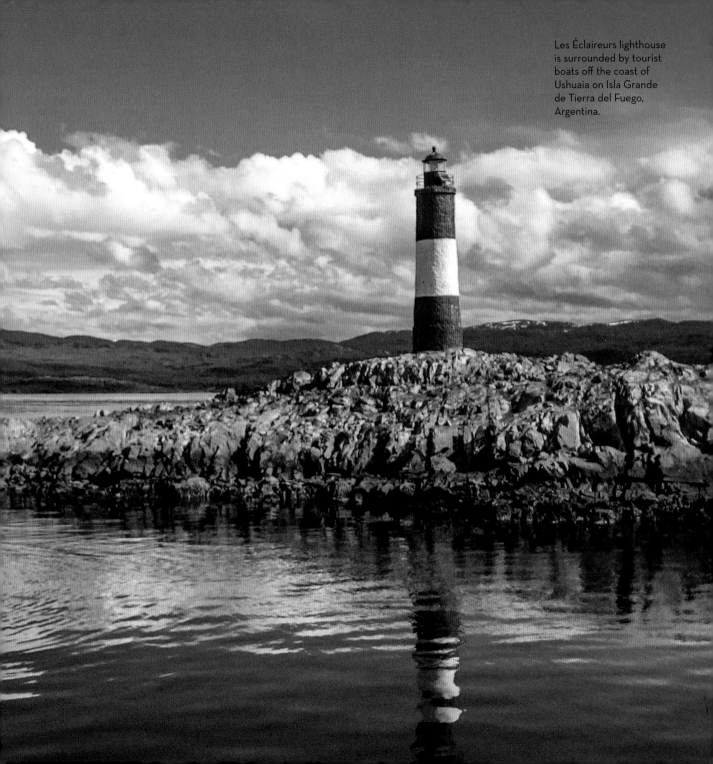

Les Éclaireurs lighthouse is surrounded by tourist boats off the coast of Ushuaia on Isla Grande de Tierra del Fuego, Argentina.

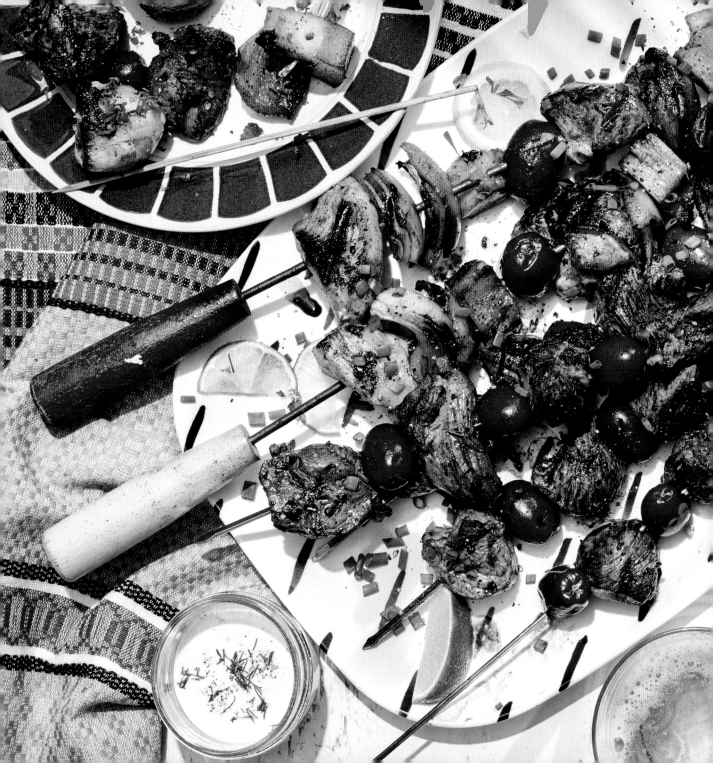

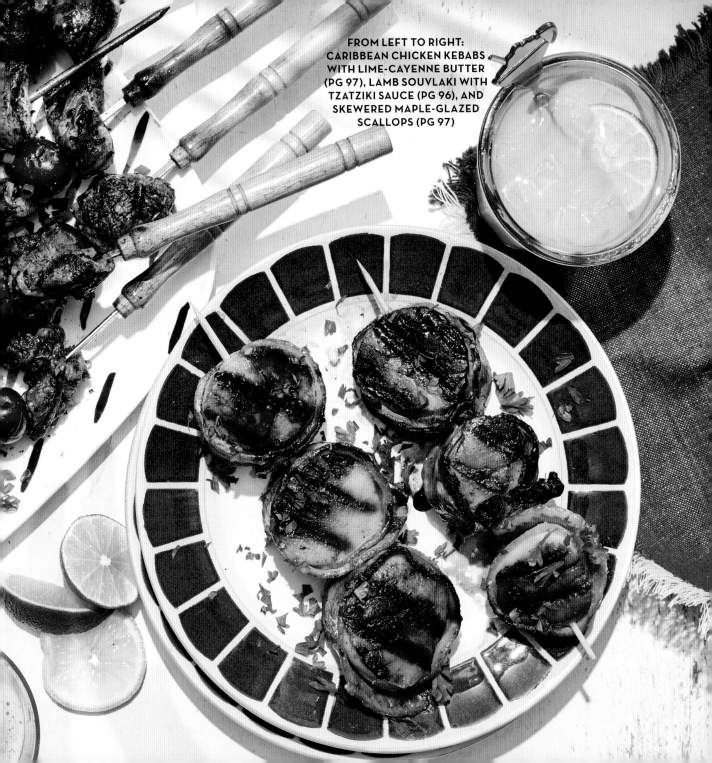

FROM LEFT TO RIGHT:
CARIBBEAN CHICKEN KEBABS
WITH LIME-CAYENNE BUTTER
(PG 97), LAMB SOUVLAKI WITH
TZATZIKI SAUCE (PG 96), AND
SKEWERED MAPLE-GLAZED
SCALLOPS (PG 97)

LAMB SOUVLAKI
WITH TZATZIKI SAUCE

Skewers always make meals more fun! Everything cooks up fast and is already bite-size to make eating easy. Serve the lamb skewered between grape tomatoes and with Tzatziki sauce for dipping.

½ cup extra-virgin olive oil
⅓ cup chopped fresh mint
¼ cup red wine vinegar
1 tablespoon dried oregano
2 teaspoons kosher salt
1 teaspoon freshly ground black pepper
½ teaspoon crushed red pepper

8 garlic cloves, grated
1½ pounds boneless leg of lamb, trimmed and cut into 36 (½-inch) cubes
2 lemons, cut into wedges
24 grape tomatoes (about 1 pint)
Tzatziki (recipe follows)

1. Place the first 9 ingredients in a large bowl; toss to coat. Squeeze the lemon wedges over the lamb mixture, and add the rinds to the mixture; toss to combine. Let stand 1 hour.

2. Thread 3 lamb cubes and 2 tomatoes onto a skewer in an alternating fashion. Discard the marinade. Repeat with remaining lamb and tomatoes.

3. Heat a large cast-iron skillet or grill pan over medium-high; coat the pan with cooking spray. Place 6 skewers in skillet. Cook 4 minutes on each side or until desired degree of doneness. Transfer the skewers to a platter. Wipe the skillet clean with paper towels. Repeat with cooking spray and remaining skewers. Serve with the Tzatziki.

TZATZIKI

1 cup plain whole Greek yogurt
1 cup grated, seeded, peeled cucumber
3 tablespoons chopped fresh dill

2 tablespoons fresh lemon juice
3 grated garlic cloves
½ teaspoon kosher salt
¾ teaspoon freshly ground black pepper

Combine all the ingredients in a medium bowl; stir well.
Makes about 1 cup

CARIBBEAN CHICKEN KEBABS
WITH LIME-CAYENNE BUTTER

Create the flavor of the islands by grilling chicken on skewers with pineapple, onion and bell pepper pieces, and topping with a spicy lime butter.

⅓ cup orange juice
¼ cup soy sauce
1 teaspoon minced fresh ginger
2 garlic cloves, minced
2 pounds boneless, skinless chicken breasts, cut into 1½-inch pieces
1 sweet onion, cut into 1½-inch pieces

2 orange or red bell peppers, cut into 1½-inch pieces
1 pineapple, cubed
1 pint cherry or grape tomatoes
Lime-Cayenne Butter (recipes follows)

1. Combine the first 4 ingredients in a large ziplock bag. Add the chicken and onion; seal and refrigerate 3 to 6 hours.

2. Preheat grill to medium (350° to 450°F). Drain the chicken and onion; discard the marinade. Thread the chicken, onion, and next 3 ingredients on 10 or 12 (10-inch) metal skewers. Brush with the Lime-Cayenne Butter.

3. Grill until the chicken is cooked through, 8 to 10 minutes, turning and basting with the Lime-Cayenne Butter.

LIME-CAYENNE BUTTER

½ cup (4 ounces) butter
1½ tablespoons fresh lime juice

½ teaspoon cayenne
½ teaspoon garlic salt

Melt the butter in a small saucepan, and stir in the remaining ingredients. **Makes ½ cup**

SKEWERED MAPLE-GLAZED SCALLOPS

To prevent scallops from rotating, use two skewers for each kebab.

12 bacon slices, cut in half
24 large sea scallops (about 2 pounds)
1 cup maple syrup
2 tablespoons butter, melted

1 teaspoon orange zest
3 tablespoons fresh orange juice
⅛ teaspoon kosher salt

1. Partially cook the bacon in a large skillet. Wrap each scallop with 1 half slice bacon. Set aside.

2. Bring the syrup to a boil in a medium saucepan over medium-high. Cook, uncovered, until reduced to ⅔ cup, about 5 minutes. Remove from the heat; stir in the butter and next 3 ingredients.

3. Thread the bacon-wrapped scallops on 12 (10- to 12-inch) metal skewers; brush the syrup mixture over the kebabs. Coat a grill grate with cooking spray; place on grill over medium-high (about 450°F). Place the kebabs on the grill grate; grill, covered, 3 to 4 minutes per side or until done, basting often.

GRILLED LAMB CHOPS
WITH ROMESCO SAUCE

Tangy Spanish romesco sauce is a perfect partner for succulent lamb hot off the grill. Try this recipe with lamb chops sliced from a rack for a meal easily eaten out of hand.

8 (1-inch-thick) lamb loin chops, trimmed
Extra-virgin olive oil
Kosher salt
Freshly ground black pepper
Romesco Sauce (recipe follows)

1. Preheat a grill to medium-high (about 450°F). Brush the chops on all sides with the olive oil, and sprinkle with the salt and pepper.

2. Grill, uncovered, 4 to 5 minutes per side (for medium-rare) or until desired degree of doneness. Serve immediately with the Romesco Sauce.

ROMESCO SAUCE

1 red bell pepper
1 ripe tomato, halved
1 tablespoon coarsely chopped almonds (8 or 9 whole almonds)
2 garlic cloves, coarsely chopped
1 tablespoon sherry vinegar
¼ cup extra-virgin olive oil
Kosher salt
Freshly ground black pepper

1. Preheat the broiler. Cut the bell pepper in half lengthwise, discarding seeds and membranes. Place the bell pepper and tomato halves, skin sides up, on an aluminum foil–lined baking sheet. Broil about 12 minutes or until skin blackens.

2. Place the bell pepper and tomato in a ziplock plastic bag; seal and let stand 15 minutes. Peel the pepper and tomato.

3. Process the bell pepper, tomato, almonds, and next 3 ingredients in a blender until smooth. Season with the salt and pepper. **Makes about ½ cup**

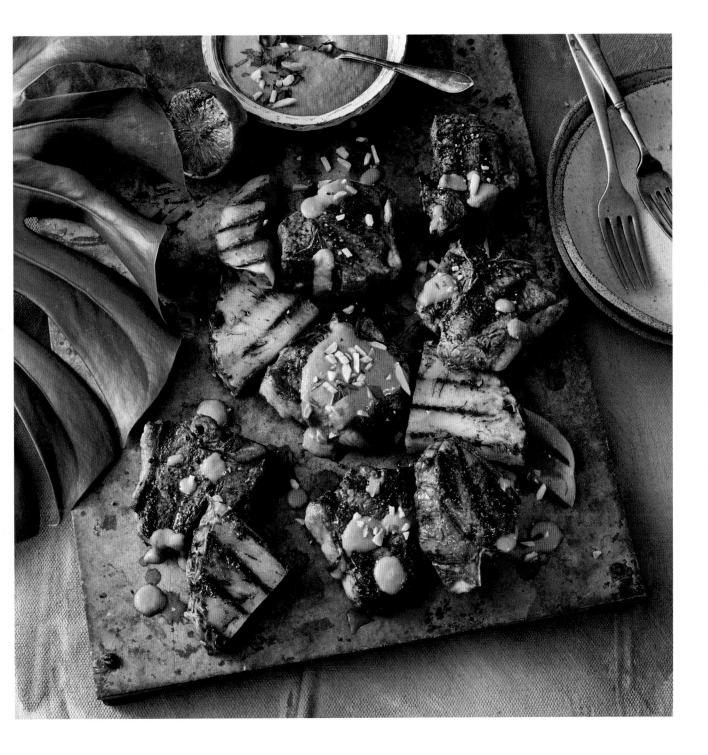

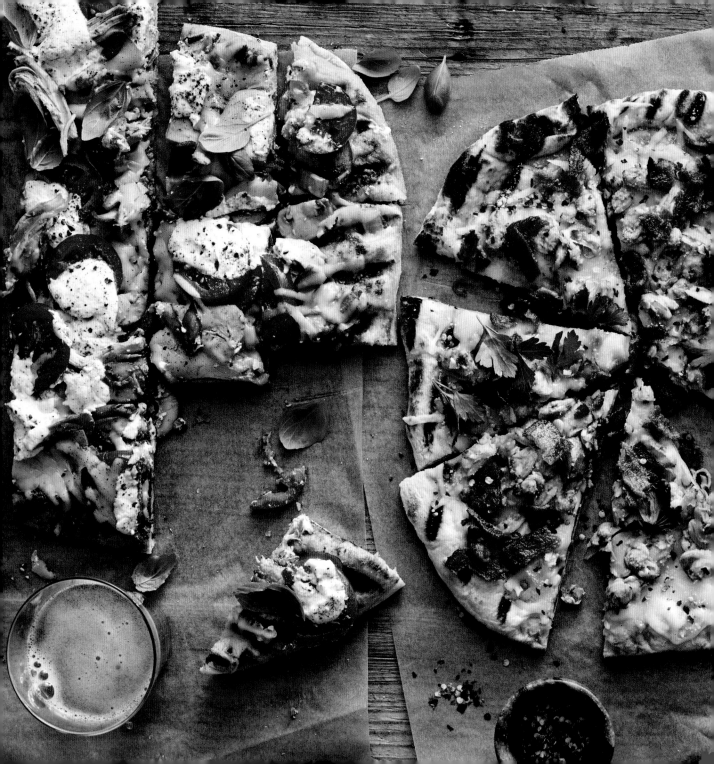

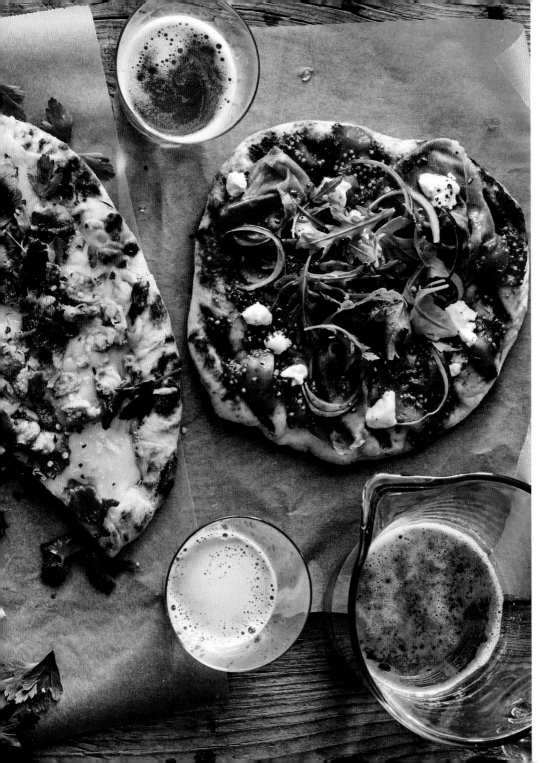

PIZZAS ON THE GRILL

Grill the dough uncovered to start for a crust that's a balance of crisp and densely chewy, and then lower the lid to finish for an ooey, gooey, melty cheese topping that will make knees buckle.

FROM LEFT TO RIGHT: Grilled Pesto Pizza with Chicken, Mozzarella, & Ricotta (Pg 102), Grilled White Pizza with Clams & Bacon (Pg 102), and Grilled Peach Chutney Pizza with Prosciutto & Goat Cheese (Pg 103)

GRILLED WHITE PIZZA
WITH CLAMS & BACON

The classic combo of clams and bacon on pizza endures for good reason. It's delicious!

12 ounces shucked clams, coarsely chopped

3 garlic cloves, minced

¼ teaspoon crushed red pepper

3½ teaspoons olive oil

3½ teaspoons lemon juice

3 tablespoons semolina flour or polenta

1 pound refrigerated prepared pizza dough, at room temperature

8 ounces shredded mozzarella cheese (about 2 cups)

2 ounces Parmigiano-Reggiano cheese, grated (about ½ cup)

4 cooked applewood-smoked bacon slices, crumbled

1 cup fresh flat-leaf parsley

⅛ teaspoon kosher salt

1. Preheat a grill to medium-high (about 450°F). Combine the first 3 ingredients, 1 tablespoon of the oil, and 1 tablespoon of the lemon juice in a small bowl. Let stand 15 minutes.

2. Sprinkle the semolina flour on a large, rimless baking sheet. Pat dough into a 14-inch circle on prepared pan.

3. Brush the grate with oil, and slide the dough onto the grate. Grill, covered, until grill marks appear, 2 minutes. Slide the baking sheet under the dough on the grill, and reduce the heat to medium (about 400°F). Sprinkle the dough evenly with the mozzarella, leaving a ¾-inch border. Top with the clam mixture, Parmigiano-Reggiano, and bacon. Grill, covered, 8 minutes or until cheese melts and crust is lightly browned, 8 minutes.

4. Meanwhile, combine the parsley, salt, and remaining ½ teaspoon each oil and lemon juice in a small bowl. Remove the pizza from the grill, and top with the parsley mixture. Serve immediately.

GRILLED PESTO PIZZA
WITH CHICKEN, MOZZARELLA & RICOTTA

Prepared pesto stands in for red sauce in this hearty pie.

2 tablespoons extra-virgin olive oil

8 ounces sliced cremini mushrooms

½ cup chopped onion

1 cup shredded rotisserie chicken

2 tablespoons chicken stock

½ cup ricotta cheese

½ teaspoon kosher salt

½ teaspoon freshly ground black pepper

3 tablespoons semolina flour or polenta

1 pound refrigerated prepared pizza dough, at room temperature

⅓ cup fresh prepared pesto

6 ounces shredded mozzarella cheese (about 1½ cups)

2 plum tomatoes, sliced

¼ cup fresh basil, cut into thin strips

1. Preheat a grill to medium-high (about 450°F). Heat 1 tablespoon of the oil in a skillet over medium-high. Add the mushrooms and onion; sauté 5 minutes. Add the chicken and chicken stock; cook 1 minute.

2. In a small bowl, combine the ricotta cheese, salt, and pepper.

3. Sprinkle the semolina flour on a large, rimless baking sheet. Pat the dough into a 14-inch circle on the prepared pan.

4. Brush the grate with the oil, and slide the dough onto the grate. Brush the top of the dough with the remaining oil. Grill until grill marks appear, 2 minutes. Reduce heat to medium-low (about 350°F) and flip the dough. Spread evenly with pesto, leaving a ¾-inch border. Top with the chicken, mozzarella and tomato slices, and ricotta. Grill, covered, until the cheese melts, 5 to 7 minutes. Remove from the grill and top with the basil. Serve immediately.

GRILLED PEACH CHUTNEY PIZZA
WITH PROSCIUTTO & GOAT CHEESE

Charcuterie board favorites make their way onto pizza.

1 pound peeled peaches, cut into wedges

½ cup dry white wine

¼ cup packed brown sugar

2 tablespoons mustard seeds

2 tablespoons apple cider vinegar

1 teaspoon kosher salt

½ teaspoon onion powder

¼ teaspoon ground coriander

¼ teaspoon crushed red pepper

3 tablespoons chopped fresh thyme

3 tablespoons semolina flour or polenta

1 pound refrigerated prepared pizza dough, at room temperature

1½ tablespoons olive oil plus more for brushing

3 ounces thinly sliced prosciutto

1 cup very thinly sliced red onion

4 ounces goat cheese

½ teaspoon freshly ground black pepper

1½ cups baby arugula

1. Preheat a grill to medium-high (about 450°F). Combine the first 9 ingredients and 2 tablespoons of the thyme in a heavy saucepan over medium. Cook 20 minutes or until thickened to a saucy consistency, stirring often and breaking up peaches with the back of a spoon. Let cool.

2. Sprinkle the semolina flour over a large, rimless baking sheet. Place the dough on the prepared baking sheet, and pat into 4 (6- to 7-inch) circles.

3. Brush the grate with oil, and slide the dough onto the grate. Grill, covered, until grill marks appear, 2 minutes. Slide the baking sheet under the dough on the grill, and reduce the heat to medium (about 400°F). Spread the dough with the peach chutney, leaving a ¾-inch border. Top with the prosciutto, onion, and goat cheese. Grill, covered, until the cheese melts and crusts are lightly browned, 8 minutes.

4. Remove the pizzas from the grill. Sprinkle with the black pepper. Brush the crust edges with ½ tablespoon oil. Combine the arugula and remaining 1 tablespoon oil in a bowl; toss gently to coat. Top the pizza with the arugula. Serve immediately.

THE WINE DOWN: BEST POURS FOR PIZZA

PESTO · **GRAPE:** VERMENTINO

Taking on the herb and evergreen characteristics of its Sardinian homeland, Vermentino plays perfectly with pesto, or white pizzas topped with peppery greens.

PEPPERONI · **GRAPE:** LAMBRUSCO

Lambrusco's palate-scrubbing bubbles carve through pepperoni's richness and spice.

MUSHROOMS · **GRAPE:** CABERNET FRANC

The town of Saumur in France's Loire Valley is known for two things: earthy 'shrooms and silky, smoky Cab Franc—natural partners anywhere they're served.

MARGHERITA · **GRAPE:** FRAPPATO

A model of austerity, margherita's striking simplicity lets red sauce shine. Look for something that will balance the innate acidity of tomatoes, such as Sicily's lithe and fruity frappato.

MEATY · **GRAPE:** SYRAH

Forget about the crust. When you opt for sausage, 'nduja, or a layer of salumi, it's all about the toppings. What to pair with all that protein? The black pepper and brambly dark fruit inherent in syrah.

HAWAIIAN · **GRAPE:** RIBOLLA GIALLA

The polarizing pineapple-and-ham pie boasts a steadfast following—and a wine soulmate. Ribolla Gialla's tropical flavors complement the salty-sweet combo.

03.
SEAFOOD SHACK

DELICACIES OF
THE SEA SERVED
RAW, COOKED,
SAUCED, OR
SANDWICHED

COCONUT ROYAL RED BITES

Found 60 miles offshore in deep, cool waters, royal reds are considered the king of Gulf shrimp, prized for their lobster-sweet meat. Unlike most shrimp, which are gray when raw, royal reds emerge a brilliant crimson when plucked from the sea. Throughout the Florida Panhandle and along the Alabama coast, you'll find these oversized prawns at high-end restaurants and humble fish shacks; when the boats bring them in, chefs and home cooks can't get enough. Coconut truly complements sweet royal reds in this addictive cocktail hour popper.

1 cup sweetened flaked coconut

¼ teaspoon ground coriander

¼ teaspoon ground ginger

2 (8-ounce) packages cream cheese, softened

½ teaspoon lime zest

12 ounces cooked royal red shrimp

2 scallions, coarsely chopped

1. Preheat the oven to 325°F. Combine the coconut, coriander, and ginger on a baking sheet. Bake at 325°F until golden, 5 to 7 minutes; set aside.

2. Process the cream cheese, lime zest, royal reds, and scallions in a food processor until blended. Chill 1 hour.

3. Shape the mixture into 1-inch balls, and roll in toasted coconut-spice mixture.

SHRIMP-BOIL NACHOS

Trade your usual nacho drill for this unique coastal spin.

6 ears fresh yellow corn

½ (8-ounce) package cream cheese, softened

½ cup half-and-half

1 tablespoon Old Bay

1 teaspoon all-purpose flour

1½ teaspoons kosher salt

1 pound andouille sausage, chopped

4 teaspoons minced garlic

1 pound medium peeled raw shrimp, chopped

1 teaspoon Cajun seasoning

1 teaspoon black pepper

2 tablespoons fresh lemon juice (from 1 lemon)

1 tablespoon Worcestershire sauce

1 teaspoon hot sauce (such as Tabasco)

3 tablespoons butter

2 tablespoons chopped fresh flat-leaf parsley

12 ounces kettle-cooked potato chips

¼ cup chopped scallions

¼ cup sliced jalapeños

1. Cut corn kernels from cobs using the blunt, flat side of a knife. Scrape the milk and pulp from the cobs into a saucepan. Discard the cobs.

2. Stir in the cream cheese, half-and-half, Old Bay, flour, and ½ teaspoon of the salt. Cook over low, stirring, until smooth, about 10 minutes. Remove from the heat; cover to keep warm.

3. Cook the sausage in a skillet over medium, 10 to 15 minutes. Remove and drain on paper towels, reserving the drippings in the skillet. Increase heat to medium-high. Add the garlic and cook, stirring constantly, 1 minute. Add the shrimp, Cajun seasoning, pepper, and remaining 1 teaspoon salt, and cook, stirring often, 3 minutes. Stir in the lemon juice, Worcestershire, and hot sauce; cook 1 minute. Remove from the heat. Add the butter and parsley, and stir until the butter melts.

4. Arrange the chips on a platter. Top with the corn sauce, sausage, and shrimp. Sprinkle with scallions and jalapeños.

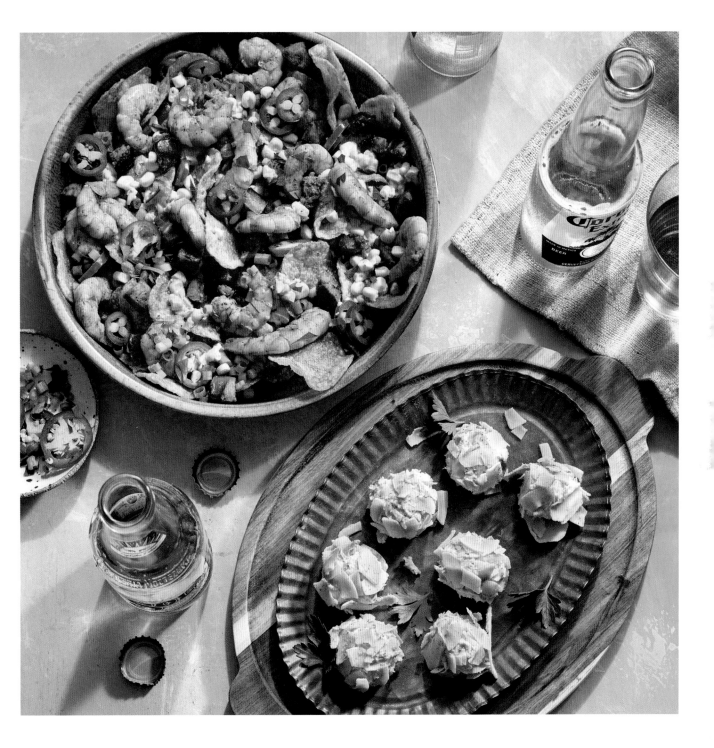

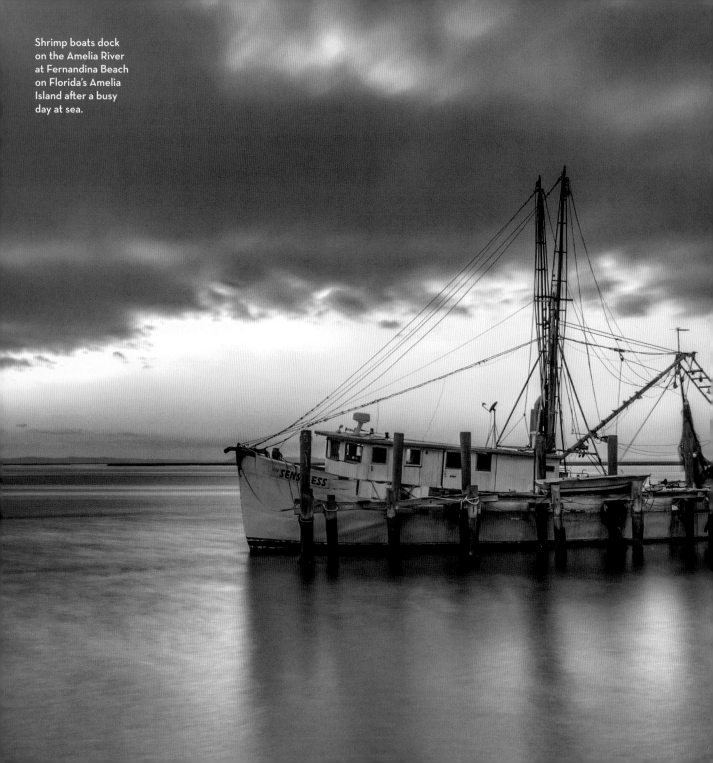

Shrimp boats dock on the Amelia River at Fernandina Beach on Florida's Amelia Island after a busy day at sea.

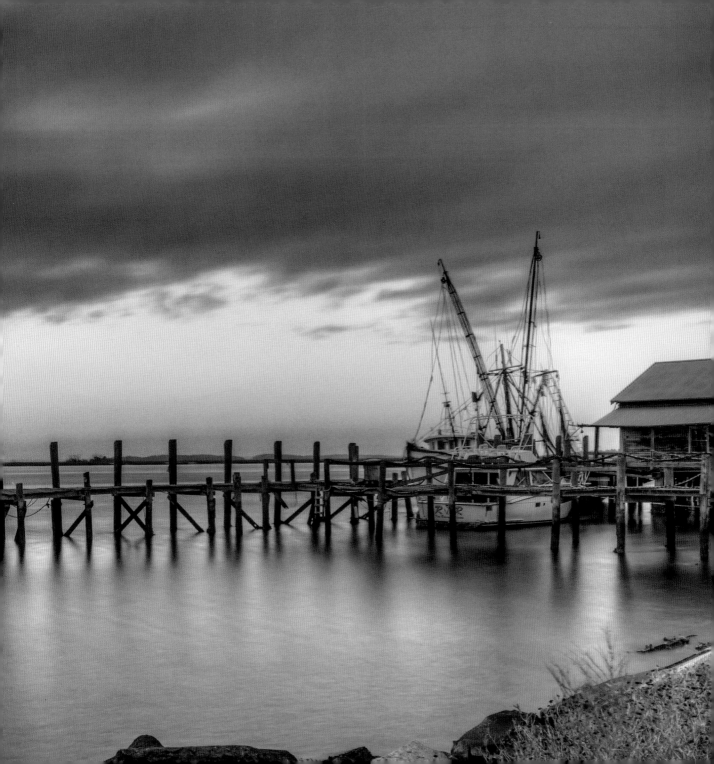

WAHOO POKE

Closely related to king mackerel, wahoo has a firm texture, moderate oil content, and sweet-tasting flesh prized by sport fishermen and cooks alike.

⅓ cup thinly sliced scallions (2 to 3 scallions) plus more for serving

¼ cup shoyu (soy sauce)

2 tablespoons sesame oil

2 tablespoons crushed wasabi peas plus more for garnish

1 tablespoon fresh lime juice (from 1 lime)

2 teaspoons rice vinegar

2 teaspoons finely crumbled nori (see note)

1 teaspoon grated fresh ginger

½ teaspoon crushed red pepper

1 pound fresh wahoo (ono) fillet, cut into ¾-inch cubes

1 ripe avocado, cut into ¾-inch pieces

1 (6-ounce) package taro chips (such as Terra)

¼ cup thinly sliced radishes (from 2 to 3 radishes)

1 teaspoon toasted sesame seeds

Whisk together the scallions, shoyu, sesame oil, wasabi peas, lime juice, vinegar, nori, ginger, and crushed red pepper in a large bowl. Place the cubed wahoo into the marinade, and stir to coat. Cover and chill 2 hours. Stir and add avocado just before serving; gently toss. Serve on taro chips topped with radish slices, toasted sesame seeds, scallions, and crushed wasabi peas.

THE QUICKEST WAY TO RIPEN AN AVOCADO

Place avocados inside a paper bag with a banana, and leave in a sunny spot for a day. The banana will release ethylene gas, which helps ripen the avocados faster.

CRISPY SALT-&-PEPPER SHRIMP

You'll fall for these crispiest of shrimp (hello, cornstarch!). Make it a meal by serving these over spicy, buttery Green Grits (page 190), brightened with a bouquet of fresh herbs, for a Low Country spin.

1½ pounds large unpeeled raw shrimp

4 tablespoons cornstarch

1 teaspoon black pepper

2½ teaspoons kosher salt

1 cup peanut oil

1 tablespoon chopped fresh flat-leaf parsley

1. Using a sharp paring knife or kitchen shears, cut along the back of the shrimp, through the shells; remove and discard the veins. Pat the shrimp dry.

2. Whisk together the cornstarch, black pepper, and 2 teaspoons of the salt in a large bowl. Add the shrimp, and toss to coat.

3. Heat the oil in a large skillet over medium-high. Fry the shrimp in 3 batches until golden brown, crispy, and cooked through, about 1 minute per side. Drain on a baking sheet lined with paper towels. Sprinkle the shrimp with remaining ½ teaspoon salt and chopped parsley.

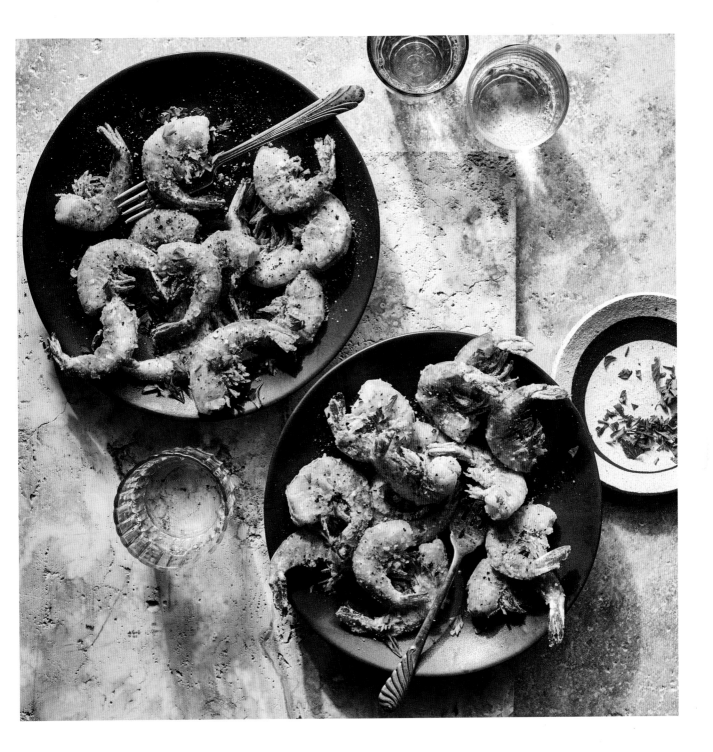

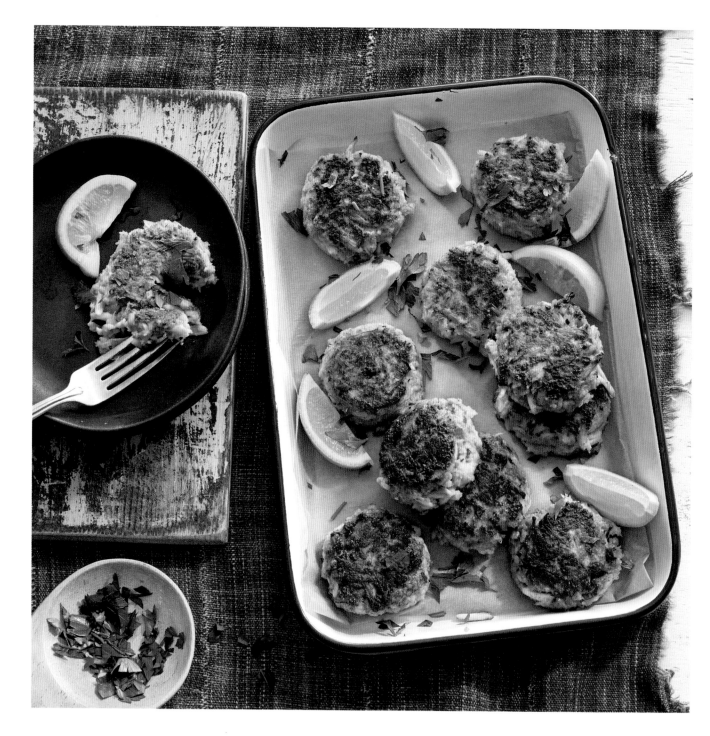

BEST-EVER CRAB CAKES

You probably have most of the ingredients on hand for these simple, elegant crab cakes; just make a quick run to the seafood market for fresh lump crabmeat. Toss together a bright, seasonal salad while the crab cakes chill.

3 tablespoons mayonnaise

2 teaspoons Dijon mustard

½ teaspoon kosher salt

½ teaspoon freshly ground black pepper

2 large eggs, lightly beaten

1 pound fresh jumbo lump crabmeat, drained and picked

⅔ cup panko (Japanese breadcrumbs)

2 tablespoons finely chopped fresh flat-leaf parsley

3 tablespoons (1½ ounces) butter

Garnish: chopped flat-leaf parsley and lemon wedges

1. Whisk together the first 5 ingredients in a bowl. Gently stir in the crabmeat, panko, and parsley. Shape the mixture into 12 (3-inch) patties, pressing gently to flatten. Place the patties on a baking sheet; cover with plastic wrap. Refrigerate 1 hour.

2. Melt 1½ tablespoons of the butter in a large nonstick skillet over medium-high. Add 6 patties to the pan; cook until golden brown, 2½ minutes per side. Remove the crab cakes from the pan; repeat with remaining 1½ tablespoons butter and remaining 6 patties. Garnish as desired.

CUCUMBER GAZPACHO
WITH BLUE CRAB

Spain's chilled soup goes green (though cucumbers were traditionally used long before tomatoes). This interpretation includes a hearty helping of blue crab and a prickle of heat from deseeded jalapeños.

¾ cup sour cream

¼ cup fresh lime juice (about 3 limes)

2 garlic cloves

4 cucumbers (about 4 pounds), peeled, seeded, and chopped (about 8 cups)

½ cup chopped fresh cilantro

½ cup chopped fresh basil

2 fresh jalapeño chiles, seeded and minced

½ cup sparkling water

1¼ teaspoons kosher salt

¼ teaspoon black pepper

1 pound fresh jumbo lump crabmeat, drained and picked

6 tablespoons extra-virgin olive oil

Garnish: cucumber slices

1. Place the sour cream, lime juice, garlic, 4 cups of the cucumbers, ¼ cup each of cilantro and basil, and 1 minced jalapeño in a blender and process until smooth. Transfer the pureed mixture to a bowl; stir in the sparkling water, salt, pepper, and remaining cucumbers and jalapeño.

2. Place the bowl with the gazpacho into a larger bowl filled with ice. Let stand, stirring often, until the gazpacho is cold, about 20 minutes. (Or place in the refrigerator for 1 hour.)

3. Place the crabmeat, oil, and remaining ¼ cup each of cilantro and basil in a bowl; toss gently. Divide the gazpacho among 6 bowls; top with the lump crabmeat mixture. Garnish as desired and serve immediately.

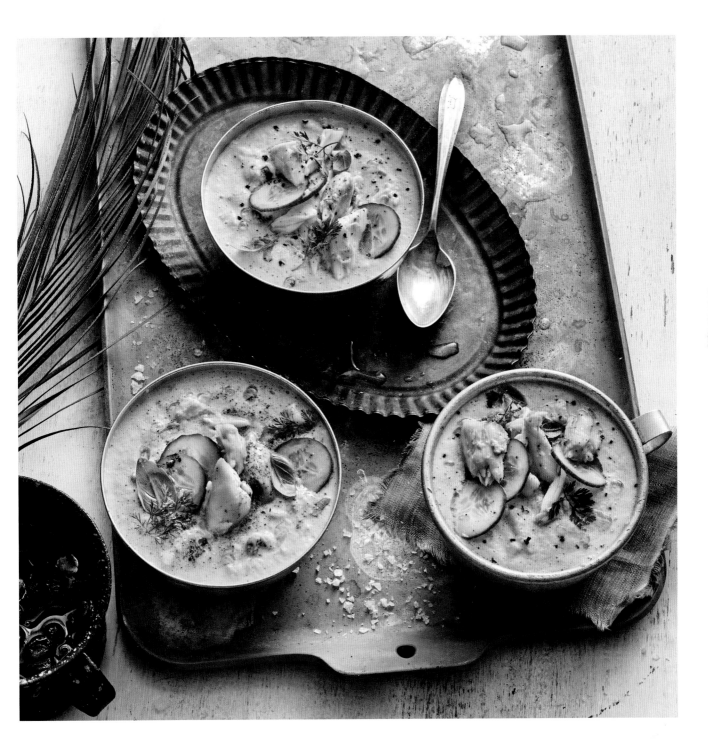

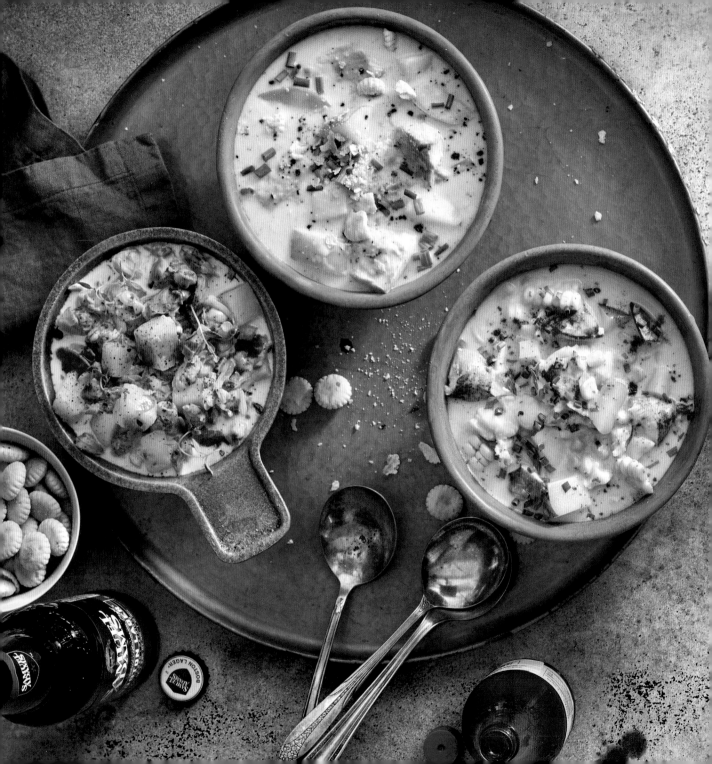

A TRIO OF CREAMY CHOWDERS TRIO

Rich and hearty, a bowl of chowder satisfies both tastebuds and hunger. Stick to the classic clam version, or go rogue with a scallop, lobster, or salmon spin.

—

FROM LEFT TO RIGHT:
New England Clam Chowder (Pg 120), Salmon Chowder with Chives (Pg 124), Nantucket Lobster Chowder (Pg 121), and Scallop & Corn Chowder (Pg 120)

NEW ENGLAND CLAM CHOWDER

The word chowder may have come from the French chaudière, or cauldron. Another theory points to the English word "jowter," for fish peddler. Whatever the origin, three ingredients are key to traditional chowder: cured pork, fresh cream, and clams. When the trifecta comes together, you get a bowlful that goes right to the farming and seafaring heart of America's Northeast. Don't forget the oyster crackers. They lend a crunchy counterpoint to the creamy soup.

4 ounces salt pork, diced

½ cup chopped onion

4 cups water

2 large russet potatoes, peeled and cubed

1 teaspoon kosher salt

½ teaspoon freshly ground black pepper

4 cups minced clams or quahogs, with juices

2 cups heavy cream

4 tablespoons (2 ounces) butter

½ teaspoon chopped fresh thyme

Oyster crackers (optional)

1. Add the salt pork and onions to a 4-quart saucepan over medium-high. Cook, stirring, until the fat begins to render and the onions become soft and golden, about 5 minutes. Add the water, potatoes, salt, and pepper, and bring to a boil. Cover and simmer until the potatoes are tender, 10 minutes.

2. Add the clams, and return the mixture to a boil, stirring occasionally. Remove from the heat, and let stand 20 minutes.

3. Stir in the cream, butter, and thyme. Cook over low, stirring constantly, until heated thoroughly. Serve with oyster crackers, if desired.

SCALLOP & CORN CHOWDER

Sweet and meaty scallops hold up well in this creamy chowder as it simmers. This is rich and filling. A crisp, cool salad would be a welcome way to make this a meal.

¾ pound red potatoes, cut into ½-inch cubes

2 cups water

3 tablespoons butter

1 cup chopped leeks

1 cup chopped celery

1 cup half-and-half

2 cups frozen whole-kernel corn, thawed and drained

1 pound bay or sea scallops, cut in half horizontally

¾ teaspoon kosher salt

½ teaspoon freshly ground black pepper

¼ teaspoon cayenne (optional)

Butter (optional)

Oyster crackers (optional)

1. Combine the potatoes and water in a medium bowl.

2. Melt 3 tablespoons butter in a large soup pot over medium. Add the leeks and celery; sauté 5 minutes or until tender. Add the potatoes and water; bring to a boil. Cover, reduce heat, and simmer just until tender, 12 minutes.

3. Stir in the half-and-half and corn. Cover and cook over medium 5 minutes or until thoroughly heated. Add the scallops, salt, black pepper, and cayenne, if desired; cook 3 minutes.

4. Stir a pat of butter into each serving, and top with oyster crackers, if desired. Serve immediately.

BAY SCALLOPS & SEA SCALLOPS

Bay scallops are tiny and sweet. They grow in shallower water than their sea scallop cousins, which are chewier, three times as big, and caught in deep waters off the East Coast. Both are readily available in the fall and winter and should be light beige or tinged pink in color.

NANTUCKET LOBSTER CHOWDER

Cooking the lobster shells in chicken broth creates a flavorful stock for the chowder.

½ cup (4 ounces) butter

½ cup (about 2¼ ounces) all-purpose flour

8 cups chicken broth

¼ cup Chardonnay

2 (¾-pound) fresh or frozen, thawed lobster tails

2 cups fresh corn kernels (about 4 ears)

1 pound small red potatoes, cubed

½ teaspoon kosher salt

½ teaspoon cayenne

2 tablespoons chopped fresh chives

1 tablespoon chopped fresh tarragon

1 cup heavy cream

1. Melt the butter in a 6-quart Dutch oven over medium-low. Whisk in the flour until smooth. Gradually whisk in the broth and wine. Bring to a boil, reduce the heat, and simmer, uncovered, 20 minutes.

2. Meanwhile, cut the top and bottom lobster shells lengthwise down the middle. Carefully separate the shell halves, and pull the lobster meat in 1 piece from the shells. Cut the shell halves in half crosswise and add to the broth. Cut the meat in half lengthwise and then crosswise into bite-size pieces. Refrigerate the meat.

3. When the shell mixture has simmered 20 minutes, add the corn, potatoes, salt, and cayenne. Return the mixture to a boil, reduce heat, and simmer, uncovered, 12 minutes. Remove the shells, and discard.

4. Add the lobster meat, chives, and tarragon to theh broth mixture; simmer 6 minutes. Stir in the cream, and cook 2 minutes or until thoroughly heated.

LOBSTER TRIVIA

· There are more than 7,000 licensed lobstermen in Maine, and they catch about 120 million pounds of lobster annually.

· Every lobsterman in the state has a unique color scheme for his or her buoys.

· No matter their original color—blue, blue-green, yellow, or red—lobster shells and flesh exterior turn red when cooked. The one exception is the white (albino) lobster, which doesn't change color at all.

· Most Maine lobsters are caught between June and December.

· Lobsters were originally caught by hand. Using traps didn't become popular until the the middle of the 19th century.

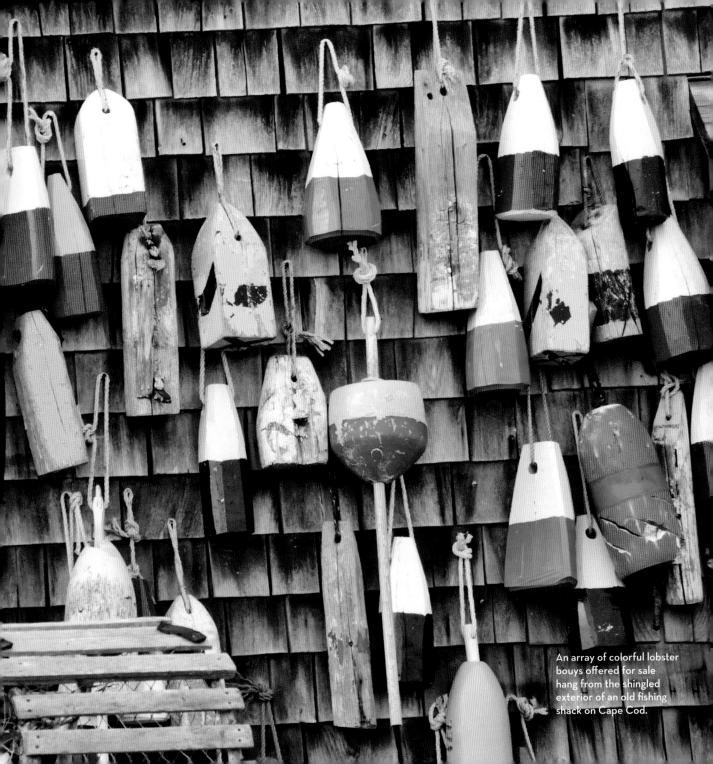

An array of colorful lobster bouys offered for sale hang from the shingled exterior of an old fishing shack on Cape Cod.

SALMON CHOWDER
WITH CHIVES

Wild Pacific salmon is indelibly associated with life in the Pacific Northwest. It began with ancient tribal culture (the salmon run—the act of these strong and determined fish fighting upstream from the ocean to spawn—has forever marked celebrations of renewal in Native American culture). A bite of Pacific salmon is an engagement with a region and its way of life; the worlds of ocean, river, and stream; the interplay of species in these delicate ecosystems; and even the personal thrill of reel and capture. Once you've had wild salmon—especially from Pacific Northwest waters—it's hard to imagine anything better.

1 shallot, minced

¼ cup (2 ounces) unsalted butter

¼ cup (about 1 ounce) all-purpose flour

½ teaspoon kosher salt

8 cups chicken broth

8 ounces red potatoes, cubed

8 ounces Yukon Gold potatoes, cubed

1 bay leaf

1½ pounds skinless wild salmon fillets, cut into 2-inch pieces

1 cup whipping cream

¼ cup minced fresh chives

2 teaspoons white wine vinegar

⅛ teaspoon freshly ground black pepper

⅛ teaspoon ground nutmeg

⅛ teaspoon cayenne

1. Sauté the shallot in butter in a large Dutch oven over medium until tender, 2 minutes. Whisk in the flour and salt until smooth. Cook 1 minute, whisking constantly. Gradually whisk in the chicken broth. Add the potatoes and bay leaf. Cover and bring to a boil; reduce heat, and simmer, uncovered, until the potatoes are almost tender, about 15 minutes. Add the salmon; simmer 5 minutes or until the fish flakes easily with a fork and the potatoes are tender when pierced.

2. Discard the bay leaf. Stir in the cream, 2 tablespoons of the chives, vinegar, and next 3 ingredients. Cook over medium, stirring often, 2 minutes or until thoroughly heated. (Do not boil.) Ladle into bowls; sprinkle with remaining 2 tablespoons chives.

BROWN-BUTTER LOBSTER BISQUE

Bisque and chowder are two types of thick soup; bisque is generally smooth while chowder is chunky. (Not pictured).

LOBSTER STOCK
3 (1¼-pound) live lobsters
2 tablespoons olive oil
1 medium-size (about 10 ounces) yellow onion, coarsely chopped (about 2 cups)
3 celery stalks, thickly sliced (about 1 cup)
1 medium parsnip, cut into chunks (about 1 cup)
2 garlic cloves, smashed
4 (15-ounce) cans lobster stock
1 bay leaf

BISQUE
¼ cup unsalted butter
1 medium-size yellow onion, chopped (about 1½ cups)
1 medium parsnip, chopped (about ¾ cup)
2 celery stalks, chopped (about ½ cup)
2 garlic cloves, minced (about 2 teaspoons)
⅛ teaspoon cayenne pepper
1 cup dry white wine
½ cup uncooked long-grain white rice
¼ cup heavy cream
2 teaspoons kosher salt
Chopped fresh chives

1. PREPARE THE LOBSTER STOCK: Bring a large pot of salted water to a boil. Cook the lobsters until bright red, 8 minutes. Transfer to a bowl of ice water to shock. Remove the meat. Reserve the shells and meat of 2 claws. Roughly chop the tail meat. Cut the remaining 4 claws in half lengthwise for serving; cover and chill.

2. Heat the oil in a Dutch oven over medium. Add the onion, celery, parsnip, and garlic; cook until softened, 6 minutes. Add the lobster shells, stock, and bay leaf. Bring to a boil; reduce heat, and simmer, uncovered, 45 minutes. Pour mixture through a fine wire-mesh strainer into a bowl and discard solids. Reserve stock.

3. PREPARE THE BISQUE: Melt the butter in a Dutch oven over medium. Cook, stirring, until the butter is nutty and golden brown. Add the onion, parsnip, celery, and garlic; cook, stirring, until softened, about 5 minutes. Add the cayenne; cook 30 seconds. Add the wine, and cook until almost dry, about 6 minutes. Add the rice, and cook, stirring, 2 minutes until lightly toasted.

4. Add the reserved lobster stock to the Dutch oven; bring to a boil; reduce heat to a simmer, cover, and cook until rice is tender, about 20 minutes. Transfer the stock-rice mixture and reserved meat from the 2 claws to a high-powered blender. Remove center piece of blender lid (to let steam escape); secure lid, and place a clean towel over the opening. Process until smooth, about 45 seconds. Return the soup to the Dutch oven over low. Stir in the cream and salt, and stir to heat through. Ladle the bisque into shallow bowls; top with the chopped lobster meat, and sprinkle with chives. Garnish each serving with a lobster claw meat half.

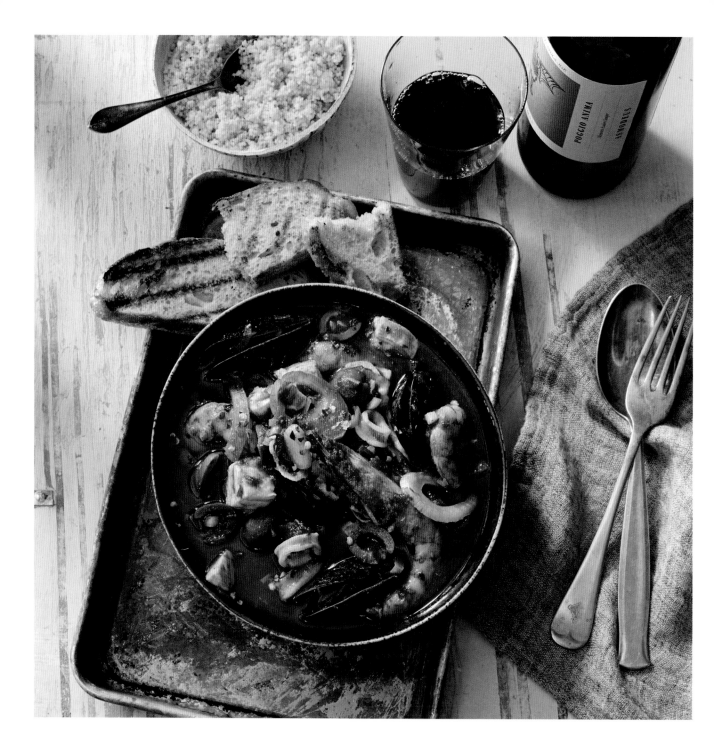

SICILIAN SEAFOOD STEW
WITH COUSCOUS

Turn your seafood bounty into a satisfying stew with a distinctly Sicilian touch, thanks to the buttery Castelvetrano olives. To prevent tough mussels and rubbery squid, it's important to add the seafood in the order listed, from longest to shortest cooking times.

- 2 tablespoons olive oil
- 2 medium leeks, white and light green parts only, rinsed and sliced into thin half-moons (about 2 cups)
- 1 medium fennel bulb, thinly sliced (about 1½ cups)
- 2 tablespoons tomato paste
- 6 garlic cloves, chopped
- 2 (15-ounce) cans fish stock
- 1 (26-ounce) box finely chopped tomatoes
- 1 (8-ounce) bottle clam juice
- ¾ cup pitted Castelvetrano olives, halved
- 2 teaspoons kosher salt
- ¾ teaspoon crushed red pepper
- 1 pound mussels, scrubbed and debearded
- 1 pound large peeled raw shrimp, head-on
- 8 ounces halibut, cut into 1-inch pieces
- 8 ounces squid, cut into ½-inch rings and small tentacles
- 4 cups cooked couscous, for serving
- ⅓ cup chopped fresh flat-leaf parsley

1. Heat the oil in a large Dutch oven medium-high. Add the leeks and fennel; cook, stirring often, until softened, about 6 minutes. Add the tomato paste and garlic; cook, stirring constantly, until fragrant, about 1 minute. Stir in the fish stock, chopped tomatoes, clam juice, olives, salt, and crushed red pepper. Bring to a boil; reduce the heat to medium-low, and simmer, uncovered, 30 minutes.

2. Increase the heat to medium-high. Add the mussels, shrimp, and halibut. Cover and cook until the shrimp and halibut are opaque, and mussels open, 5 to 6 minutes. Gently stir in the squid. Serve over the couscous, and sprinkle with parsley.

FRIED GROUPER & CREAMY COLESLAW SANDWICH

Using carbonation—beer or club soda—in the batter is an easy trick to create that signature airy-crisp coating.

1 cup (4.25 ounces) all-purpose flour
¼ cup cornstarch
1 tablespoon garlic powder
½ teaspoon freshly ground black pepper
4 (4-ounce) grouper fillets
½ teaspoon kosher salt
¼ teaspoon freshly ground black pepper
¼ cup buttermilk
¼ cup club soda
Canola oil
4 onion sandwich rolls, split
Creamy Coleslaw (recipe follows)

1. Combine the first 4 ingredients in a large shallow dish. Set aside.

2. Sprinkle the fillets with salt and pepper. Dredge the fish in the flour mixture; dip in the buttermilk-club soda mixture, and then dredge in the flour mixture again.

3. Pour the oil to a depth of 3 inches in a Dutch oven; heat to 350°F. Fry the fish 5 to 6 minutes or until golden; drain on paper towels. Serve on the rolls with Creamy Coleslaw.

CREAMY COLESLAW

1 (10-ounce) package finely shredded cabbage mix (purple and green)
½ carrot, shredded
¼ cup granulated sugar
¼ teaspoon kosher salt
⅛ teaspoon freshly ground black pepper
¼ cup mayonnaise
2 tablespoons milk
2 tablespoons buttermilk
1½ tablespoons fresh lemon juice
1 tablespoon white vinegar

1. Combine the shredded cabbage mix and carrot in a large bowl.

2. Whisk together the sugar and next 7 ingredients until blended; toss with cabbage mixture. Cover and chill mixture at least 2 hours. **Makes 4 cups**

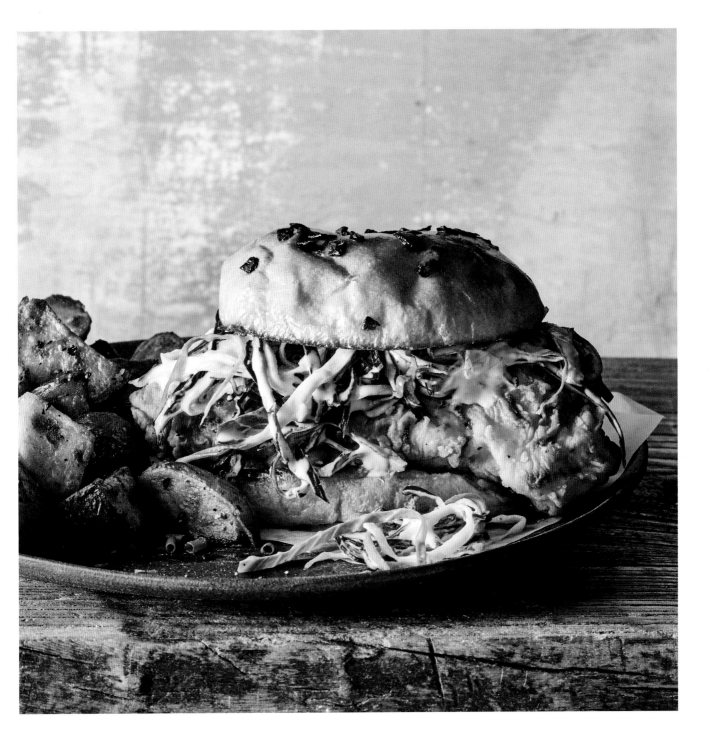

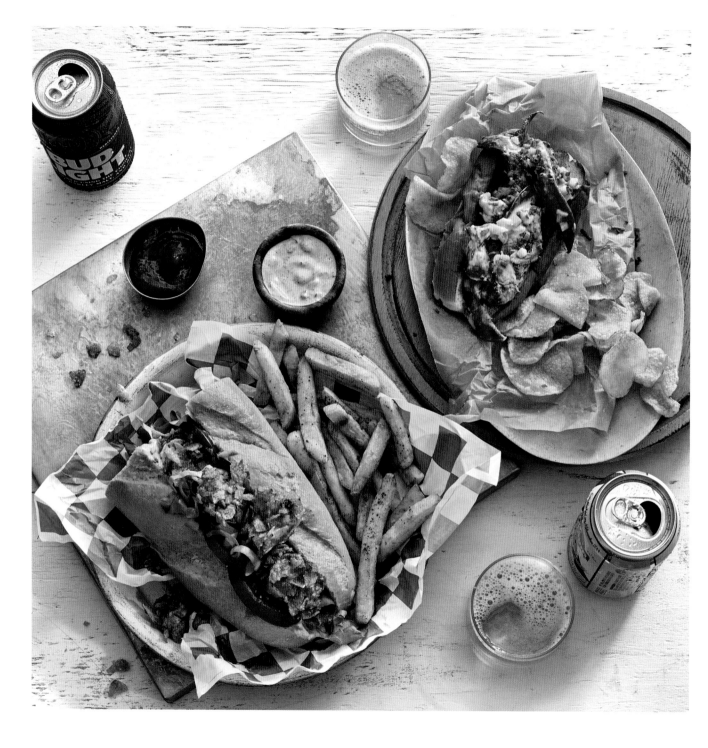

LOBSTER ROLLS

Lobster rolls are a quintessential New England creation and tied to Maine thanks to the state's bountiful catch of these delicious crustaceans.

4 cups cooked, chilled, and chopped lobster meat

½ cup mayonnaise

2 celery stalks, finely chopped

½ teaspoon lemon zest

1 tablespoon fresh lemon juice

½ teaspoon kosher salt

¼ teaspoon hot sauce

2 tablespoons butter, softened

4 top-loading hot dog buns

2 teaspoons chopped fresh chives

¼ teaspoon cracked black pepper

1. Combine the first 7 ingredients in a large bowl. Cover and chill until ready to serve.

2. Spread the butter on buns; press buns open, and place, buttered sides down, in a large nonstick skillet over medium-high. Cook until golden brown. Fill the buns with the lobster mixture, and sprinkle with the chives and cracked black pepper.

FRIED OYSTER PO' BOYS

A New Orleans classic, Po' Boys are stuffed with fried oysters, shrimp, green tomatoes, or roast beef. A potato chip coating adds extra crunch to this oyster breading.

Canola oil

1 cup (about 4¼ ounces) all-purpose flour

1 teaspoon kosher salt

½ teaspoon black pepper

1 cup buttermilk

1 large egg, lightly beaten

1 tablespoon water

4 cups crushed potato chips (such as Zapp's Voodoo)

1 pint fresh oysters, drained

1½ baguettes, cut into 6-inch lengths

Horseradish Rémoulade (recipe follows)

1½ cups shredded lettuce

2 tomatoes, thinly sliced

Hot sauce

1. Pour 3 inches of oil into a Dutch oven; heat to 360°F.

2. Combine the flour, salt, and pepper in a shallow dish. Whisk the buttermilk, egg, and water in a second dish. Place the crushed potato chips in a third dish. Dredge the oysters in the flour, and then the egg mixture, ending with the crushed chips. Press to adhere. Fry in batches until golden, 2 to 3 minutes. Drain.

3. Spread the bread with the rémoulade; top with the lettuce, tomatoes, and oysters. Serve with hot sauce.

HORSERADISH RÉMOULADE

1 cup mayonnaise

3 tablespoons Creole mustard

2 tablespoons chopped fresh flat-leaf parsley

2 tablespoons fresh lemon juice

3 teaspoons prepared horseradish

1 teaspoon paprika

3 scallions, sliced

Mix all the ingredients; cover and chill until ready to serve.
Makes 1½ cups

VIET-CAJUN CRAWFISH BOIL

After the collapse of Saigon in 1975, Houston became home to the second-largest Vietnamese population in the United States. But it was another exodus, this time from Louisiana during Hurricane Katrina, that stoked an insatiable demand for crawfish. Enterprising Vietnamese restaurateurs, like those at Crawfish & Noodles, began putting their own distinctive twist on a classic Cajun boil, tossing the cooked mudbugs in butter, chiles, garlic, and Southeast Asian ingredients such as lemongrass and ginger. Today, that love child of two coastal communities is the preferred preparation in the Bayou City.

CRAWFISH BOIL

2½ gallons water

1½ cups Old Bay seasoning or Zatarain's Crawfish, Shrimp & Crab Boil

½ cup fish sauce

2 lemongrass stalks, smashed

2 lemons, halved

2 heads garlic, halved horizontally

¾ cup kosher salt

2 pounds small red potatoes

6 pounds live crawfish, cleaned

3 ears fresh corn, halved

BUTTER SAUCE

2 cups (1 pound) unsalted butter

2 tablespoons very finely chopped lemongrass

½ cup chopped garlic (from 16 cloves or 1 large head)

1½ teaspoons kosher salt

2 teaspoons cayenne

3 tablespoons lemon juice

½ bunch cilantro sprigs (optional)

1. PREPARE THE CRAWFISH BOIL: Place the water, Old Bay, fish sauce, lemongrass, lemons, garlic, and ¼ cup of the salt in a large stockpot. Cover and bring to a boil over high. Reduce the heat to medium-low, and simmer 15 minutes. Add the potatoes, and cook until just tender, 15 to 20 minutes. Add the remaining ½ cup salt. Increase the heat to high, and bring to a rolling boil. Add the crawfish and corn; boil until the crawfish are bright red, about 8 minutes. Remove from the heat, and let stand 15 minutes.

2. PREPARE THE BUTTER SAUCE: Heat ¼ cup of the butter in a stainless steel saucepan over medium-high until foamy. Add the lemongrass; sauté until very soft, 4 to 5 minutes. Add the remaining butter, garlic, salt, and cayenne. Cook until butter is melted and garlic is just softened, 8 to 10 minutes. Remove from heat; stir in the lemon juice. Cover to keep warm.

3. Drain the crawfish mixture. Discard the garlic, lemons, and lemongrass. Place the crawfish, corn, and potatoes in a huge bowl. Toss with half of the Butter Sauce and cilantro, if desired. Serve with the remaining sauce on the side.

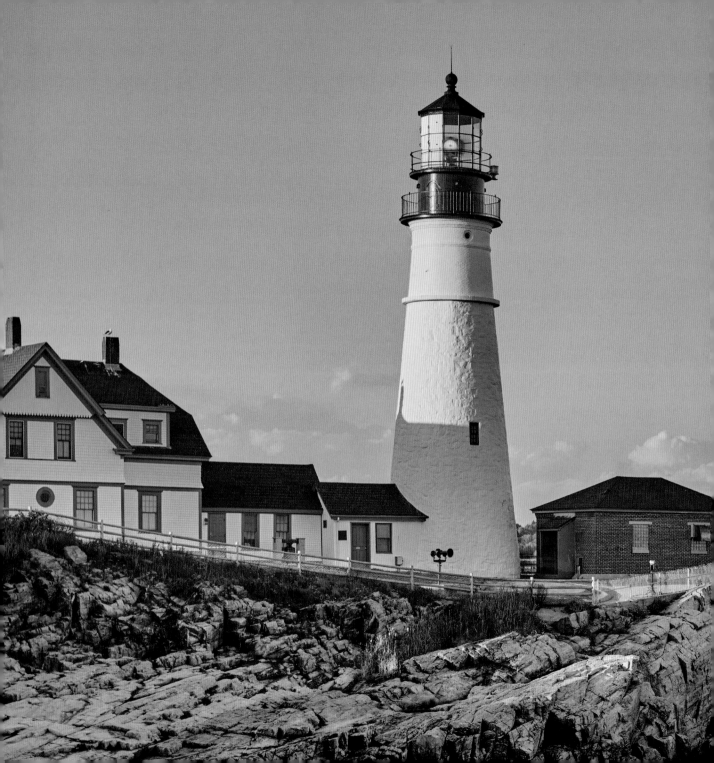

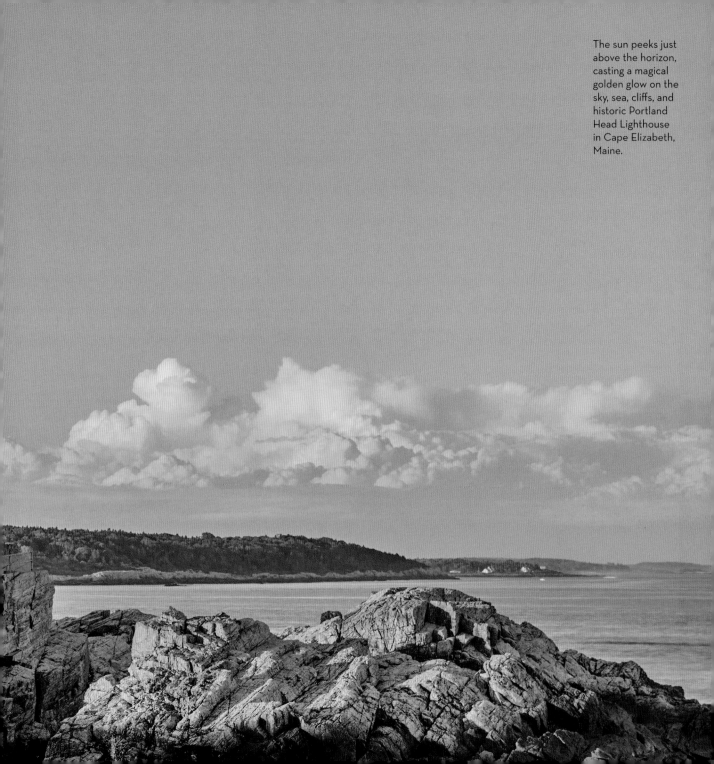

The sun peeks just above the horizon, casting a magical golden glow on the sky, sea, cliffs, and historic Portland Head Lighthouse in Cape Elizabeth, Maine.

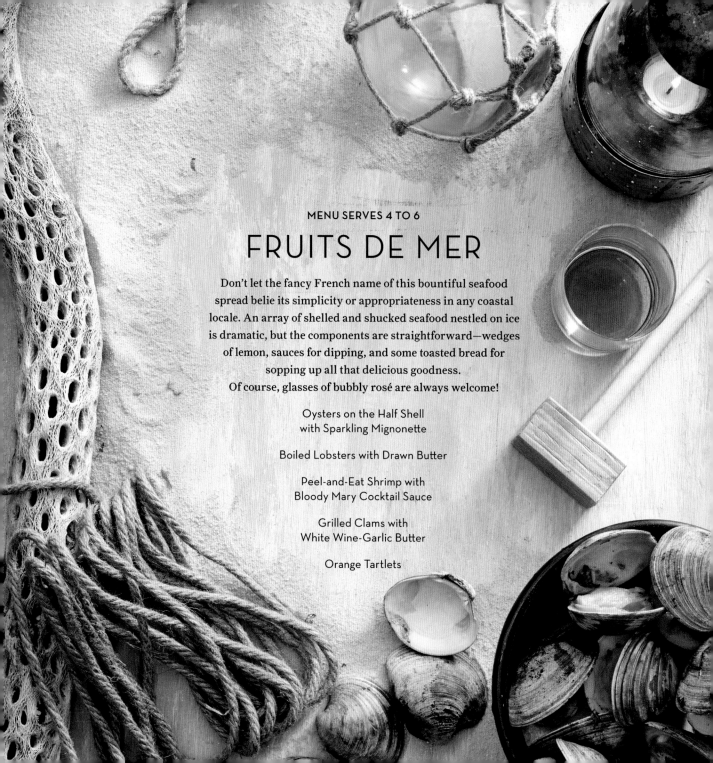

FRUITS DE MER

Don't let the fancy French name of this bountiful seafood spread belie its simplicity or appropriateness in any coastal locale. An array of shelled and shucked seafood nestled on ice is dramatic, but the components are straightforward—wedges of lemon, sauces for dipping, and some toasted bread for sopping up all that delicious goodness.
Of course, glasses of bubbly rosé are always welcome!

Oysters on the Half Shell
with Sparkling Mignonette

Boiled Lobsters with Drawn Butter

Peel-and-Eat Shrimp with
Bloody Mary Cocktail Sauce

Grilled Clams with
White Wine-Garlic Butter

Orange Tartlets

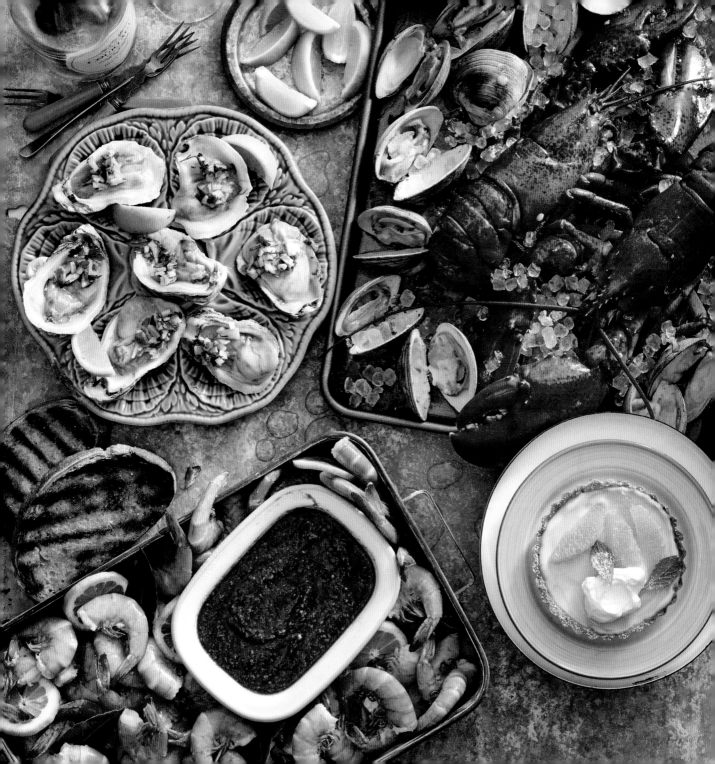

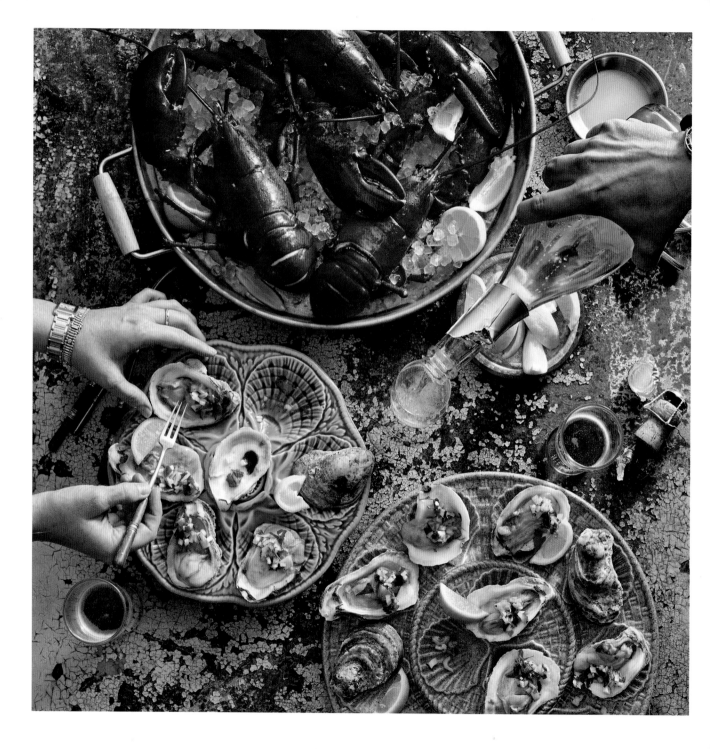

OYSTERS ON THE HALF SHELL
WITH SPARKLING MIGNONETTE

Champagne vinegar laced with shallots is a classic dunk for briny raw oysters. Adding an equal dose of Champagne adds a welcome sparkle to the mix.

2 dozen raw oysters, shucked (see below)

MIGNONETTE
½ cup Champagne vinegar
½ cup Champagne or sparkling wine

2 shallots, minced
2 teaspoons minced fresh flat-leaf parsley
½ teaspoon freshly ground black pepper

Whisk together all the mignonette ingredients in a small bowl. Cover and chill until ready to serve. Serve with raw oysters on the half shell. **Makes 1 cup**

SHUCKING OYSTERS

1. Place an oyster, curved-side down, at the end of a kitchen towel, narrow end pointing right (if right-handed) or left (if left handed). Fold the towel over the flat side that is face up, keeping the narrow end exposed.

2. Steady the oyster with the towel and a gloved hand, insert the oyster knife with the other hand into the small gap where top and bottom shells meet.

3. Twist the knife up with a turn of the wrist to loosen the joint. Hold the oyster in your gloved hand, flat-side up, and work the knife all the way around the joint until the shells are separated. Draw the backside of the knife up and across the underside of the top shell to remove it.

4. Using the same motion, draw the knife beneath the oyster to release it from the bottom shell for easy eating.

BOILED LOBSTER
WITH DRAWN BUTTER

Believe it or not, lobster used to be considered lowly rations in colonial New England. Cheap and abundant, they were a primary protein source for the poor and prisoners who would likely raise an eyebrow at the lobster's status today. Because the meat is mild and delicately sweet, don't overwhelm the flavor with big, bold sauces. Instead, a side of clarified butter and lemon wedges for squeezing are perfect pairings.

2 tablespoons kosher salt
4 quarts water
4 (1½-pound) live lobsters

1 cup (8 ounces) butter
Lemon wedges

1. Combine the salt and 4 quarts water in a large Dutch oven or stockpot; bring to a boil. Plunge the lobsters headfirst into boiling water and return to a boil. Cover, reduce the heat, and simmer 10 minutes. Drain and cool slightly.

2. Meanwhile, place the butter in a medium saucepan over medium-low. Cook until completely melted, about 5 minutes. Skim the solids off the top with a spoon and discard. Slowly pour the melted butter out of pan, leaving any solids in the bottom of the pan; discard solids.

3. Place each lobster on its back, twist the body and tail apart. Cut the body shell open using kitchen shears. Remove the liver and coral roe. Remove the meat from tail shell. Remove the intestinal vein that runs from the stomach to tip of the tail. Return the tail meat to shell. Crack the claws using a seafood cracker or nutcracker. Serve the tail and claws with the warm clarified butter and lemon wedges.

PEEL-AND-EAT SHRIMP
WITH BLOODY MARY COCKTAIL SAUCE

Will work for food! The fruits of a little labor always taste better, and this beachside standard is even tastier dipped in a tripped-out cocktail sauce comprised of all the elements of your favorite brunchtime Bloody Mary.

- 1½ gallons water
- 1 cup hot sauce
- 1½ cups liquid shrimp-and-crab-boil seasoning
- ¾ cup fresh lemon juice
- 1 (3-ounce) package boil-in-bag shrimp-and-crab boil
- ½ cup Creole seasoning
- ¼ cup kosher salt
- 5 bay leaves
- 3 pounds large unpeeled raw shrimp
- Bloody Mary Cocktail Sauce (recipe follows)

1. Combine 1½ gallons water and next 7 ingredients in a large Dutch oven, stirring well. Bring to a boil. Add the shrimp, and cook over high just until the shrimp turn pink, about 3 minutes; drain.

2. Place the shrimp immediately in a single layer over ice (do not rinse) on a rimmed baking sheet. Let cool 5 minutes. Remove the shrimp with tongs to a bowl; cover and chill. Serve with cocktail sauce and lots of napkins.

BLOODY MARY COCKTAIL SAUCE

- 1 cup ketchup
- ½ cup chili sauce
- 3 tablespoons prepared horseradish
- 1 tablespoon vodka
- 2 tablespoons fresh lemon juice
- 1½ teaspoons Worcestershire sauce
- 1 teaspoon hot sauce
- ¼ teaspoon celery salt
- ¼ teaspoon freshly ground black pepper

Combine all the ingredients in a medium bowl. **Makes 1¾ cups.**

PEELING BOILED SHRIMP IN 3 EASY STEPS

1. Pull off the head, if intact, and the legs.

2. Pinch the tail and pull it off.

3. Slide your thumb under the shell beneath the curve of the body and pull the shell up and around to get it off in one piece.

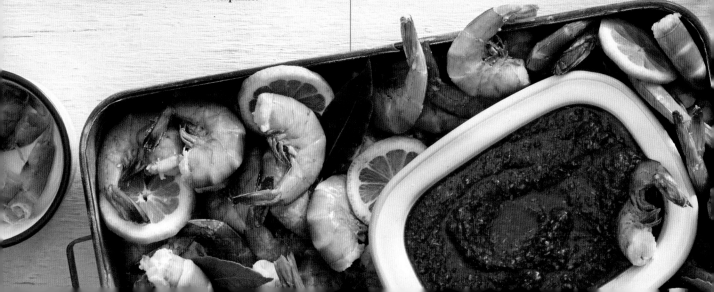

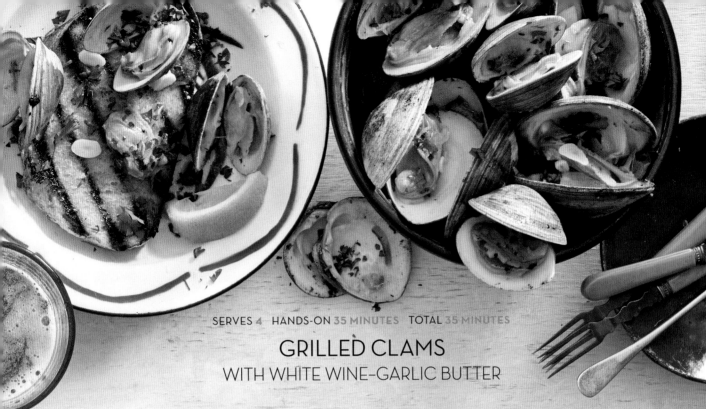

SERVES 4 HANDS-ON 35 MINUTES TOTAL 35 MINUTES

GRILLED CLAMS
WITH WHITE WINE–GARLIC BUTTER

Meaty cherrystone clams are larger than delicate littlenecks, so they stand up well to grilling. Because they take longer to cook, they also have the benefit of time to soak up more smoky flavor.

2 garlic cloves, minced

8 tablespoons (4 ounces) unsalted butter

¼ cup white wine

28 cherrystone clams, scrubbed

4 (¾-inch-thick) slices crusty bread

¼ cup chopped fresh parsley

Kosher salt

1. Preheat a grill to medium-high (about 450°F). Place the garlic and 4 tablespoons of the butter in a small heatproof saucepan on the grill; cook 3 minutes or until the butter foams. Add the wine to the pan and cook until the mixture is reduced by half. Remove the pan from the heat and set aside.

2. Place the clams directly on the grate; grill, covered, 10 minutes or until the clams just begin to crack open, checking every 2 to 3 minutes.

3. Return the saucepan to grill. As the clams open, use tongs to pour their juices into the garlic butter, and then return the clams to grill. Cook just until clam shells open wide, 2 to 3 more minutes; remove the clams from the grill as soon as they are done.

4. Grill the bread slices 1 to 2 minutes on each side. Remove from the heat. Remove the garlic butter from heat, and stir in the parsley and remaining 4 tablespoons butter. Season with the kosher salt to taste. Spoon the butter mixture over clams; serve with the grilled bread.

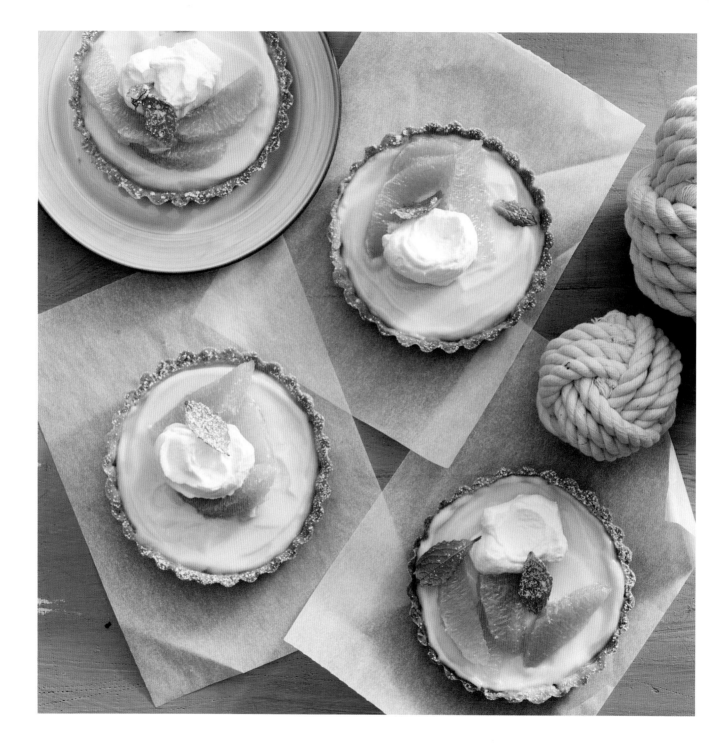

ORANGE TARTLETS

A palate-cleansing finish to any meal, make these citrus sweeties with blood oranges when available. The fruit's distinctive ruby flesh is sweeter than a common orange and adds vibrant wow factor.

¾ cup powdered sugar

14 tablespoons (7 ounces) unsalted butter, softened

7 large egg yolks

1½ cups (about 6⅜ ounces) all-purpose flour

½ teaspoon kosher salt

3 cups half-and-half

½ cup granulated sugar

½ cup packed light brown sugar

6 tablespoons cornstarch

2 tablespoons orange zest plus 3 tablespoons fresh juice (from 2 oranges)

2 teaspoons fresh lemon juice (from 1 lemon)

2 cups orange segments (from 3 oranges)

2 cups sweetened whipped cream

Garnish: mint leaves

1. Preheat the oven to 325°F. Beat the powdered sugar and 10 tablespoons of the butter in a large bowl of a stand mixer on medium speed until light and fluffy, about 3 minutes. Add 1 of the egg yolks, and beat just until combined. Stir together the flour and ¼ teaspoon of the salt and gradually add to the butter mixture, beating on low speed just until just incorporated. Transfer the dough to a large sheet of plastic wrap; shape into an 8-inch disk, and wrap tightly. Chill 1 hour.

2. Divide the dough into 6 equal pieces. Press each piece onto the bottom and up the sides of 6 lightly greased 4-inch tart pans with removable bottoms. Prick the bottoms with a fork, and place on a rimmed baking sheet. Bake at 325°F until golden brown, 18 to 20 minutes. Remove from the oven, and cool completely, about 20 minutes.

3. Whisk together the half-and-half, granulated sugar, brown sugar, cornstarch, and remaining 6 egg yolks and ¼ teaspoon salt in a medium saucepan over medium. Cook, whisking constantly, until the mixture just begins to thicken and bubble, about 10 minutes. Immediately remove from the heat, and stir in remaining ¼ cup butter until melted. Transfer the mixture to a medium bowl, and let stand until cooled to room temperature, about 1 hour, stirring often. Stir in the orange zest, orange juice, and lemon juice.

4. Spoon about ¾ cup filling into each cooled crust, and chill until set, at least 2 hours. Top evenly with the orange segments and whipped cream just before serving. Garnish as desired.

SCANDINAVIAN LOBSTER BOIL
WITH POTATO, FENNEL & CORN SALAD

When you can, opt for fresh lobster, as it will yield tender, more flavorful tail meat. Lobster quickly turns chewy and dense after the tail has been removed from the body. If you're working with frozen lobster, be sure to thaw the tails in a refrigerator for 8 to 10 hours. You'll know the lobster is completely thawed when the tail is flexible.

1 large fennel bulb with stalks

6 quarts water

1½ pounds red potatoes

1 tablespoon crushed red pepper

½ cup plus 3 tablespoons apple cider vinegar

2 tablespoons plus ¾ teaspoon kosher salt

2 ears fresh yellow corn, husks removed

6 (8-ounce) lobster tails

3 tablespoons sour cream

3 tablespoons mayonnaise

3 tablespoons chopped fresh dill

2 tablespoons chopped fresh flat-leaf parsley

¾ teaspoon black pepper

½ teaspoon hot sauce

2 cups (16 ounces) butter

Lemon wedges

1. Trim the stalks and outer leaves from the fennel bulb. Discard the outer leaves; reserve the stalk and bulb. Bring the stalks, water, potatoes, red pepper, ½ cup vinegar, and 2 tablespoons of the salt to a boil in a stockpot over high. Reduce the heat to medium-high, and simmer 12 minutes. Add the corn, and simmer until the potatoes are tender, 10 to 12 minutes. Remove the corn and potatoes; let cool.

2. Return the fennel mixture to a boil over high. Add the lobster; boil 10 minutes. Transfer to a bowl of ice to shock.

3. Cut the fennel crosswise into very thin slices. Cut the corn kernels from the cobs; discard cobs. Cut potatoes into eighths if large or leave whole if small. Stir together the sour cream, mayonnaise, dill, parsley, black pepper, hot sauce, remaining vinegar and salt in a large bowl. Add the fennel bulb slices, potatoes, and corn; toss to coat.

4. Cut lobster tails lengthwise using kitchen shears and arrange on a warm platter.

5. Melt the butter in a saucepan over medium and heat until melted and foamy. Spoon the butter over the lobster tail meat in the shells. Serve with the potato salad and lemon wedges.

LOBSTER LINGO

BERRIES Lobster eggs

BUGS Lobster larvae

CHICKEN A one-pound lobster

HEN A female lobster

EGGER A female lobster with eggs. Lobstermen must cut a v-notch on the fertile female's tail and release her. The notch is a note to others that this egg-producing female must not be harvested

COCK A male lobster

SNAPPER Immature lobster noted by its flicking tail

PISTOL A lobster missing both claws

KEEPERS Legal lobsters that measure 3.25 to 5 inches from eyes to end of thorax where it meets the tail

SHORTS Lobsters smaller than Keepers that are not big enough to harvest legally

SHEDDER A molting lobster

V-TAIL Eggers, once caught, that have notch cut on their tail to signal that they are a producing female and must be released

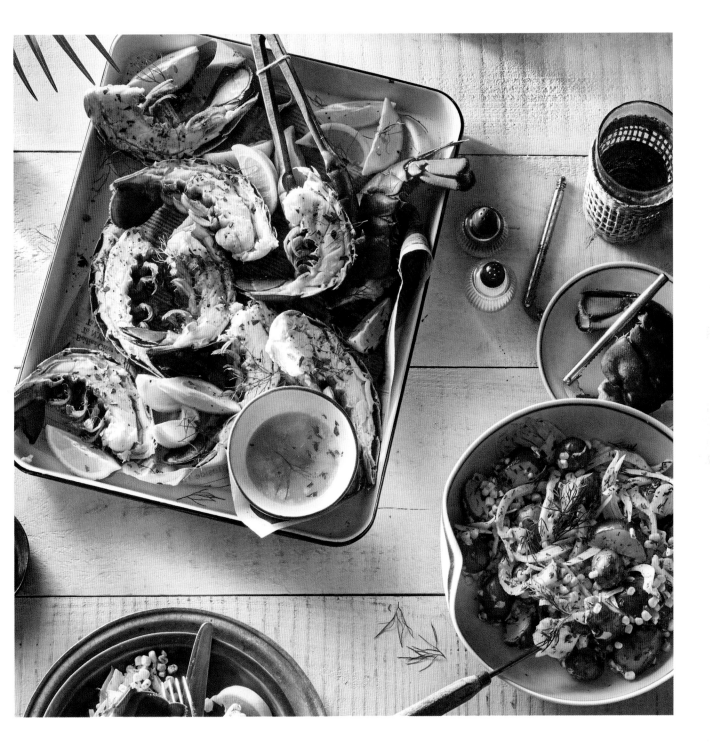

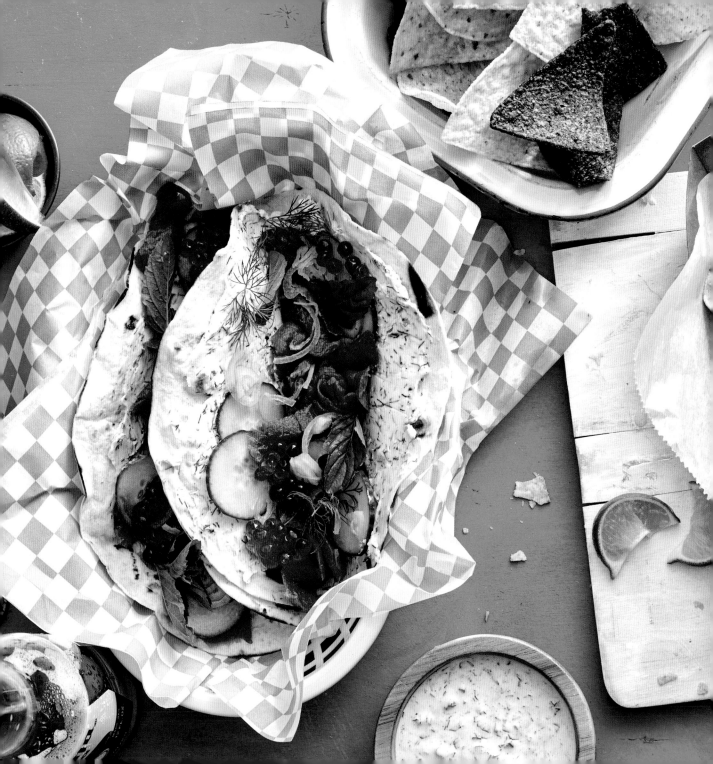

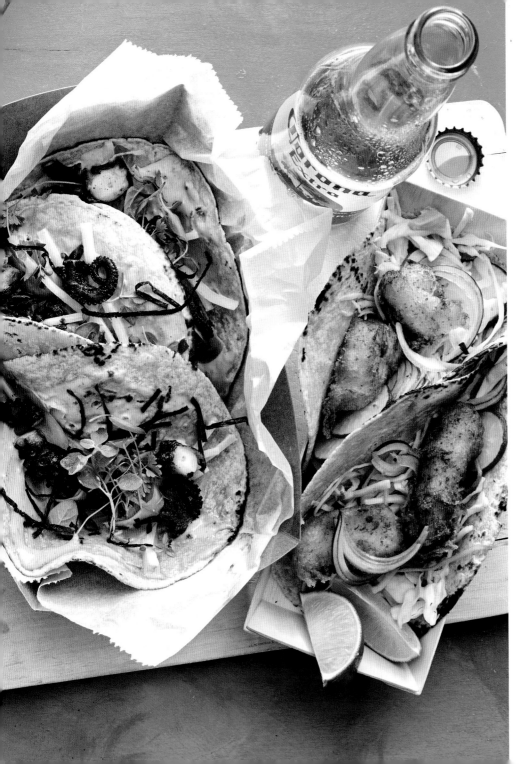

TACO TRUCK

No matter what coast you travel to these days, the globetrotting taco is as common as sand and sunshine. Cheap and satisfying, They are a complete meal in a perfectly portable package.

———

FROM LEFT TO RIGHT:
Pacific Northwest Smoked Salmon Tacos (Pg 148)
Japanese Tako Tacos (Pg 149),
and Baja Fish Tacos (Pg 148)

BAJA FISH TACOS

The OG that put fish tacos on the map.

1 pound firm white fish,
 cut into 1½-inch pieces
1 (12-ounce) bottle Mexican
 beer
1 tablespoon Mexican
 seasoning*
Vegetable oil
1 cup (4¼ ounces)
 all-purpose flour
1 teaspoon kosher salt
1 teaspoon granulated sugar
½ teaspoon baking powder

1 cup Mexican beer
½ teaspoon hot sauce
12 fresh corn tortillas
1 lime, cut into wedges
¾ cup shredded queso
 blanco
3 cups shredded green
 cabbage
½ red onion, cut into strips
 (about ½ cup)
Baja Sauce (recipe follows)

1. Place the fish in a large ziplock plastic bag. Add the beer and seasoning. Seal and chill 2 to 3 hours.

2. Pour the oil to a depth of 1½ inches into a deep skillet or Dutch oven; heat to 360°F.

3. Combine the flour and next 3 ingredients in a medium bowl. Whisk in 1 cup beer and the hot sauce. Drain the fish, discarding the marinade. Coat the fish in the batter.

4. Fry the fish in batches for 4 minutes. Drain. Place 2 to 3 pieces of fish on each tortilla. Squeeze with a lime wedge and top with cheese, cabbage, onion and a drizzle of the Baja Sauce.

BAJA SAUCE

½ cup sour cream
½ cup mayonnaise
2 teaspoons taco
 seasoning

1 small jalapeño, seeded
 and diced
¼ cup fresh lime juice
½ cup chopped cilantro

Combine all the ingredients; stir well. **Makes 1½ cups**

PACIFIC NORTHWEST SMOKED SALMON TACOS

Big-time flavor with just the right amount of crunch, this taco combines hot smoked salmon, crisp English cukes, and dill-flecked cream cheese. Sprinkle with mint leaves and some salty salmon roe to take it over the top.

8 ounces cream cheese,
 softened
2 tablespoons chopped
 fresh dill
2 teaspoons lemon zest
 plus 1 tablespoon fresh
 juice (about 1 lemon)
½ teaspoon kosher salt
¼ teaspoon black pepper
16 (6-inch) flour tortillas,
 warmed

1 pound hot smoked
 salmon, flaked into
 bite-size pieces
8 ounces thinly sliced
 English cucumber
 (about 1½ cups)
½ cup thinly sliced shallot
 (about 1 medium)
16 teaspoons salmon roe
2 tablespoons torn mint
 leaves

1. Stir together the cream cheese, dill, lemon zest, lemon juice, salt, and pepper in a medium bowl.

2. Divide the cream cheese mixture evenly among the tortillas. Top the tortillas with the smoked salmon, cucumber, shallot, and salmon roe. Sprinkle with the mint leaves.

JAPANESE TAKO TACOS

Feed your wild side with tender tako (Japanese for octopus) dressed with pickled ginger, julienned daikon, and a sambal-spiked Kewpie mayo sauce.

OCTOPUS
6 cups water

3 cups sake

½ cup rice wine vinegar

½ cup soy sauce

3 Thai chiles

2 small yellow onions, each cut into 4 pieces

1 garlic bulb, halved

1 (4-inch) piece fresh ginger, halved crosswise

2 tomatoes, each cut into 4 pieces

2 bay leaves

4 thyme sprigs

1 (4- to 5-pound) whole octopus, cleaned

KEWPIE MAYO SAUCE
1 cup Kewpie mayonnaise

1 tablespoon sambal oelek (ground fresh chile paste)

½ teaspoon soy sauce

¼ teaspoon fish sauce

ADDITIONAL INGREDIENTS
2 tablespoons sesame oil

½ teaspoon kosher salt

¼ teaspoon black pepper

8 (6-inch) yellow corn tortillas, warmed

¼ cup chopped toasted nori

½ cup 2-inch daikon radish sticks

¼ cup pickled ginger

½ cup microgreens

1. PREPARE THE OCTOPUS: Preheat the oven to 350°F. Stir together the water, sake, vinegar, soy sauce, Thai chiles, onions, garlic, ginger, tomatoes, bay leaves, and thyme sprigs in a large Dutch oven, and bring to a boil over high. Reduce the heat to medium, and simmer 20 minutes. Add the octopus; cover. Place the Dutch oven in the oven, and cook at 350°F until the octopus is tender when pierced with a sharp knife, about 1 hour and 20 minutes.

2. Remove the Dutch oven from the oven. Uncover and cool theh octopus completely in the cooking liquid. Remove the octopus; discard the liquid. Cut the legs from the body and head; discard the body and head.

3. MEANWHILE, PREPARE THE KEWPIE MAYO SAUCE: Stir together the Kewpie mayonnaise, sambal oelek, soy sauce, and fish sauce in a small bowl. Cover and chill until ready to serve.

4. Preheat a grill to high (450° to 550°F). Rub the skin from octopus tentacles using a paper towel, keeping the suckers intact. Toss the octopus with the sesame oil, salt, and pepper, and place on oiled grate. Grill, uncovered, until well charred, 3 to 4 minutes per side. Slice into ½-inch pieces.

5. Spread about 3 teaspoons of the mayo sauce on each tortilla. Divide the octopus among the tortillas. Sprinkle with nori, daikon, pickled ginger, and microgreens.

Surfboards rest against a beach hut while surfers take a lunch break on Mexico's Baja Peninsula.

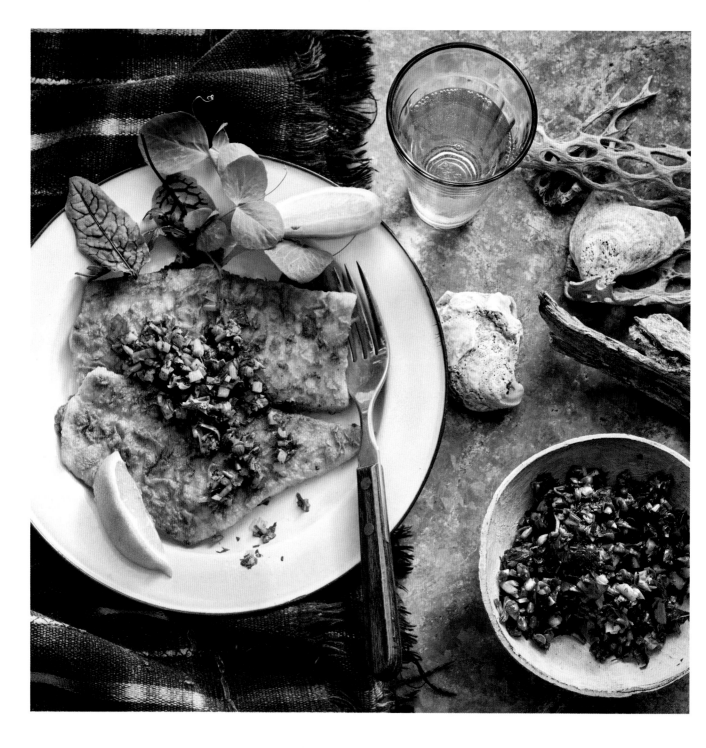

FLOUNDER PICCATA
WITH ITALIAN SALSA VERDE

Not the prettiest fish at your fishmonger, the flounder is a demersal flatfish. Demersal refers to bottom feeders (as opposed to pelagic fish that thrive above the bottom of the sea floor). As the flounder matures on the ocean bottom, its eyes migrate to the side of the fish that faces up, as protection against predation. No matter how it looks, it tastes delicious!

½ cup (about 2⅛ ounces) all-purpose flour

1½ teaspoons kosher salt

½ teaspoon black pepper

1 large egg white, well beaten

4 (5- to 6-ounce) skinless flounder fillets (about ½ inch thick)

½ cup (4 ounces) salted butter

2 tablespoons olive oil

1 cup seafood broth

¼ cup fresh lemon juice (from 2 lemons)

2 tablespoons drained and rinsed capers

2 tablespoons chopped fresh flat-leaf parsley

Italian Salsa Verde (recipe follows)

1. Stir together the flour, salt, and pepper in a shallow dish. Place the beaten egg white in a separate shallow dish. Dip each flounder fillet in the egg white, and dredge in the flour mixture, shaking off any excess.

2. Heat 2 tablespoons of the butter and 1 tablespoon of the oil in a large nonstick skillet over medium-high until the butter melts. Add 2 fillets, and cook until golden brown, 2 to 3 minutes per side. Transfer to a plate. Wipe the skillet clean, and repeat the process with 2 tablespoons of the butter and remaining olive oil and fillets. Discard the drippings; do not wipe skillet clean.

3. Add the broth, lemon juice, and capers to the skillet. Bring to a boil over high, stirring and scraping to loosen browned bits from the bottom of the skillet. Reduce the heat to medium, and simmer until reduced to about ⅓ cup, about 5 minutes. Whisk in the parsley and remaining 4 tablespoons butter.

4. Place the flounder fillets on a warm platter. Spoon the sauce over the fish and serve immediately with the Italian Salsa Verde.

ITALIAN SALSA VERDE

2 cups packed fresh flat-leaf parsley

2 tablespoons thinly sliced fresh chives

1 garlic clove

1 tablespoon drained capers

1 tablespoon minced shallot

½ cup extra-virgin olive oil

1 teaspoon white wine vinegar

½ teaspoon kosher salt

¼ teaspoon black pepper

Combine the parsley, chives, garlic, and 1½ teaspoons each of the capers and shallot in a food processor. Add the oil, and pulse until mixture is blended and chunky, 3 or 4 times. Transfer the mixture to a small bowl, and add the vinegar, salt, pepper, and remaining 1½ teaspoons each capers and shallot. **Makes ¾ cup**

GRILLED WHOLE FISH
WITH CHERMOULA

Keep the heat out of the kitchen and cook for a crowd on your outdoor grill. This flavorful recipe is a showstopper.

FISH
3 (1-pound) whole branzino, cleaned and scaled, fins removed

6 large fresh mint sprigs

12 (2-inch) lemon peel strips (from 2 lemons)

¼ cup olive oil

1 teaspoon kosher salt

1½ teaspoons black pepper

CHERMOULA
2 cups loosely packed fresh cilantro leaves

2 cups loosely packed fresh flat-leaf parsley

½ cup loosely packed fresh mint leaves

2 teaspoons ground cumin

1 teaspoon hot smoked paprika

½ teaspoon ground coriander

4 garlic cloves

¾ cup extra-virgin olive oil plus more for serving

3 tablespoons fresh lemon juice (from 1 large lemon)

1 teaspoon kosher salt

6 lemon wedges

1. PREPARE THE FISH: Cut 3 (¼-inch-deep) diagonal slits on each side of the fish. Place the mint sprigs and lemon peel strips in cavity of fish. Chill 1 to 2 hours. Rub the fish with the olive oil, and sprinkle with the salt and pepper.

2. PREPARE THE CHERMOULA: Pulse the cilantro, parsley, mint, cumin, paprika, coriander, and garlic in a food processor until roughly chopped, 8 to 10 times. Add the olive oil, lemon juice, and salt; process until finely chopped, 5 to 10 seconds.

3. Prepare a wood or charcoal grill. Close the vent holes on the grill lid completely. (This is important; closing the vent holes will cut off oxygen to the fire so there are no flames coming up to burn the oil on the fish.) Place the fish on oiled grate over direct heat. Immediately close the grill lid. Grill, undisturbed, until the skin is crispy and starting to char, 3 to 4 minutes. Using a spatula so you don't tear the skin, carefully turn the fish charred side up; transfer to indirect heat. Top each fish with 1½ tablespoons of the chermoula. Open the vent holes on the grill lid and close lid. Grill until the fish flakes easily with a fork and a thermometer registers 140°F, 7 to 9 minutes.

4. Spread the remaining chermoula on a warm platter. Top with the fish. Serve with the lemon wedges.

THE DO'S AND DON'TS OF BUYING FRESH FISH

DO buy whole fish. It gives you the best opportunity to assess the quality, as the fins, scales, and eyes all tell a story of where the fish has been. If you opt for fillets, look for ones that are glistening and firm, and absent of any damage or gaps in the flesh.

DON'T wait too long to eat fully flavored fish, like mackerel and bluefish, which tend to spoil more rapidly. Most other seafood has a shelf life of up to five days.

DO make friends with your fishmonger. He or she will be able to tell you the best fish available that day.

DON'T overlook the frozen aisle. Find an array of high-quality options. To thaw: Pull the needed amount from the freezer at least 12 hours before use, placing it on a plate in the refrigerator. Thawing slowly is key to the best texture.

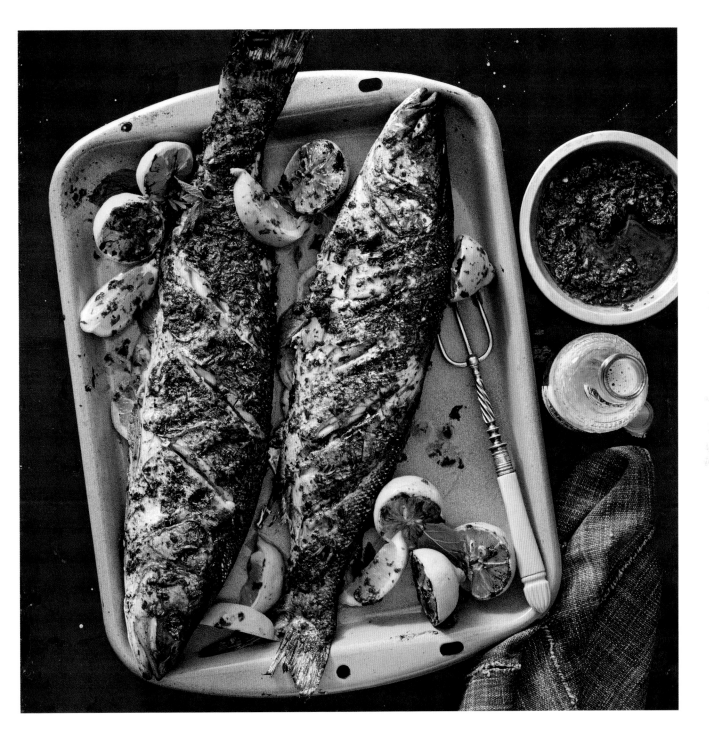

04.
ROADSIDE STAND

A CELEBRATION OF
VIBRANT SEASONAL
PRODUCE TO ROUND
OUT ANY MEAL

PICO DE GALLO BRUSCHETTA

Literally translated "rooster's beak" because it was eaten between pinched thumb and forefinger, pico de gallo is a Mexican condiment as common as ketchup or mustard stateside. The juicy tomato-onion mixture would normally make bread soggy, but a layer of melted cheese provides a delicious barrier.

1 baguette, cut into 36 (¼-inch-thick) slices
Olive oil
1½ cups (4½ ounces) shredded Mexican melting cheese or Monterey Jack
3 tomatoes, seeded and chopped
2 jalapeño chiles or serrano chiles, seeded and finely chopped
2 garlic cloves, minced
½ cup chopped red onion
⅓ cup chopped fresh cilantro
2 tablespoons fresh lime juice
½ teaspoon coarsely ground black pepper
¼ teaspoon table salt

1. Preheat the oven to 425°F. Brush the baguette slices with the olive oil, and place on a baking sheet. Bake at 425°F until light golden brown, 7 minutes. Remove from the oven; sprinkle with the cheese, and bake until the cheese is melted, 1 minute.

2. Combine the tomatoes and next 7 ingredients in a bowl; spoon the mixture onto the bread slices. Serve immediately.

CHORIZO & GOAT CHEESE-STUFFED PEPPERS

Spicy Spanish pork sausage adds bold flavor to these gooey little poppers.

24 baby sweet red, orange, and yellow peppers (about 1 pound)
8 ounces soft Mexican chorizo sausage
3 ounces goat cheese, crumbled
4 ounces cream cheese, softened
Garnish: chopped fresh cilantro

1. Preheat the oven to 425°F. Line a baking sheet with aluminum foil.

2. Cut a ¼-inch horizontal slice from one side of each pepper to create a "boat." Seed the peppers, if desired, and finely chop the pepper slice.

3. Combine the chopped peppers and chorizo in a large nonstick skillet over medium-high. Cook, stirring occasionally, until the chorizo is browned, 8 minutes. Drain well, if necessary. Add the cheeses, stirring until well blended.

4. Spoon or pipe the sausage mixture into the pepper boats. Place on the prepared baking sheet, and bake until the cheese melts and peppers are tender, 15 minutes. Garnish as desired.

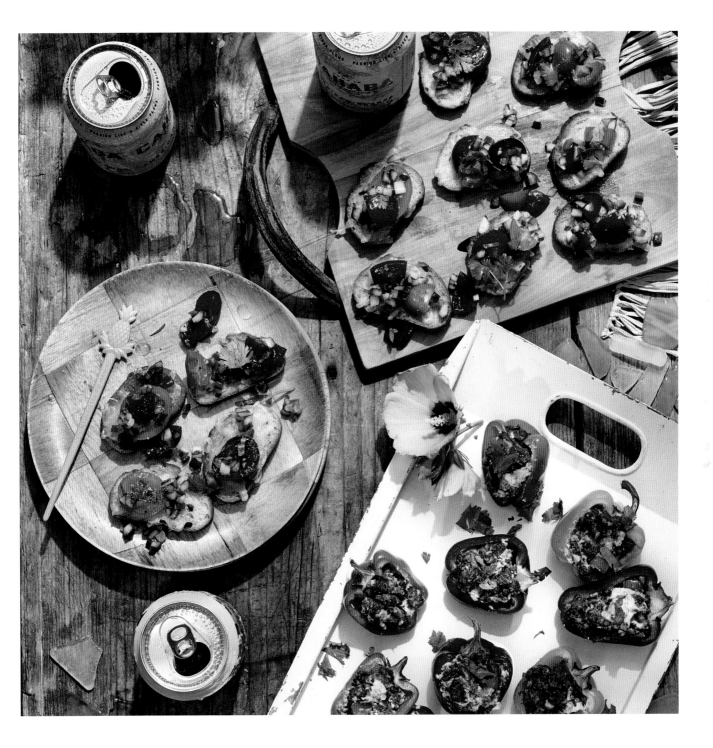

Brightly-colored rooftops pop against white stucco buildings and the azure sky above and sea beyond in Sevilla, Spain.

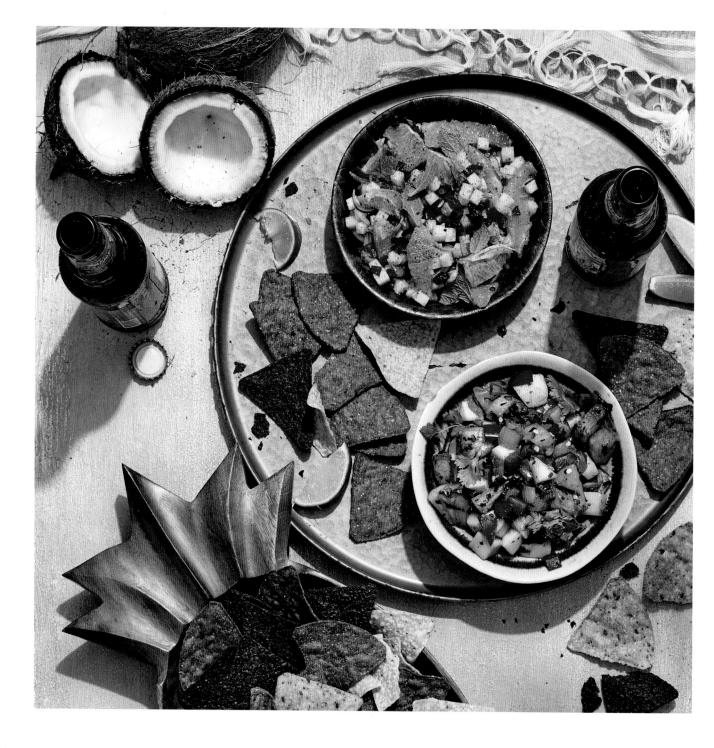

SMOKY ORANGE-JICAMA SALSA

Originally brought over by Spanish colonialists, jicama has been embraced by many cuisines. Purchase this under-the-radar root vegetable, also called "savory apple," in the grocery store produce section or in Latin markets. It adds a water chestnut-like crunch to recipes.

4 navel oranges, peeled and cut into segments

1 cup finely chopped jicama

½ cup finely chopped red bell pepper

¼ cup red onion, very thinly sliced

1 teaspoon orange zest

½ teaspoon ground cumin

¼ cup fresh orange juice

1 teaspoon chopped canned chipotle pepper in adobo sauce

½ teaspoon table salt

Combine the first 6 ingredients in a bowl, breaking the orange segments into pieces if large. Combine the orange juice, chipotle pepper, and salt; stir into the orange mixture. Cover and chill.

GRILLED PINEAPPLE-MANGO SALSA

Grilling pineapple and onion until slightly caramelized, adds caramelized sweetness that pairs beautifully with grilled meats and grilled fish and shellfish.

1 pineapple, peeled, cored, and sliced

½ sweet onion, cut into wedges

2 large or 3 small mangoes, peeled and chopped

1 red bell pepper, chopped

⅓ cup chopped fresh cilantro

1 to 2 teaspoons chopped canned chipotle pepper in adobo sauce

¾ teaspoon table salt

½ teaspoon granulated sugar

¾ teaspoon lime zest

3 tablespoons fresh lime juice

Preheat a grill to medium-high (about 450°F). Grill the pineapple and onion until slightly charred but not cooked through, 5 minutes. Chop and place in a large bowl. Stir in the mangoes and remaining ingredients. Cover and chill.

TIP: To tell if a mango is ripe, look for heftier fruit with firm skin, which gives slightly when pressed—similar to a ripe peach or avocado. A mango's color doesn't dictate ripeness; instead, focus on its feel and smell. A ripe mango is extremely fragrant.

HOW TO CUT A MANGO

1. Once your mango is ripe, slice it lengthwise along the large center seed to get two oblong mango halves.

2. Slice the mango into cubes by holding one of the halves in your hand and slicing it lengthwise, then crosswise without cutting through the skin.

3. Scoop out the diced mango cubes with a spoon, or turn the mango inside out to slice them off the skin. Repeat with the other half.

SWEET POTATO LATKES
WITH TOBIKO

Update your Jewish potato pancakes with sweet potatoes for a sunset hue. Press the individual latkes tightly so they don't fall apart in the pan, then top with a dollop of sour cream and a sprinkle of mildly salty red tobiko, or flying fish roe.

1 pound sweet potatoes or yams, peeled and grated

⅓ cup potato starch

3 scallions, thinly sliced (about ⅓ cup)

2 serrano chiles, seeded and finely chopped

2 large eggs, lightly beaten

1½ teaspoons kosher salt

½ teaspoon black pepper

¾ cup coconut oil

½ cup sour cream

¼ cup red tobiko (flying fish roe) (from 1 [3-ounce] container)

1 tablespoon very thinly sliced chives

1. Combine the potatoes, potato starch, scallions, chiles, eggs, salt, and pepper in a large bowl, stirring to blend.

2. Heat ¼ cup of the oil in a large nonstick skillet over medium-high until shimmering. Spoon 8 (2-tablespoon) potato portions into the skillet, flattening each portion into a 1½-inch disk. Cook until crisp on the first side, about 4 minutes. Turn and cook the second side until crisp, 3 to 4 minutes more. Drain on paper towels. Keep the latkes warm in a single layer on a baking sheet in a 175°F oven. Repeat the process twice with remaining oil and potato mixture.

3. Place the warm latkes on a serving platter and top each with 1 teaspoon sour cream and ½ teaspoon tobiko. Sprinkle with the chives.

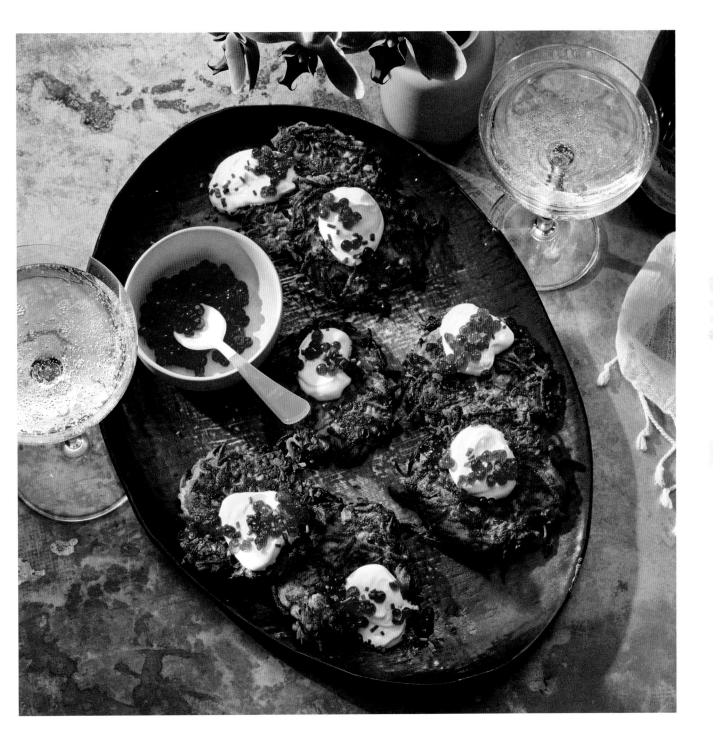

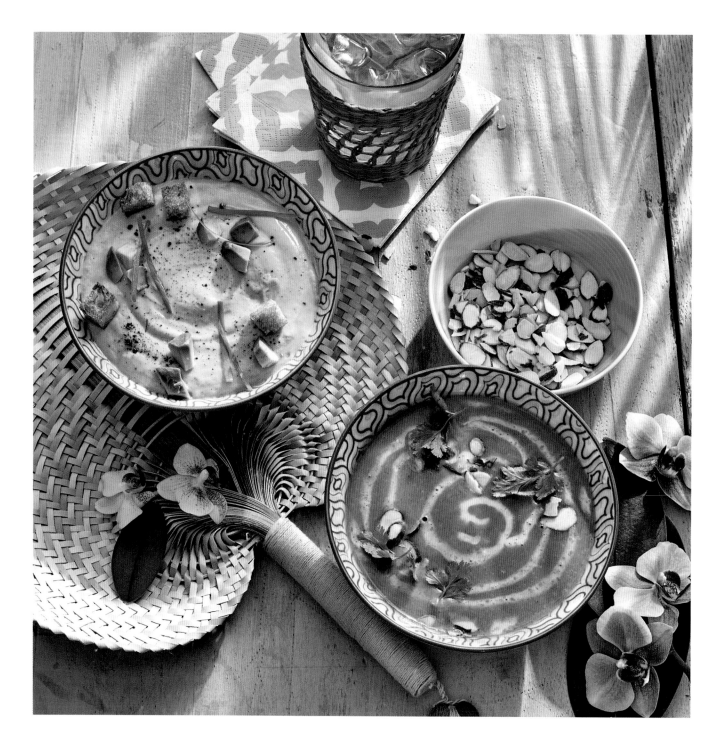

COLD AVOCADO SOUP

Cold, creamy and packed with tantalizing flavor, this refreshing soup is what you'll crave on hot beach days.

3 cups chopped peeled English cucumber (about 1½ cucumbers)

1 cup chopped sweet onion (about 1 onion)

1 tablespoon olive oil

2 teaspoons kosher salt

3 ripe avocados (about 1½ pounds)

1 cup cold water

1 large garlic clove, smashed

2 tablespoons fresh lime juice

½ teaspoon freshly ground black pepper

½ cup plain Greek yogurt

Sourdough Croutons (recipe follows)

Garnish: thinly sliced scallions

1. 1. Combine the first 3 ingredients and ½ teaspoon salt in a saucepan over medium-low. Cover and cook until the vegetables are soft, 10 minutes. Spread in a single layer on a baking sheet. Chill 15 minutes.

2. Place the cucumber mixture, flesh of 2½ avocados, and remaining salt in a blender. (Wrap the remaining avocado half in plastic wrap to prevent browning.) Add cold water and next 4 ingredients; process until smooth. Pour into a bowl and place plastic wrap on surface. Chill 2 hours.

3. Thinly slice remaining avocado half. Divide the soup among 4 bowls. Top with the avocado slices and croutons. Garnish as desired.

SOURDOUGH CROUTONS

1 tablespoon unsalted butter

1½ teaspoons extra-virgin olive oil

1½ cups diced sourdough bread

Dash of kosher salt

Melt butter in a skillet over medium heat; stir in oil. Add bread and cook, stirring, 5 minutes or until golden. Sprinkle with salt. Remove from pan and cool completely. **Makes about 1 cup**

CARIBBEAN SWEET POTATO SOUP

Blending humble sweet potatoes with floral lemongrass, fresh ginger, spices, and creamy coconut milk creates a soul-warming island-inspired soup.

2 tablespoons canola oil

⅓ cup chopped shallots (from 2 small shallots)

2 tablespoons finely chopped lemongrass (from 1 stalk)

1 tablespoon finely chopped fresh ginger

5 garlic cloves, chopped

5½ cups vegetable broth

3½ pounds sweet potatoes, peeled and cut into 1-inch pieces (about 14 cups chopped)

2½ teaspoons kosher salt

½ teaspoon ground turmeric

¼ teaspoon cayenne

1 (15-ounce) can coconut milk

3 tablespoons fresh lime juice (from 2 limes)

¼ cup toasted sliced almonds

¼ cup chopped fresh cilantro

1. Heat the oil in a Dutch oven over medium. Add the next 5 ingredients; cook, stirring often, until softened, about 6 minutes. Add the broth, sweet potatoes, salt, turmeric, and cayenne. Boil over medium-high. Reduce heat to low; cover and cook until potatoes are tender, about 20 minutes.

2. Skim ¼ cup thick coconut cream from the top of the can of coconut milk and whisk with 2 tablespoons lime juice; set aside. Whisk together the remaining coconut milk with remaining lime juice in a medium bowl until smooth and stir into the soup. Place the soup in a blender. Remove the center piece of the blender lid (to allow steam to escape); secure lid on the blender, and cover opening with a kitchen towel. Puree in batches until smooth, about 30 seconds. Pour the soup into bowls, and drizzle with the reserved coconut cream mixture. Top with the almonds and cilantro.

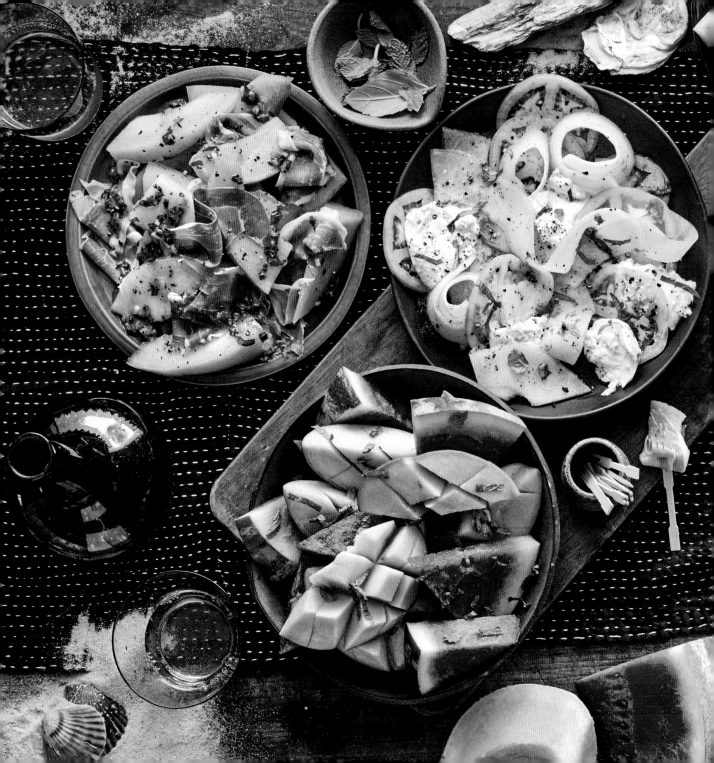

MELON MEDLEYS

Weave bright and juicy melons into breakfast, lunch, or dinner with these simple, refreshing recipes that satisfy the senses and hunger.

FROM LEFT TO RIGHT:
Summer Melon Salad with Ham & Mint Vinaigrette (Pg 171), Summer Fruit with Cardamom-Lime Syrup (Pg 171), Honeydew Caprese with Green Tomato & Burrata (Pg 170), Cucumber-Watermelon Gazpacho (Pg 170)

CUCUMBER-WATERMELON GAZPACHO

Cold soups may need an extra pinch of salt or squeeze of lime, so be sure to taste and adjust the seasoning again after the soup is well chilled.

2 English cucumbers, halved lengthwise, seeds removed (about 1½ pounds)

1½ cups plain whole milk yogurt

¾ cup chicken or vegetable stock

¾ cup half-and-half

2 scallions, finely chopped (about 2 tablespoons)

3 tablespoons finely chopped mint leaves

3 tablespoons finely chopped cilantro leaves

1 jalapeño chile, seeded and finely chopped (about 2 tablespoons)

2 teaspoons grated fresh ginger

3 tablespoons lime zest plus 2 teaspoons fresh juice (2 to 3 limes)

2½ teaspoons kosher salt

¼ teaspoon black pepper

1 cup finely chopped watermelon

1. Shred the cucumbers using the large holes of a box grater. Whisk together the yogurt, stock, and half-and-half in a large bowl until smooth. Stir in the cucumbers, scallions, mint, cilantro, jalapeño, ginger, 3 tablespoons lime juice, 1½ teaspoons salt, and ⅛ teaspoon pepper.

2. Cover and chill 4 to 12 hours. Stir the soup well. Taste, and stir in the remaining 1 teaspoon salt, ⅛ teaspoon pepper, and 2 teaspoons lime juice, if desired. Top with the watermelon.

HONEYDEW CAPRESE
WITH GREEN TOMATO & BURRATA

Ripe honeydew—typically found at the bottom of many a fruit salad—shaved into ribbons and swirled with torn pieces of creamy burrata and slices of green tomato is the star of the show here.

1 tablespoon white balsamic vinegar or white wine vinegar

1 teaspoon lime zest plus 2 tablespoons fresh juice (from 1 lime)

1 teaspoon honey

½ teaspoon kosher salt

¼ teaspoon black pepper

3 tablespoons extra-virgin olive oil

1 small (1½-pound) honeydew melon

1 medium-size (6-ounce) green tomato, cored and thinly sliced on a mandoline

4 ounces burrata cheese, torn into pieces

2 tablespoons thinly sliced fresh basil

1. Whisk together the vinegar, lime zest and juice, honey, salt, pepper, and 2 tablespoons of the oil in a small bowl. Toss together the tomato slices and 2 tablespoons of the vinegar-lime mixture in a medium bowl; set aside. (Reserve the remaining vinegar-lime mixture.)

2. Cut the honeydew melon in half; remove and discard the seeds. Cut each melon half into 4 wedges; remove the rinds. Shave the melon wedges into thin ribbons using a mandoline.

3. Arrange the tomato slices, melon ribbons, and burrata on a large platter. Drizzle with the reserved vinegar-lime mixture. Sprinkle with the sliced basil, and drizzle with the remaining 1 tablespoon oil. Serve immediately.

SUMMER MELON SALAD
WITH HAM & MINT VINAIGRETTE

Juicy, ripe honeydew and cantaloupe meet salty ham for the perfect yin and yang of sweet and savory.

2 tablespoons sherry vinegar

1 tablespoon minced shallot (from 1 shallot)

½ tablespoon honey

¼ teaspoon kosher salt

3 tablespoons olive oil

2 tablespoons chopped fresh mint

1 small cantaloupe (about 3 pounds), halved lengthwise

1 small honeydew melon (about 3 pounds), halved lengthwise

2 ounces thinly sliced salt-cured ham (such as speck or prosciutto)

¼ teaspoon black pepper

1. Whisk the vinegar, shallot, honey, and salt in a small bowl. Add the oil in a slow, steady stream, whisking until incorporated. Stir in 1 tablespoon chopped mint. Set aside.

2. Remove and discard the seeds from 1 half of each melon; cut each into 2-inch-wide radial spokes, about 6 slices each. Reserve the remaining melon halves for another use.

3. Using a sharp knife, follow the natural curve of the melon to remove the rind. Cut the slices in half. Arrange the melon pieces and ham slices on a platter. Drizzle the vinaigrette over the top; sprinkle with the black pepper and remaining 1 tablespoon mint.

SUMMER FRUIT
WITH CARDAMOM-LIME SYRUP

A sweet, spiced syrup puts fruit salad on a pedestal.

½ cup granulated sugar

Pinch of table salt

⅓ cup water

6 green cardamom pods, cracked

¼ cup fresh lime juice

1 small watermelon, sliced into wedges

4 large mangoes, cut into 1-inch wedges and scored

1 tablespoon julienned fresh mint

1. Combine the sugar, salt, and ⅓ cup water in a saucepan over medium-low. Simmer until the sugar dissolves. Stir in the cardamom and lime juice. Remove from the heat; steep 30 minutes. Strain, cover, and chill 8 hours or overnight.

2. Arrange the fruit on a platter. Sprinkle with the mint. Drizzle with half of the syrup. Serve the rest on the side.

UNUSUAL SUSPECTS

Watermelon, honeydew, and cantaloupe get all the glory. Try these other varieties for a juicy epiphany.

CANARY This football-shaped melon's tropical tang shines with fresh herbs in gazpacho.

CASABA This wrinkly gourd with its cucumber aroma pairs beautifully with bitter greens and curries.

CRENSHAW A super sweet relative of the casaba that plays well with salty ham and cheeses like feta or goat.

GALIA Lime green flesh with floral notes (heightened by a pinch of salt) make this melon the star of any cheese board.

HAMI Picture a sweeter, crunchier cantaloupe. Cut through this oblong muskmelon's sugar with a squeeze of lime juice.

SANTA CLAUS melons are harvested late in the season and have a subtle honeydew flavor.

YELLOW WATERMELON The sunny, honey-tinged flesh of this watermelon is great for sorbet or granita.

MINTY GRILLED SUMMER SQUASH

Raid your farmer's market for a wide variety of summer squash—pattypan, zephyr, and zucchini—for visual interest. This is a home run side dish for any meal.

1 pound assorted summer squash (such as pattypan, zucchini, or zephyr)
½ cup packed fresh mint leaves
1 teaspoon kosher salt
½ cup plus 2 tablespoons extra-virgin olive oil
½ teaspoon black pepper
⅓ cup red wine vinegar

2 tablespoons finely chopped shallot (from 1 shallot)
1 tablespoon honey
½ teaspoon Dijon mustard
2 ounces feta cheese, crumbled (about ½ cup)
¼ cup packed fresh flat-leaf parsley

1. Preheat a grill to medium (350° to 400°F). Cut the larger squash into 1-inch-thick slices; leave any smaller squash whole. Place the squash, mint, salt, 2 tablespoons of the oil, and ¼ teaspoon of the pepper in a small bowl; toss to coat. Let stand 20 minutes.

2. Meanwhile, stir together the vinegar, shallot, honey, mustard, ¼ cup of the feta, and the remaining ¼ teaspoon pepper in a small bowl. Gradually whisk in the remaining ½ cup oil.

3. Grill the squash until slightly charred and tender, about 5 minutes per side. Transfer the squash to a serving platter; drizzle with 3 tablespoons of the dressing. Sprinkle with the parsley and the remaining ¼ cup feta. Serve immediately with the remaining dressing.

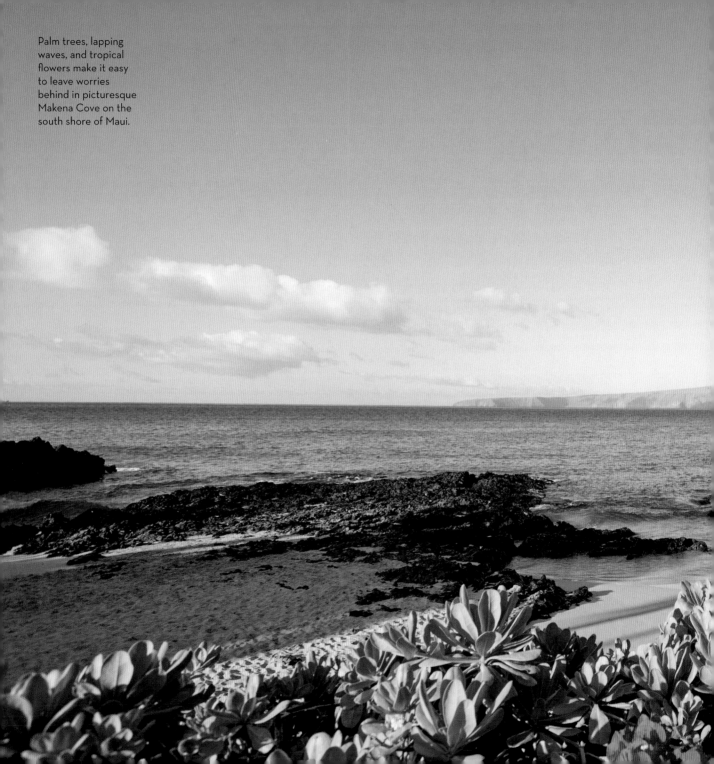

Palm trees, lapping waves, and tropical flowers make it easy to leave worries behind in picturesque Makena Cove on the south shore of Maui.

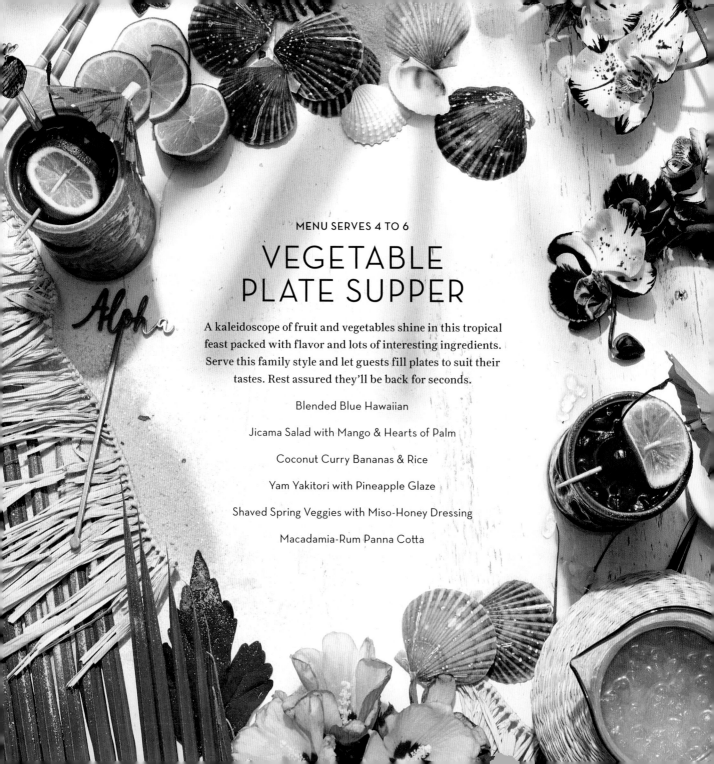

VEGETABLE PLATE SUPPER

A kaleidoscope of fruit and vegetables shine in this tropical feast packed with flavor and lots of interesting ingredients. Serve this family style and let guests fill plates to suit their tastes. Rest assured they'll be back for seconds.

Blended Blue Hawaiian

Jicama Salad with Mango & Hearts of Palm

Coconut Curry Bananas & Rice

Yam Yakitori with Pineapple Glaze

Shaved Spring Veggies with Miso-Honey Dressing

Macadamia-Rum Panna Cotta

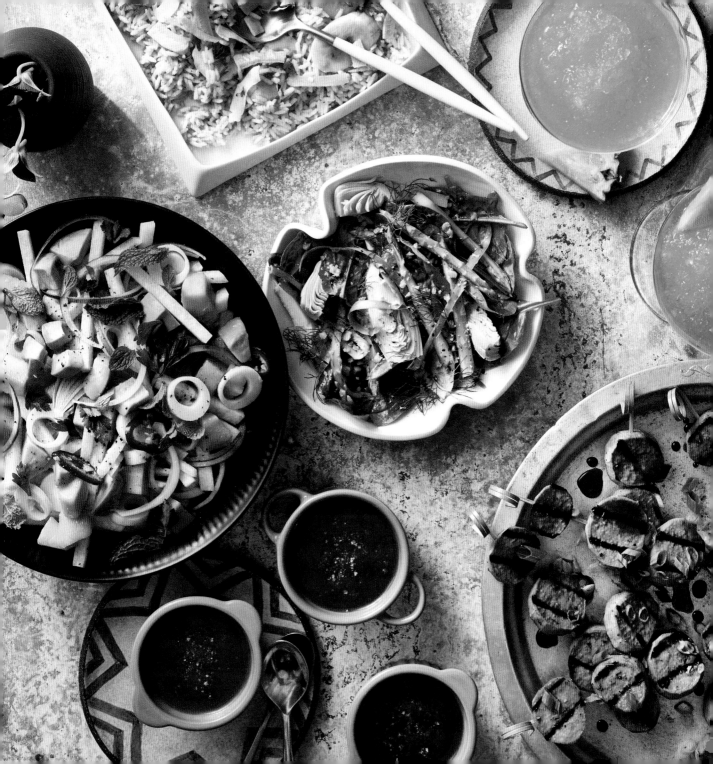

BLENDED BLUE HAWAIIAN

Why this orange-flavored liqueur is available in a hue the shade of a 1970s grandma's bouffant hairdo is an interesting story. Sixteenth century Spanish colonizers of the island of Curaçao tried to grow sweet Valencia oranges on the island, but the arid climate resulted in a lackluster crop, which the Spanish abandoned. A few centuries later, enterprising distillers extracted oil from the dried peels of the "wild" orange trees and distilled it into a nuanced liqueur. Dutch liqueur maker Lucas Bols, stockholder in the Dutch West Indian Company, enjoyed adding an eye-catching element to products, so he infused the liqueur with an azure sea-blue dye and nicknamed it "Crème de Ciel," meaning "cream of the sky." (The coloring does not impact the flavor.)

1/3 cup (2 1/2 ounces) pineapple-flavored vodka

2 tablespoons (1 ounce) blue Curaçao

2 tablespoons (1 ounce) coconut-flavored rum

1 tablespoon (1/2 ounce) amaretto liqueur

2 tablespoons (1 ounce) lime juice

1/4 cup agave nectar or granulated sugar

4 cups cracked ice

Combine all the ingredients in a blender. Blend on high until smooth.

JICAMA SALAD
WITH MANGO & HEARTS OF PALM

Originally brought over by Spanish colonialists, crisp jicama has been embraced by Hawaiians for adding a water chestnutlike crunch to sushi and salads.

1/4 cup fresh lime juice (from 2 limes)

1/4 cup extra-virgin olive oil

2 tablespoons apple cider vinegar

1 1/2 tablespoons honey

3/4 teaspoon table salt

1/4 teaspoon black pepper

1 medium jicama, peeled and cut into matchsticks (about 3 cups)

1 mango, peeled and chopped

1 (14.4-ounce) can hearts of palm, drained and rinsed

1/2 cup thinly sliced red onion (from 1 red onion)

1 red Fresno chile, seeded and thinly sliced

1 ripe avocado, cut into 3/4-inch pieces

1/2 cup chopped fresh mint

1/2 cup loosely packed fresh flat-leaf parsley

Whisk together the lime juice, oil, vinegar, honey, salt, and pepper in a large bowl. Add the jicama, mango, hearts of palm, red onion, and chile slices; toss to coat. Cover and chill 1 to 8 hours. Gently stir in the avocado, mint, and parsley just before serving.

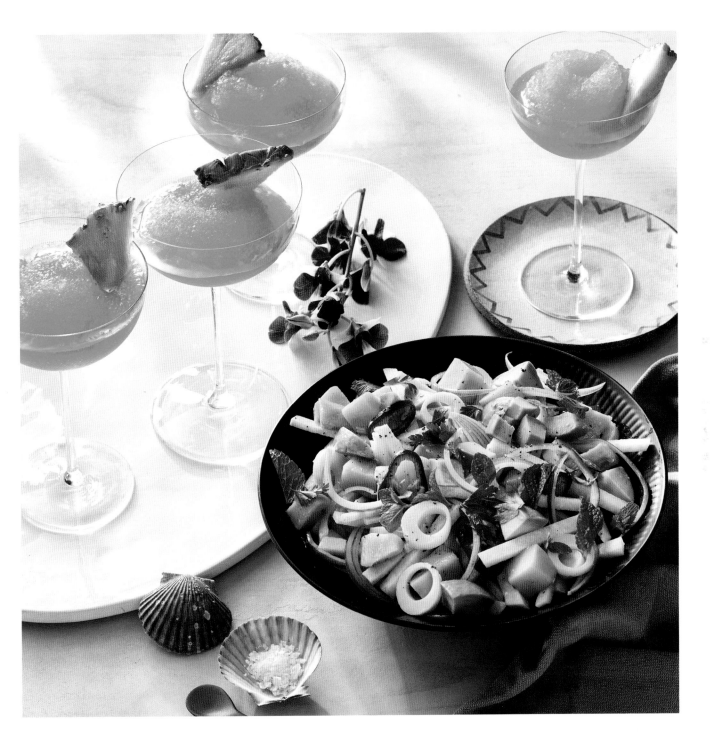

YAM YAKITORI
WITH PINEAPPLE GLAZE

This meat-free spin on the Japanese izakaya classic makes the most of starchy tubers. Alternate between the copper tones of fingerling sweet potatoes and purple-fleshed Okinawans for a colorful skewer ready for a drizzle of fragrant pineapple glaze.

- 2 pounds small fingerling sweet potatoes (about 6 [7- x 1½-inch] potatoes)
- ½ cup pineapple juice
- ½ cup mirin
- ¼ cup sake
- ¼ cup soy sauce
- 2 teaspoons light brown sugar
- 8 (8-inch) wooden skewers, soaked in water 30 minutes
- 1 tablespoon olive oil
- ½ teaspoon kosher salt
- ¼ teaspoon black pepper
- ¼ cup thinly sliced scallions (from 2 scallions)

1. Preheat the oven to 425°F. Pierce the potatoes several times with a fork. Arrange in a single layer in a rimmed baking sheet, and bake at 425°F until just tender, 25 to 30 minutes. Transfer to a wire rack; cool 30 minutes.

2. Meanwhile, combine the pineapple juice, mirin, sake, soy sauce, and brown sugar in a small saucepan over medium. Simmer, stirring often, until thickened, 10 to 15 minutes. Remove from the heat; set aside.

3. Peel the sweet potatoes, and cut crosswise into 1-inch pieces, discarding ends.

4. Preheat a grill to medium (350° to 400°F). Skewer the sweet potato pieces. Brush with the oil, and sprinkle with the salt and pepper; grill, uncovered, 3 minutes. Brush with some of the pineapple glaze, and continue grilling, turning every 2 to 3 minutes and brushing with the glaze after each turn, until charred on both sides.

5. Transfer to a serving platter, and sprinkle with the scallions; drizzle evenly with ¾ cup of the pineapple glaze. Serve immediately with the remaining glaze.

COCONUT-CURRY BANANAS & RICE

Stir in 2 cups grilled, chopped chicken and then chill the mixture to turn this flavorful side into a hearty salad.

- 2 cups uncooked long-grain white rice
- 3 bananas, sliced
- 1 tablespoon orange juice
- 1 teaspoon curry powder
- ½ teaspoon ground ginger
- ½ teaspoon table salt
- ⅛ to ¼ teaspoon cayenne
- ½ cup sweetened shredded coconut
- ½ cup coconut milk
- 2 tablespoons chopped fresh cilantro or parsley

1. Cook rice according to package directions; keep warm.

2. Toss the bananas and orange juice in a medium bowl. Stir in the curry powder and next 5 ingredients. Fold in the cooked rice, and sprinkle with the chopped herbs.

SHAVED SPRING VEGGIES
WITH MISO-HONEY DRESSING

Sweet and salty honey-miso dressing and buttery, rich walnuts elevate tender farmstand favorites. Shaving the walnuts on a Microplane grater ensures that they don't turn into nut butter here.

2 tablespoons white miso

1 tablespoon honey

½ cup extra-virgin olive oil

7 tablespoons lemon juice plus 1 lemon wedge (from 3 medium lemons)

1½ teaspoons kosher salt

1 teaspoon black pepper

4 to 6 cups water

4 fresh globe artichokes, stems removed

½ cup toasted walnuts

1 pound jumbo asparagus spears, trimmed

3 cups loosely packed baby spinach

3 tablespoons roughly chopped dill fronds

1. Preheat the oven to 400°F. Line a rimmed baking sheet with aluminum foil. Whisk together the miso, honey, 5 tablespoons of the olive oil, 3 tablespoons of the lemon juice, ½ teaspoon of the salt, and ¾ teaspoon of the pepper in a bowl.

2. Stir together 4 to 6 cups water (enough to cover the artichokes) and remaining ¼ cup lemon juice in a large bowl. Trim about 2 inches from top of each artichoke. Cut each artichoke in half vertically. Remove the fuzzy thistle from the bottom with a spoon; discard. Trim any leaves and the dark outer green layer from base. Rub all the cut edges with the lemon wedge, and submerge each artichoke in the lemon-water mixture as you finish trimming. (This will keep them from turning brown.) Cut the artichokes into wedges. Toss the artichoke wedges with the remaining olive oil, 1 teaspoon salt, and ¼ teaspoon pepper. Spread in a single layer on prepared baking sheet. Roast at 400°F until golden brown and tender, 20 to 25 minutes, stirring halfway through. Cool 15 minutes on baking sheet.

3. Grate the walnuts on a Microplane grater to equal 1 cup. Using a sharp knife, cut the asparagus diagonally into very thin slices, and place in a large bowl. Add the artichokes, spinach, miso dressing, dill fronds, and half of the grated walnuts to the asparagus; toss to coat. Top with the remaining grated walnuts.

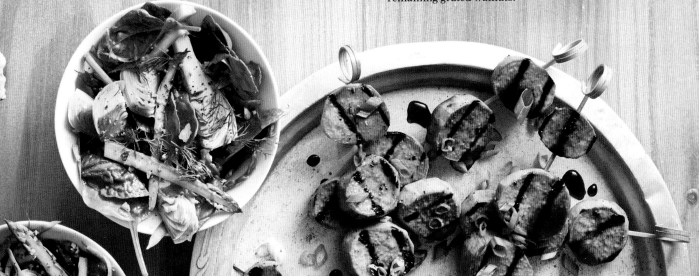

SERVES 8 HANDS-ON 15 MINUTES
TOTAL 8 HOURS, 45 MINUTES, INCLUDING CHILLING

MACADAMIA-RUM PANNA COTTA

This sweet confection features a rich caramel mixture poured over delicious macadamia nuts for a tropical fall treat.

2½ teaspoons unflavored gelatin (from 1 envelope)

3 tablespoons cold water

2 cups plain whole-milk yogurt

2 teaspoons macadamia nut extract

3 cups heavy cream

¾ cup granulated sugar

3 tablespoons plus 2 teaspoons dark rum

½ cup jarred caramel sauce

Fleur de sel

1. Sprinkle the gelatin in cold water in a small bowl. Stir and let stand 10 minutes.

2. Meanwhile, whisk together the yogurt, macadamia extract, and 1½ cups of the cream in a large bowl. Heat the sugar and remaining 1½ cups cream in a small saucepan over medium; bring to a simmer, stirring until dissolved. Remove from the heat; stir the softened gelatin into the hot cream mixture until dissolved. Pour the hot cream-gelatin mixture and 3 tablespoons of the rum into the yogurt mixture, and stir until blended. Divide the custard among 8 (4-ounce) ramekins, and refrigerate, uncovered, until thoroughly chilled, about 30 minutes. Cover with plastic wrap; chill 8 hours or overnight.

3. Heat the caramel sauce with remaining 2 teaspoons rum in a small saucepan over low until warm, about 1 minute. Cool slightly, and spoon a thin layer of caramel rum sauce on each custard; sprinkle with the fleur de sel, and serve.

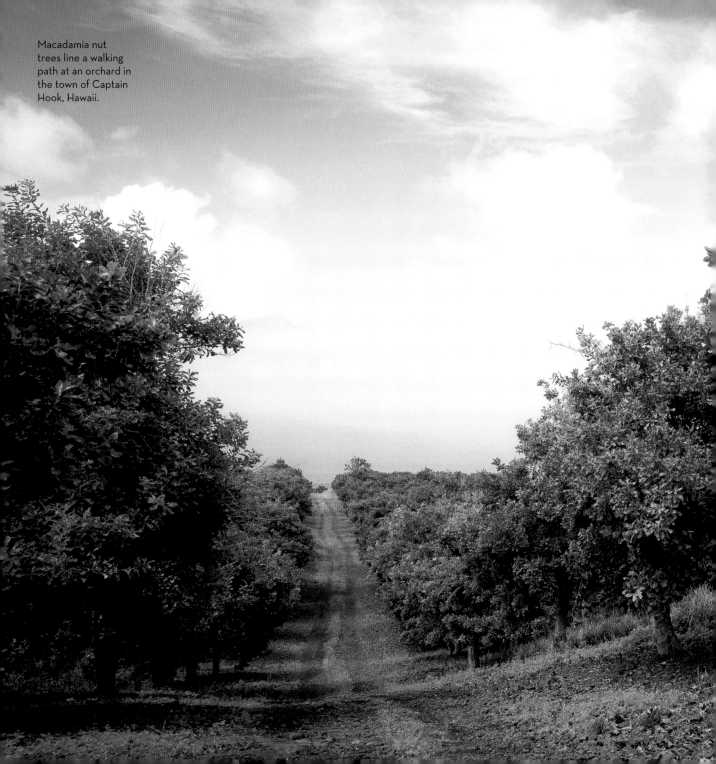

Macadamia nut trees line a walking path at an orchard in the town of Captain Hook, Hawaii.

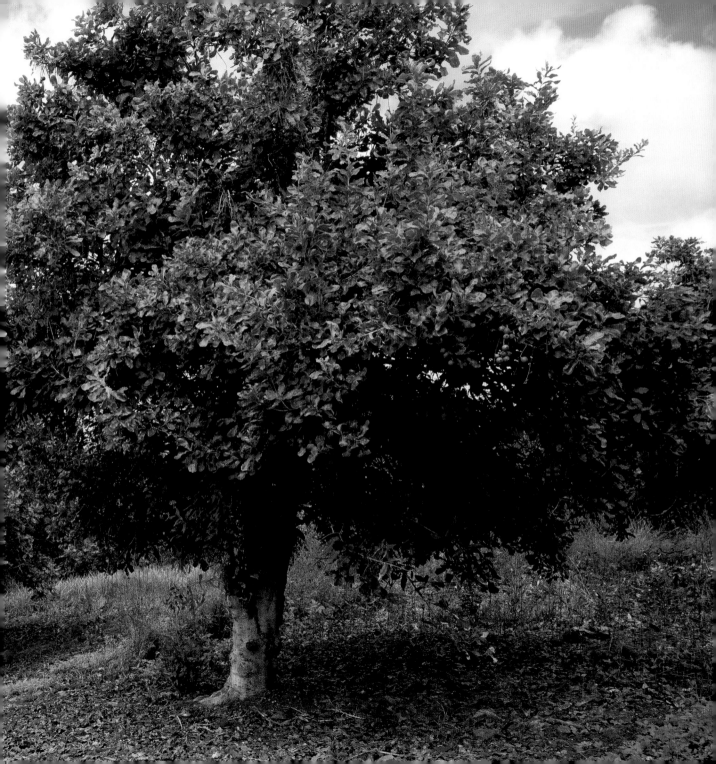

FRESH VEGETABLE SUCCOTASH
WITH BASIL

Packed with a bumper crop of garden goodness, including asparagus, zucchini, yellow squash, and lots of fresh basil, this classic Southern side is a welcome addition to any plate.

2 tablespoons salted butter

1 tablespoon finely chopped garlic

1 pound thin asparagus, trimmed and cut into 1-inch pieces

3/4 teaspoon kosher salt

1/2 teaspoon black pepper

1 cup diced yellow squash

1 cup diced zucchini

1/2 cup loosely packed fresh basil leaves, torn

2 ounces shaved pecorino Romano cheese (about 1/2 cup)

Melt the butter in a large skillet over medium-high. Add the garlic, and cook, stirring constantly, 30 seconds. Add the asparagus, salt, and pepper to the skillet; cook, stirring constantly, 2 to 3 minutes. Add the squash and zucchini to the skillet; cook, stirring constantly, until the vegetables are tender, about 2 minutes. Remove the skillet from the heat; stir in the basil and half of the cheese. Sprinkle with the remaining half of the cheese to serve.

ROASTED CARROTS & FENNEL

Ready in less than an hour, tender, caramelized carrots and fennel add sweet flavor to any meal. Reserve the fennel fronds to create a pretty, frilly garnish.

1 pound rainbow carrots or tender young carrots, halved lengthwise

1 large fennel bulb, cored and cut into 1/2-inch slices, plus a few fronds for garnish

1 small lemon, quartered

3 shallots, halved lengthwise

2 teaspoons fresh thyme leaves

2 tablespoons olive oil

1/2 teaspoon table salt

1/2 teaspoon freshly ground black pepper

Preheat the oven to 425°F. Combine all the ingredients on a baking sheet, tossing well to coat. Bake at 425°F until the vegetables are tender and caramelized, 25 to 30 minutes, stirring after 15 minutes. Arrange on a platter, and sprinkle with the reserved fennel fronds, if desired.

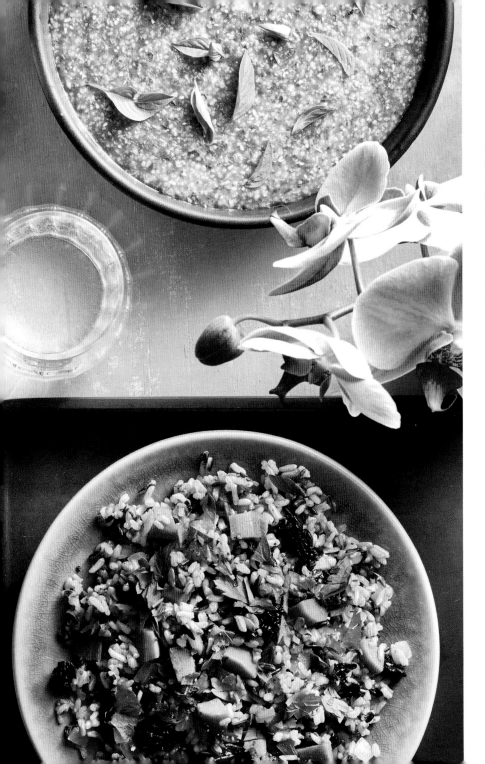

GO WITH THE GRAIN

Wholesome, hearty grains give salads and sides toothsome texture that satisfies.

FROM LEFT TO RIGHT:

Red Quinoa Salad with Beets, Kale, & Parmesan (Pg 191), Farro Salad with Peas, Pancetta & Radishes (Pg 190), Green Grits (Pg 190), and Wild Rice Salad with Carrots, Dried Cherries & Parsley (Pg 191)

FARRO SALAD
WITH PEAS, PANCETTA & RADISHES

Nutty grains, peak-season produce, and sweet honey make this pretty salad an ideal side for roasted chicken or sautéed shrimp.

3 cups water

1 cup pearled farro

1¼ teaspoons table salt

4 ounces finely chopped pancetta

1½ cups radishes, trimmed and cut into wedges

2 tablespoons fresh lemon juice

1 tablespoon canola oil

1 tablespoon honey

1 cup frozen peas, thawed

1 packed cup baby arugula leaves

¼ cup torn fresh mint

¼ teaspoon freshly ground black pepper

1. Bring 3 cups water to a boil in a large saucepan. Stir in the farro and 1 teaspoon of the salt; cover and simmer 15 minutes or until just tender, stirring occasionally. Drain; transfer the farro to a large bowl.

2. Heat a large skillet over medium-high; add the pancetta. Cook until browned, about 3 minutes. Remove the pancetta from the pan with a slotted spoon; drain on paper towels, and set aside. Reserve 1 tablespoon drippings in the pan; discard the remaining drippings. Return the pan to medium-high. Add the radishes; sauté 3 to 4 minutes or until crisp-tender.

3. Remove the pan from the heat. Stir in the lemon juice, oil, and honey. Pour the radish mixture over the farro; toss to coat. Add half of the reserved pancetta, peas, arugula, mint, pepper, and remaining ¼ teaspoon salt; toss gently to combine. Top with the remaining pancetta.

GREEN GRITS

Try this verdant spin on a Lowcountry favorite with the Crispy Salt & Pepper Shrimp (page 112).

1½ cups uncooked white stone-ground grits

2½ tablespoons unsalted butter

1 teaspoon kosher salt

1 (4-ounce) can chopped green chiles

½ cup firmly packed fresh cilantro leaves

½ cup firmly packed fresh Thai basil leaves

2 tablespoons thinly sliced fresh chives

1. Cook the grits according to the package directions. Stir in the butter and salt.

2. Process the remaining ingredients in a food processor 45 seconds until smooth. Stir into the hot grits and serve.

PICK YOUR GRAIN

BARLEY Hulled barley is the highest in fiber of all whole grains. It's a protein-packed alternative to rice, a hearty addition to soups and stews, and a delicious warm cereal.

QUINOA Not technically a grain, quinoa is in the beet and spinach family. It's gluten-free, high in potassium and amino acids, and is excellent in salads too.

BROWN RICE Cooked brown rice is denser, chewier texture than white because the bran and germ, which are loaded with antioxidants, remain intact. It stands up well in stir-fries, casseroles, and sushi.

BULGUR These par-cooked and dried wheat kernels cook fast. Bulgur stars in tabbouleh, but is great in veggie burgers, salads, and pilafs too.

FARRO Three ancient wheat grains—spelt, einkorn, and emmer—are all sold under this Italian name. Farro has a nutty flavor similar to wheat berries and is a brilliant stand-in for arborio rice in risotto.

WILD RICE SALAD
WITH CARROTS, DRIED CHERRIES & PARSLEY

This grain salad tastes equally delicious served warm or at room temperature. If serving at room temperature, let the rice cool completely before adding the parsley and cherries.

- ¼ cup (2 ounces) unsalted butter
- 1 cup chopped onion
- ¾ cup chopped carrot
- 2 cups uncooked royal blend wild rice mix
- ½ cup almonds, chopped
- 2¼ cups unsalted chicken stock
- 1½ teaspoons kosher salt
- 1 teaspoon freshly ground black pepper
- ½ cup chopped fresh flat-leaf parsley
- 1 (5-ounce) package dried sweet cherries, chopped

1. Melt the butter in a large skillet over medium-high. Add the onion and carrot; sauté 4 minutes or until the onion begins to brown. Stir in the rice and almonds; sauté 3 minutes. Add the stock, salt, and pepper; bring to a boil.

2. Cover, reduce the heat to low, and cook until the liquid is absorbed and rice is tender, 16 minutes. Remove from the heat; stir in the parsley and cherries.

RED QUINOA SALAD
WITH BEETS, KALE & PARMESAN

This colorful salad combines superfoods quinoa and kale with iron-rich beets, toasty pecans, and nutty Parmesan.

- 1 cup uncooked red quinoa
- 1¼ cups water
- ¼ cup extra-virgin olive oil
- 2½ tablespoons sherry vinegar
- 2 teaspoons honey
- ½ tablespoon finely minced shallot
- 1 teaspoon chopped fresh thyme
- 1 garlic clove, minced
- ¼ teaspoon table salt
- ¼ teaspoon freshly ground black pepper
- 2 packed cups thinly sliced lacinato kale
- ⅓ cup lightly toasted chopped pecans
- 10 ounces golden or candy-stripe beets, peeled and thinly sliced
- ½ cup shaved Parmesan cheese (2 ounces)

1. Soak the quinoa in cold water to cover 15 minutes; drain. Bring 1¼ cups water to a boil in a medium saucepan; stir in the quinoa. Cover and simmer 15 minutes. Remove the pan from the heat; let stand, covered, 5 minutes. Fluff the quinoa with a fork; scrape into a large bowl.

2. Whisk together the oil and next 7 ingredients in a small bowl. Add the kale, pecans, and beets to the quinoa; toss gently to combine. Drizzle with the vinaigrette, and toss gently to coat. Top with the cheese.

CHARRED EGGPLANT
WITH SALSA VERDE & BOCCONCINI

Bring the heat and char Japanese eggplant until it becomes crisp and creamy on the grill. A drizzle of herb-laden salsa verde and little balls of fresh mozzarella rounds out the flavors. This is terrific pairing for the Grilled Whole Fish with Chermoula (page 154).

SALSA VERDE
¼ cup finely chopped shallots (from 1 large shallot)

3 tablespoons red wine vinegar

2 tablespoons drained capers, chopped

2 medium garlic cloves, minced (about 2 teaspoons)

2 anchovy fillets, minced

¾ cup extra-virgin olive oil

½ cup chopped fresh flat-leaf parsley

½ cup chopped fresh cilantro

¼ cup chopped fresh tarragon

VEGETABLES
3 (6-ounce) Japanese eggplants, halved lengthwise

1 (7-ounce) red bell pepper, halved lengthwise and seeded

1 (7-ounce) yellow bell pepper, halved lengthwise and seeded

6 scallions

¼ cup olive oil

2 teaspoons kosher salt

1 teaspoon black pepper

ADDITIONAL INGREDIENT
1 (7-ounce) container bocconcini cheese, drained

1. **PREPARE THE SALSA VERDE:** Combine the shallot, vinegar, capers, garlic, and anchovies in a bowl. Let stand 10 minutes. Stir in the olive oil, parsley, cilantro, and tarragon; set aside.

2. **PREPARE THE VEGETABLES:** Prepare a wood or charcoal grill. Place the eggplants, red bell pepper, yellow bell pepper, and scallions on a rimmed baking sheet. Drizzle with the olive oil; toss to coat. Sprinkle with the salt and pepper.

3. Place the eggplants and bell peppers on oiled grill grate over direct heat; grill, uncovered and turning occasionally, until charred, 2 to 3 minutes. Transfer the eggplants and bell peppers to indirect heat, and grill, covered, until just tender, 5 to 7 minutes. Transfer to a baking sheet; cover with aluminum foil to keep warm.

4. Place the scallions on grill grate over direct heat; grill, uncovered, 1 minute; turn the scallions. Grill, uncovered, until lightly charred and wilted, 1 to 2 minutes.

5. Roughly chop the peppers, and arrange on a platter with the eggplant and scallions; top with the bocconcini and Salsa Verde.

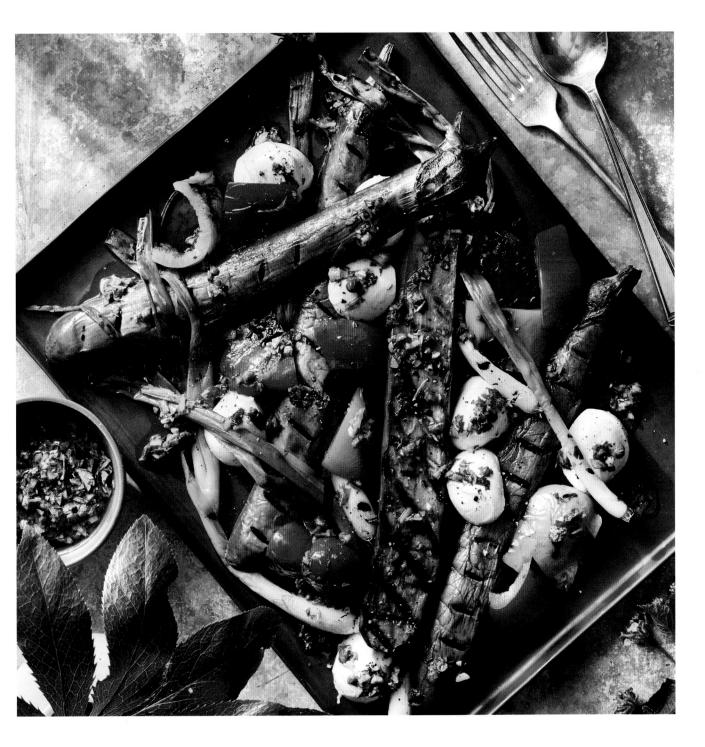

Anchovy fishing is the main livelihood of many locals in Vietnam's Phu Yen province. Boats cast nets wide and then "lasso" their catch.

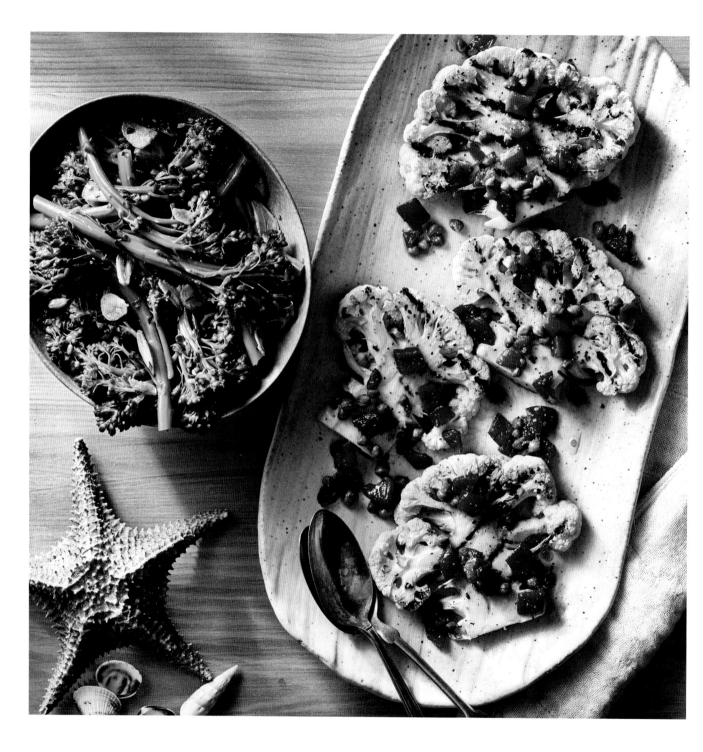

SPICY BROCCOLINI

This five-ingredient recipe is quick and easy to prepare and is an ideal side for grilled meats or seafood. Leftovers are lovely folded into an omelet.

2 pounds broccolini, ends trimmed

6 tablespoons (3 ounces) unsalted butter

3 garlic cloves, sliced

1 teaspoon table salt

½ teaspoon crushed red pepper

1. Cook the broccolini in boiling salted water to cover 4 to 7 minutes. Drain.

2. Melt the butter in a large skillet over medium-high. Add the garlic, salt, and red pepper; sauté 2 minutes. Add the broccolini, stirring to coat. Sauté 1 minute or until heated through.

GRILLED CAULIFLOWER

The brassica-averse may well become fans after a taste of these vegan "steaks" kissed with smoke and char and dressed in typical ribeye accents.

1 large head cauliflower

3 tablespoons olive oil

2 teaspoons lemon-pepper seasoning

1 roasted red bell pepper, diced

2 tablespoons capers

1. Preheat grill to medium-high (350° to 400°F). Cut the cauliflower into ½-inch-thick (ends) and ¼-inch-thick (middle) slices.

2. Brush the cauliflower generously with oil on both sides, and place on a baking sheet. Sprinkle with the lemon-pepper seasoning. (Place any small pieces of cauliflower on a piece of heavy-duty aluminum foil.)

3. Grill the cauliflower planks (and small pieces on foil) until tender, 5 minutes per side. Transfer to a serving platter, and sprinkle with the bell pepper and capers.

ELOTE-STYLE CORN
WITH COTIJA & SPICY CILANTRO CREAM

The secret to this grilled Mexican street corn is the tangy amchur (also spelled amchoor) powder, a tart spice made from dried green mangoes. Use it for curries, chutneys, and pickles, or wherever you want to add acidity to a recipe.

¼ cup mayonnaise
¼ cup sour cream
¼ teaspoon ancho chile powder
¼ teaspoon ground cumin
¼ teaspoon kosher salt
4 ounces Cotija cheese, crumbled (about 1 cup)
2 tablespoons chopped fresh cilantro

1 tablespoon thinly sliced fresh chives
1 tablespoon amchur powder (ground mango powder) or 1 tablespoon lime zest (from 2 limes)
6 ears fresh corn with husks

1. Stir together the first 5 ingredients in a bowl. Set aside.

2. Process the Cotija in a food processor until finely ground, about 20 seconds. Stir together the Cotija, cilantro, chives, and amchur powder in a small bowl; set aside.

3. Pull back the husks from corn (do not remove husks); remove and discard corn silk. Tie the husks of each ear of corn together with kitchen twine to form a handle.

4. Preheat a grill to medium-high (350° to 400°F). Place the corn, husk handles up, in a large stockpot of cold salted water. (Make sure ears of corn are completely submerged.) Soak 10 minutes; drain.

5. Grill the corn until well charred on all sides, about 10 minutes, turning occasionally.

6. Brush the corn with the mayonnaise mixture, and sprinkle with the Cotija mixture. Serve immediately.

TOASTY MACADAMIA NUT GREEN BEANS

Up your green bean side dish game by swapping the usual toasted pecan garnish with rich, buttery macadamias for an island twist.

1½ pounds haricots verts (French green beans), trimmed
1 teaspoon kosher salt
½ teaspoon black pepper
¼ cup olive oil

2 shallots, thinly sliced
2 teaspoons lemon zest plus 1 tablespoon fresh juice (from 1 lemon)
½ cup chopped toasted macadamia nuts

1. Preheat the broiler with oven rack 6 inches from heat. Line a rimmed baking sheet with aluminum foil. Toss the haricots verts with salt, pepper, and 2 tablespoons of the oil. Spread in an even layer on prepared baking sheet. Broil until the beans are blistered, about 6 minutes, stirring after 3 minutes.

2. Heat the remaining 2 tablespoons oil in a small skillet over medium-high. Add the shallots, and cook, stirring often, until golden brown, about 5 minutes. Transfer to a plate lined with paper towels to drain.

3. Place the haricots verts in a serving bowl, and toss with the zest and juice. Sprinkle with the shallots and macadamia nuts.

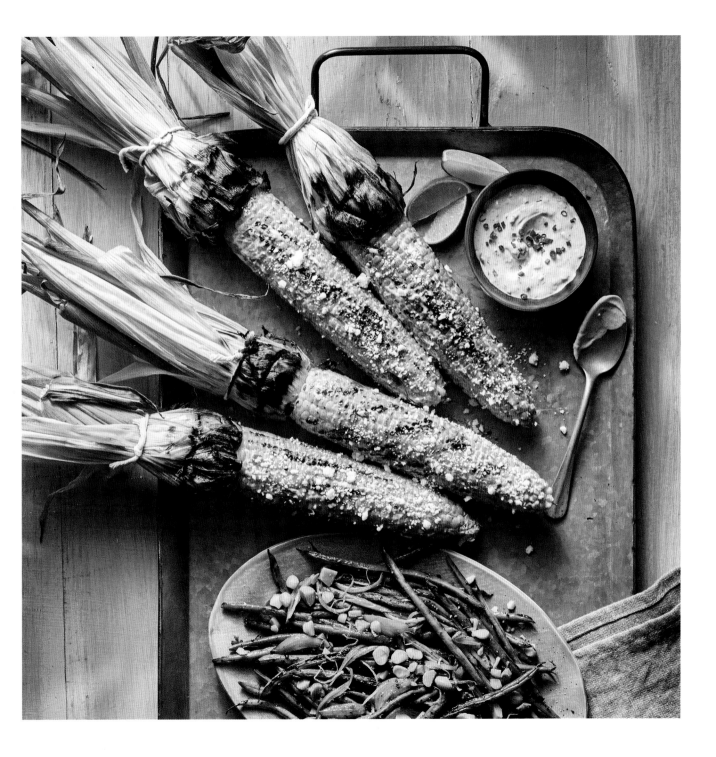

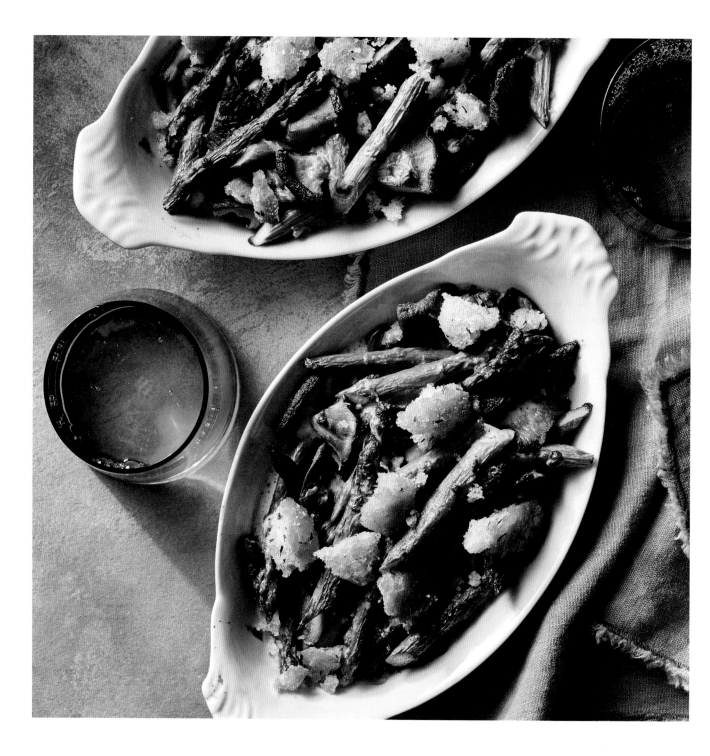

ASPARAGUS & SHIITAKE GRATIN

The gratin gets its name from the French word *gratter* which means to grate. The gratings of cheese and bits of bread create the rich flavor and crisp crust that is a delicious must. Shiitakes add an earthy element to this comforting dish.

8 garlic cloves

5 tablespoons (2½ ounces) salted butter

1 cup torn French bread

½ teaspoon lemon zest

4 teaspoons chopped thyme

1½ tablespoons all-purpose flour

1½ cups whole milk

⅛ teaspoon grated nutmeg

1¼ teaspoons kosher salt

¾ teaspoon black pepper

2 cups quartered shiitake mushroom caps (about 5 ounces)

½ pound medium-size fresh asparagus, trimmed and cut diagonally into 2-inch pieces

⅓ cup chicken stock

1. Crush 5 of the garlic cloves and cook with 3 tablespoons of the butter in a large nonstick skillet over medium-high, stirring occasionally, until the garlic begins to brown, about 4 minutes. Remove from the heat; let stand 10 minutes. Remove the garlic with a slotted spoon; discard.

2. Heat the garlic-infused butter in skillet over medium. Stir in the torn bread, zest, and 2 teaspoons of the thyme. Cook, stirring often, until toasted, 2 to 3 minutes. Remove the breadcrumbs from the skillet; wipe the skillet clean.

3. Whisk together the flour and ¼ cup of the milk in a small bowl until smooth. Combine the flour mixture and remaining 1¼ cups milk in a small saucepan. Bring to a boil over medium-high; reduce the heat to medium-low, and cook, whisking often, until thickened and reduced to about ½ cup, about 20 minutes. Remove from the heat. Stir in the nutmeg, ½ teaspoon of the salt, ¼ teaspoon of the pepper, and the remaining 2 teaspoons thyme.

4. Cook the remaining 2 tablespoons butter in the skillet over medium-high until butter sizzles, about 1½ minutes. Add the mushrooms; cook, stirring, until lightly browned, 3 to 4 minutes. Thinly slice the remaining 3 garlic cloves. Add the asparagus and sliced garlic to the mushrooms; cook, stirring often, 3 minutes. Add the stock, and bring to a boil. Cook, stirring occasionally, until the liquid has evaporated and asparagus is tender, about 2 minutes. Stir in the remaining ¾ teaspoon salt and ½ teaspoon pepper.

5. Preheat the broiler with oven rack 6 inches from heat. Spread the milk mixture in a small oval gratin dish; top with the mushroom mixture. Broil until bubbly, about 2 minutes. Remove from the oven, and top with the breadcrumbs.

POTATO-LEEK GRATIN

A mix of Gruyère and Parmesan adds nutty richness to this cheesy gratin. Fresh rosemary adds a woodsy flavor note.

2 tablespoons butter
2 leeks, sliced
3 garlic cloves, minced
1 tablespoon chopped fresh
 rosemary
2 teaspoons sea salt
1 teaspoon cracked black
 pepper
2 pounds Yukon Gold
 potatoes, very thinly
 sliced

2 cups heavy cream
1 cup whole milk
1 cup shredded Gruyère
 cheese (4 ounces)
½ cup grated Parmesan
 cheese (2 ounces)
Garnish: fresh rosemary
 leaves

1. Preheat the oven to 400°F. Melt the butter in a large, deep skillet or saucepan over medium-high. Add the leeks and garlic; sauté until tender, 5 to 7 minutes. Stir in the rosemary, sea salt, and pepper.

2. Add the potatoes, cream, and milk to leek mixture in pan, stirring gently to combine. Bring the mixture to a boil, reduce heat, and simmer, uncovered, 10 to 15 minutes or until the potatoes are barely tender. (Do not overcook. Potatoes should be pliable, but not fully cooked.)

3. Spoon half of the potato mixture into a lightly greased 2½-quart baking dish. Sprinkle with ½ cup of the Gruyère cheese and ¼ cup of the Parmesan. Top with remaining potato mixture; sprinkle with remaining cheeses. (May be covered and refrigerated overnight. Let come to room temperature before baking.)

4. Bake at 400°F until potatoes are tender and top is golden brown, 20 to 30 minutes. Garnish, if desired.

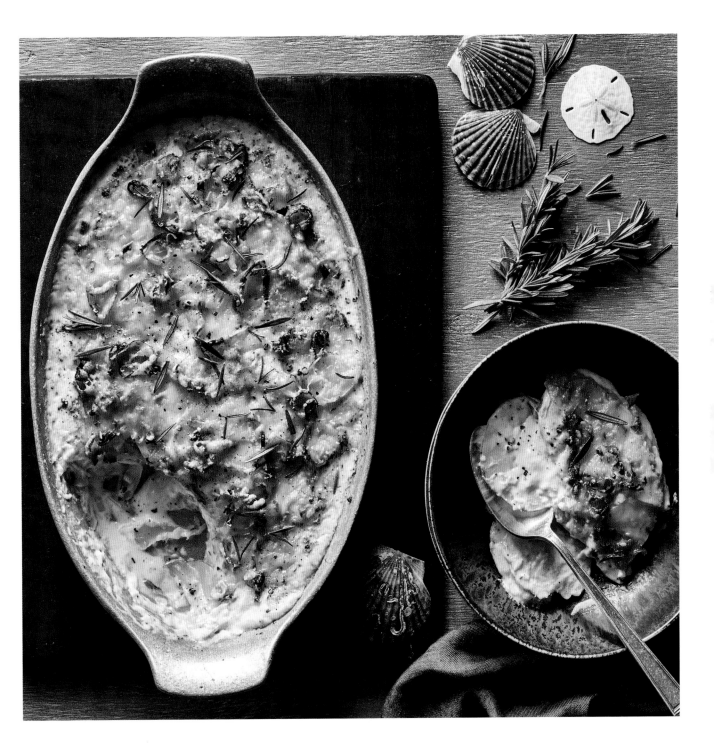

05.
BOARDWALK BAKERY

SAVORY BREADS,
ROLLS, AND SWEET
TREATS TO ROUND
OUT ANY MEAL

SIMPLE & SAVORY GARLIC BREAD

Perfect for toasting to pair with a bowl of soup or as a hearty addition to round out a salad lunch, this crusty garlic bread is easy and delicious.

½ cup (4 ounces) unsalted butter, at room temperature

2 garlic cloves, minced

2 tablespoons finely chopped flat-leaf parsley

2 tablespoons finely chopped oregano leaves

1 teaspoon kosher salt

½ teaspoon freshly ground black pepper

1 baguette or ciabatta loaf

Extra-virgin olive oil, for drizzling

1. Preheat the oven to 350°F.

2. In a small bowl, combine the softened butter, minced garlic, finely chopped parsley and oregano, salt, and freshly ground black pepper.

3. Slice the baguette or ciabatta loaf in half horizontally. Spread the butter mixture on the cut sides of both halves; drizzle with the olive oil. Wrap the bread in aluminum foil, and bake at 350°F for 10 minutes.

TAPENADE TWISTS

Salty snacks are a favorite cocktail hour nibble. These flaky, flavorful twists pull out all the stops.

¾ cup grated Parmesan cheese (about 3 ounces)

1 cup pitted Kalamata olives

1 tablespoon fresh rosemary

2 tablespoons chopped fresh basil

1 teaspoon chopped anchovies or ½ teaspoon anchovy paste

½ (17.3-ounce) package frozen puff pastry sheets, thawed

1. Preheat the oven to 400°F. Grease a baking sheet. Process the first 5 ingredients in a food processor until smooth. Unfold the pastry sheet onto a lightly floured surface. Roll into a 12- x 10-inch rectangle.

2. Spread the olive mixture onto the lengthwise half of the rectangle to within 1 inch of the long edge; fold the pastry over the filling. Roll gently with a rolling pin; pinch the edges to seal. Cut crosswise into ½-inch strips. Twist the strips and place on the prepared baking sheet.

3. Bake at 400°F for 15 minutes. Transfer to a wire rack to cool.

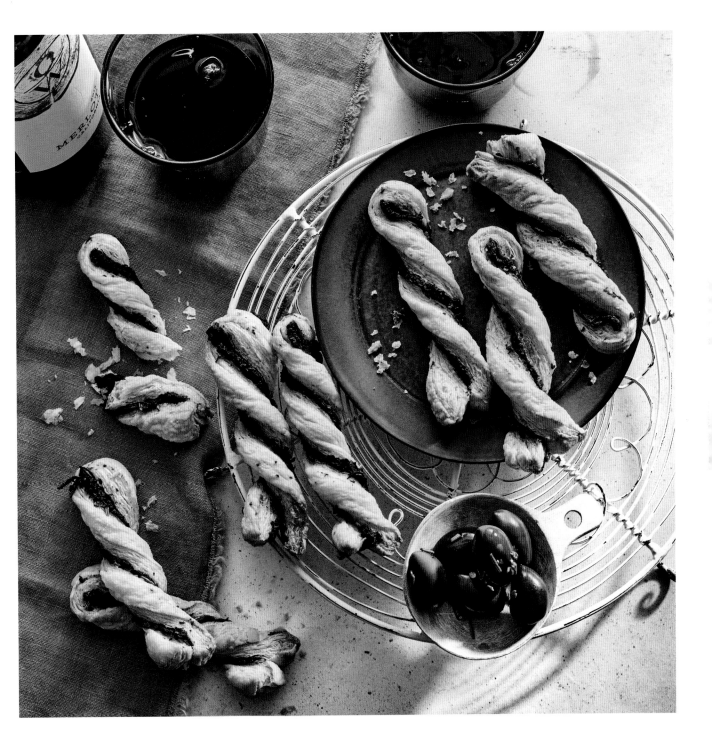

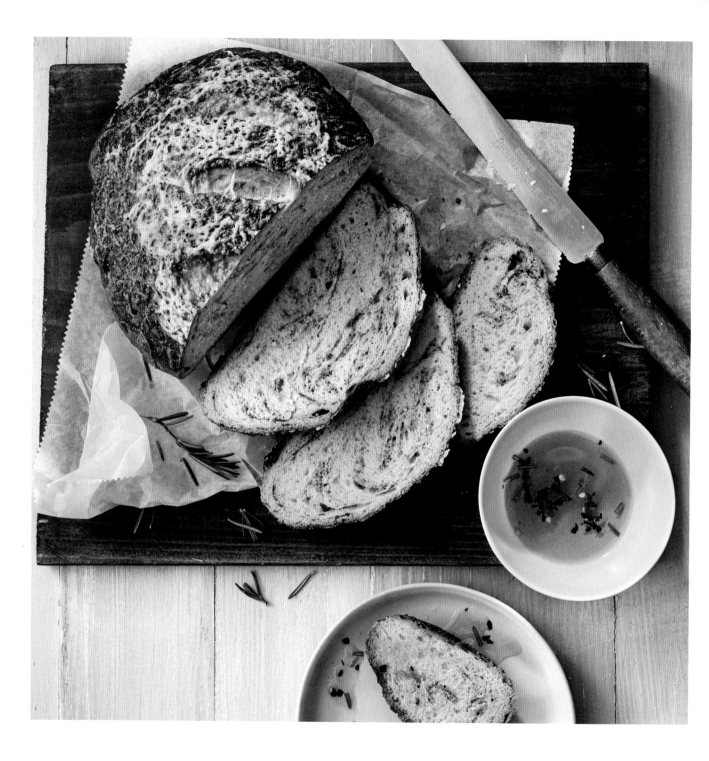

ASIAGO-ROSEMARY-PEPPER BREAD

This crusty, rustic bread is fantastic served warm with olive oil for dipping, but also terrific toasted for breakfast or layered with deli meats and cheeses for a mouthwatering sandwich.

1 (¼-ounce) envelope or 2½ teaspoons active dry yeast

2 teaspoons granulated sugar

1 cup warm water (105° to 110°F)

¼ cup extra-virgin olive oil

3¼ cups (about 13⅞ ounces) bread flour

1 tablespoon chopped fresh rosemary

1 tablespoon cracked black pepper

1 teaspoon kosher salt

1½ cups shredded Asiago or Parmesan cheese (6 ounces)

1 large egg, lightly beaten

1. Dissolve the yeast and sugar in warm water in a large bowl; let stand 5 minutes. Stir in the olive oil, flour, and the next 3 ingredients until a soft dough forms.

2. Turn the dough out onto a lightly floured surface. Knead in 1 cup of the cheese; knead 5 minutes or until smooth and elastic. Shape the dough into a ball, and place in a lightly greased bowl, turning to grease top. Cover and let rise in a warm (80° to 85°F) place, free from drafts, until doubled in size, 45 minutes. Punch dough the down.

3. Shape the dough into a round loaf, and place on the bottom of bread cloche sprinkled with flour. Cover with bread cloche dome lid. Let rise 25 minutes.

4. Preheat the oven to 450°F. Cut 3 or 4 (¼-inch-wide) slits into the top of loaf. Combine the egg and 1 tablespoon water; brush on top of the dough. Sprinkle the loaf with remaining ½ cup cheese. Bake at 450°F, covered with bread cloche dome lid, until the loaf sounds hollow when tapped, about 45 minutes; let cool.

Surfers ride Hawaii's big waves the way diners all over the world devour Hawaii's sweet Portuguese rolls.

SWEET PORTUGUESE ROLLS

When you say "bread" in Hawaii, Portuguese sweet bread is what comes to most locals' minds. It all started at Robert R. Taira's tiny bakery in Hilo in the 1950s, which soon expanded to Honolulu's King Street. Today, the bakery also operates in Torrance, California, and Oakwood, Georgia. It's still a family business. The third generation of Tairas has made the fluffy sweet bread an American staple, with King's Hawaiian now the No. 1 branded dinner roll in the United States.

2½ cups (about 8½ ounces) all-purpose flour
½ cup (about 2¾ ounces) potato flour
6 tablespoons (3 ounces) unsalted butter, softened
⅓ cup granulated sugar
2 (¼-ounce) envelopes instant-rise yeast (4½ teaspoons)
½ cup milk
5 large egg yolks
¼ cup plus 1 tablespoon water
1½ teaspoons kosher salt
1 large egg, lightly beaten
2 tablespoons pretzel salt

1. Combine the flours, butter, sugar, and yeast in the bowl of a stand mixer fitted with a dough hook attachment. Beat on low until very well combined, about 1 minute. Add the milk, egg yolks, and ¼ cup of the water. Increase the speed to high, and beat 3 minutes. Add the kosher salt; beat until the dough starts to come together, 1 minute. Turn the dough out onto a lightly floured surface, and knead until a supple, shiny dough forms, about 3 minutes. Shape the dough into a ball, and place in a large bowl coated with cooking spray, turning to grease dough. Cover the bowl with plastic wrap, and let rise in a warm (80° to 85°F) place, free from drafts, until doubled in size, about 1 hour and 30 minutes.

2. Divide the dough into 16 equal (2-ounce) portions. Roll each into a ball. Place in a 9-inch metal baking pan coated with cooking spray. Cover with plastic wrap; let rise in a warm (80° to 85°F) place, free from drafts, until very puffy, about 1 hour.

3. Preheat the oven to 325°F. Whisk together the egg and remaining 1 tablespoon water. Remove the plastic wrap from the rolls, and brush the tops of the rolls with the egg mixture; sprinkle with pretzel salt. Bake at 325°F until golden brown and a thermometer inserted into the center of the rolls registers 190°F, 30 to 35 minutes. Cool in the pan on a wire rack 10 minutes. Remove and serve.

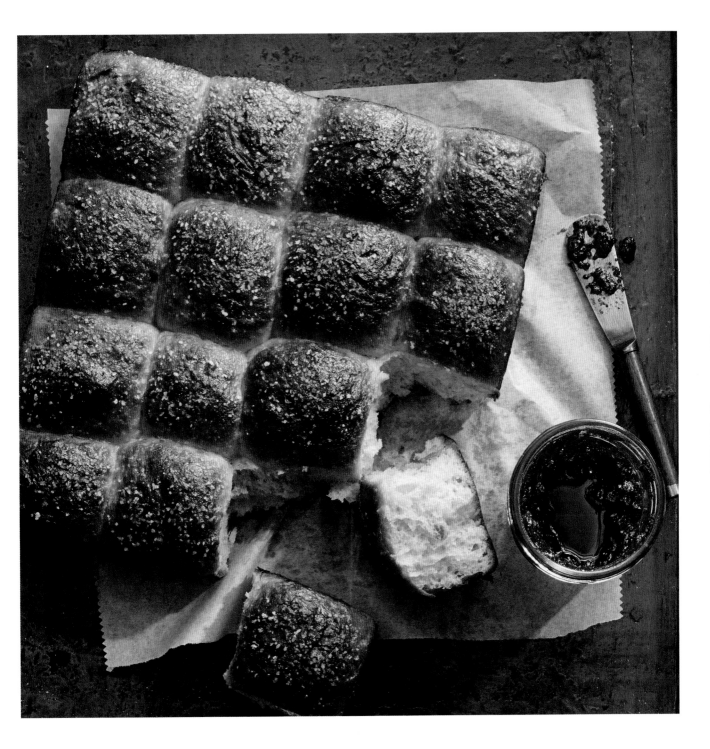

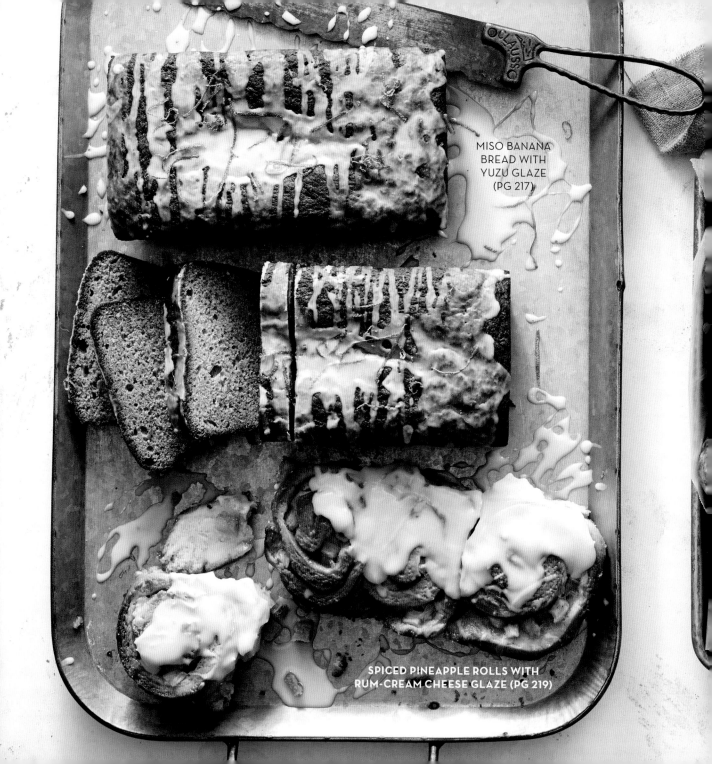

MISO BANANA
BREAD WITH
YUZU GLAZE
(PG 217)

SPICED PINEAPPLE ROLLS WITH
RUM-CREAM CHEESE GLAZE (PG 219)

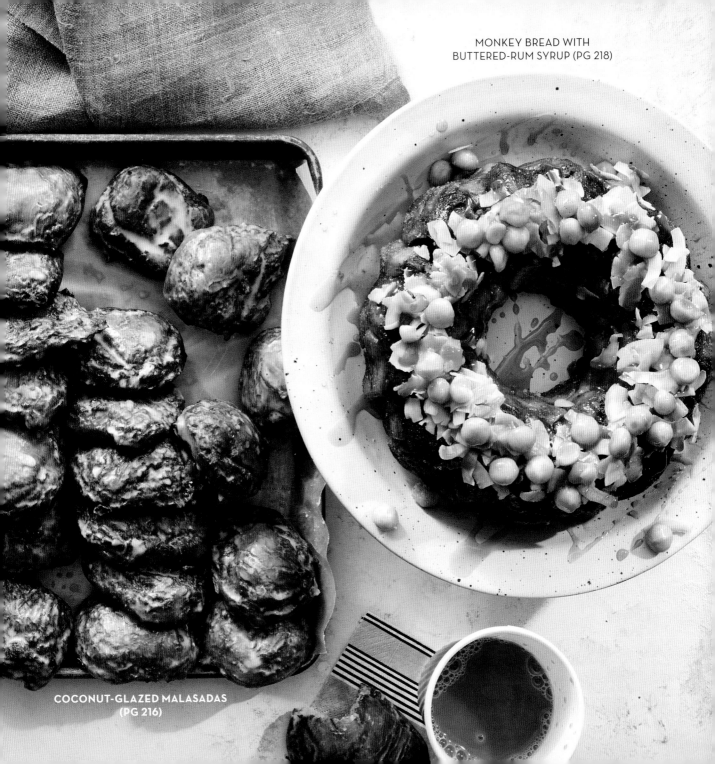

MONKEY BREAD WITH
BUTTERED-RUM SYRUP (PG 218)

COCONUT-GLAZED MALASADAS
(PG 216)

COCONUT-GLAZED MALASADAS

A Portuguese import, malasadas are holeless doughnuts enriched with butter, eggs, and often milk. Although typically only rolled in sugar, variations include those filled with custard or *haupia*, a kind of coconut pudding.

2 tablespoons hot water (115°F)

1 (¼-ounce) envelope active dry yeast

½ cup granulated sugar

3 large eggs

½ cup whole milk

½ cup half-and-half

2 tablespoons unsalted butter, melted

1 teaspoon kosher salt

4 cups (about 17 ounces) bread flour, sifted

Canola oil

Coconut Glaze (recipe follows)

1. Combine the water, yeast, and 1 teaspoon of the sugar in a bowl, and let stand until foamy, about 10 minutes; set aside. Beat the eggs in a mixer fitted with the paddle attachment on medium speed until fluffy, about 2 minutes. Add the yeast mixture, milk, half-and-half, butter, salt, and remaining sugar; beat until combined. Gradually add the flour; beat until dough is smooth, about 2 minutes. Transfer to a lightly greased bowl, and cover loosely with plastic wrap; let rise in a warm (80° to 85°F) place, free from drafts, until doubled in size, about 1 hour and 30 minutes.

2. Grease 2 parchment paper–lined baking sheets. On a lightly floured surface, roll the dough into a 12-inch square about ½ inch thick. Using a knife, cut the dough into 2-inch squares; gather and reuse scraps. Place on the prepared baking sheets 3 inches apart; cover loosely with plastic wrap, and let stand in a warm (80° to 85°F) place, free from drafts, until doubled in size, about 30 minutes.

3. Heat 2 inches of oil in a 6-quart saucepan over medium-high to 350°F. Using scissors, cut paper around each malasada, leaving about 1 inch of paper around the sides of each. (The paper makes it easier to transfer to frying oil.) Working in batches, place the malasadas in the hot oil, paper side up, using tongs to peel off and discard paper. Cook until puffed and golden, 2 to 3 minutes, flipping once. Transfer to a wire rack set inside a baking sheet; let cool completely, about 20 minutes. Dip each malasada in the Coconut Glaze; serve immediately.

COCONUT GLAZE

1½ cups (6 ounces) powdered sugar

3 tablespoons whole milk

1 tablespoon fresh lemon juice (from 1 lemon)

1 teaspoon coconut extract

Whisk together the powdered sugar, milk, lemon juice and coconut extract in a bowl until smooth. **Makes about ½ cup**

MISO BANANA BREAD
WITH YUZU GLAZE

Transform overripe bananas into this new take on the breakfast classic, infused with umami-laden white miso and drizzled with citrusy yuzu glaze.

1 cup (8 ounces) unsalted butter, softened

¼ cup white miso

2 cups packed light brown sugar

3 large eggs

1 teaspoon vanilla extract

3¼ cups (about 13⅞ ounces) all-purpose flour

¾ teaspoon baking powder

¾ teaspoon baking soda

¾ teaspoon kosher salt

¼ teaspoon ground nutmeg

2 cups mashed ripe bananas (about 5 medium bananas)

Yuzu Glaze (recipe follows)

Garnish: lime zest

1. Preheat the oven to 350°F. Lightly grease 2 (8- x 4-inch loaf pans with cooking spray. Beat the butter and miso with a mixer on medium speed until creamy; add the brown sugar, and beat until light and fluffy. Add the eggs, 1 at a time, beating just until blended after each addition. Add the vanilla, and beat just until blended.

2. Stir together the flour, baking powder, baking soda, salt, and nutmeg. Gradually add the flour mixture to the butter mixture, beating at low speed just until blended. Stir in the bananas just until blended. Spoon the batter into the prepared loaf pans, filling three-fourths full.

3. Bake at 350°F until a wooden pick inserted in the center comes out clean, about 1 hour. Cool in the pans on a wire rack 10 minutes. Remove, and cool completely, about 30 minutes. Drizzle each loaf with Yuzu Glaze. Garnish as desired.

YUZU GLAZE

1½ cups (6 ounces) powdered sugar

2½ tablespoons bottled yuzu juice

Whisk together the powdered sugar and yuzu juice until smooth. **Makes ½ cup**

MONKEY BREAD
WITH BUTTERED-RUM SYRUP

The pull-apart nature of monkey bread makes it easy to dive right in, especially with the prospect of licking the buttered-rum syrup off of your fingers.

1¼ cups granulated sugar

2¼ teaspoons ground cinnamon

1 (1-pound, 9-ounce) package frozen Parker house-style yeast roll dough (such as Bridgford)

¾ cup (6 ounces) unsalted butter, melted

Buttered-Rum Syrup (recipe follows)

½ cup toasted macadamia nuts

¼ cup toasted unsweetened shredded coconut

1. Preheat the oven to 375°F. Lightly grease a 12-cup Bundt pan with cooking spray. Combine the sugar and cinnamon in a medium bowl. Set aside.

2. Place the roll dough 1 inch apart on a lightly greased baking sheet; cover and let rise in a warm (80° to 85°F) place, free from drafts, until the dough is thawed and doubled in size, about 1 hour.

3. Cut each roll dough in half. Dip dough halves in the melted butter; toss in the sugar-cinnamon mixture, and arrange in the prepared Bundt pan, overlapping slightly. Bake at 375°F until golden brown, about 25 minutes. Cool in the pan 5 minutes; invert onto a wire rack, and cool 15 minutes.

4. Drizzle the top of the warm bread with 2 to 3 tablespoons Buttered-Rum Syrup. Stir together the macadamia nuts and coconut, and sprinkle over the bread. Serve immediately with the remaining Buttered-Rum Syrup.

BUTTERED-RUM SYRUP

1 cup pure maple syrup

2 tablespoons unsalted butter

2 tablespoons dark rum

Cook the maple syrup with butter in a small saucepan over medium, stirring until the butter melts. Stir in 2the rum; use immediately. **Makes 1 cup**

SPICED PINEAPPLE ROLLS
WITH RUM-CREAM CHEESE GLAZE

These Hawaiin-inspired cinnamon rolls are a sweet addition to a weekend brunch.

½ cup warm whole milk (110°F)

⅓ cup granulated sugar

2 (¼-ounce) envelopes active dry yeast

4 cups (17 ounces) all-purpose flour

1½ teaspoons kosher salt

¾ cup (6 ounces) unsalted butter, softened

3 large eggs, at room temperature

¾ teaspoon canola oil

⅓ cup packed light brown sugar

½ teaspoon pumpkin pie spice

⅓ cup pineapple preserves

1 tablespoon orange zest

1½ cups chopped fresh pineapple, well drained

Rum-Cream Cheese Glaze (recipe follows)

1. Combine the milk, sugar, and yeast in the bowl of a mixer; let stand 5 minutes or until foamy. Beat on low speed; gradually add 1 cup of the flour, beating until blended and scraping down the sides of the bowl as needed. Add the salt and 6 tablespoons of the butter; beat at low speed until smooth. Add the eggs, 1 at a time, beating until incorporated and scraping down the sides of the bowl as needed. Gradually add the remaining 3 cups flour, beating until blended. Increase the mixer speed to medium; beat until the dough forms a ball and begins to pull away from the sides of the bowl. Beat 4 more minutes or until the dough is smooth and elastic.

2. Coat the inside of a large bowl with the canola oil. Place the dough in the bowl, turning to grease the top. Cover with plastic wrap; let stand in a warm (80° to 85°F) place, free from drafts, until dough doubles in size, 1 hour. Punch the dough down and transfer to a lightly floured surface. Roll the dough into a 16- x 12-inch rectangle.

3. Lightly spray a 13- x 9-inch glass or ceramic baking pan with cooking spray, and line it with parchment paper. Whisk together the brown sugar and pumpkin pie spice in a small bowl. Whisk together the preserves, orange zest, and remaining 6 tablespoons butter in a medium bowl. Spread the butter mixture evenly over the dough, leaving a 1-inch border; sprinkle with the brown sugar mixture and pineapple, pressing lightly to adhere. Roll up the dough, jelly-roll style, starting at 1 long side. Cut crosswise into 12 even slices. Arrange in the prepared baking pan. Cover with plastic wrap; let stand in a warm (80° to 85°F) place, free from drafts, 45 minutes.

4. Preheat the oven to 325°F. Uncover the dough. Bake until golden, 25 to 30 minutes. Let cool 10 minutes. Drizzle with the Rum-Cream Cheese Glaze.

RUM-CREAM CHEESE GLAZE

1 cup sifted powdered sugar

3 ounces softened cream cheese

1 tablespoon (½ ounce) spiced rum

½ teaspoon vanilla extract

2 tablespoons whole milk

Combine powdered sugar, cream cheese, rum, and vanilla extract in a large bowl. Beat with a mixer at medium speed until smooth. Stir in milk, 1 teaspoon at a time, until the glaze reaches desired consistency. **Makes 1½ cups**

PINK LEMONADE ICEBOX CAKE

Delicate, thin purchased cookies are the secret to this stunning no-cook dessert. Look for options from brands like Murray or Uncle Al's.

6 ounces fresh raspberries

7 tablespoons fresh lemon juice

4 cups heavy cream

12 ounces cream cheese, softened

1¼ cups powdered sugar

2 tablespoons lemon zest

3 (10½-ounce) packages thin butter cookies

1 lemon, thinly sliced (optional)

1. Process the raspberries and 1 tablespoon of the lemon juice in a food processor 30 seconds or until very smooth. Strain the raspberry mixture through a fine mesh strainer; discard the solids.

2. Beat the cream with a mixer at medium-high speed just until soft peaks form; set aside. Combine the cream cheese, raspberry mixture, remaining 6 tablespoons lemon juice, and sugar in a large bowl; beat at medium-high speed 3 minutes or until pale and smooth. Gently fold in the whipped cream and lemon zest.

3. Arrange the cookies in a 9-inch circle, edges touching, to create a single layer on a 10-inch cake stand. Carefully spread 1½ cups of the cream mixture over the cookies, leaving a ¼-inch border. Repeat to create 6 additional layers, finishing with the cream cheese mixture. Chill at least 4 hours. Top with the lemon slices, if desired.

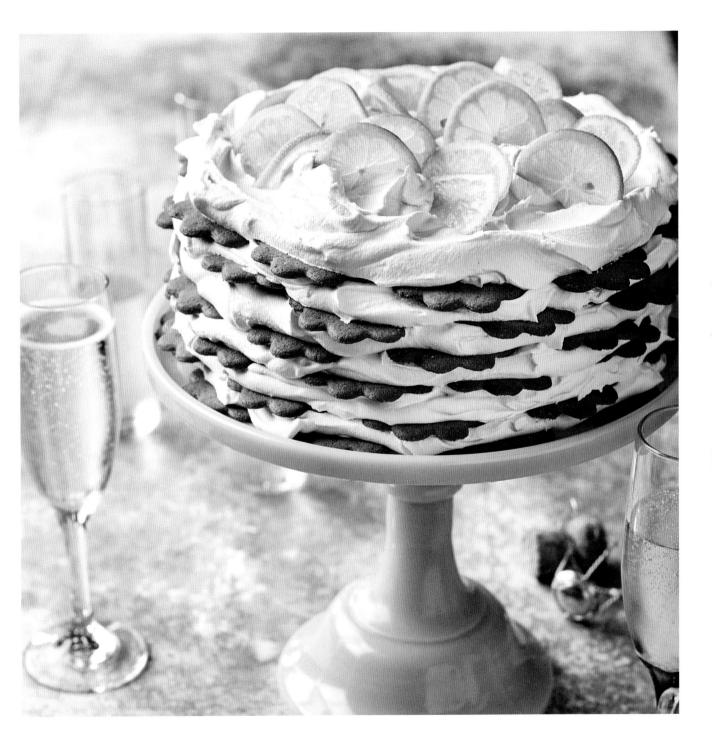

Key West
Historic
Chicken District

GUIDED TOURS
& FEEDINGS

©MacMoe 2004

A sign marking the tour route through the Historic Chicken District in Bahama Village, Key West, Florida.

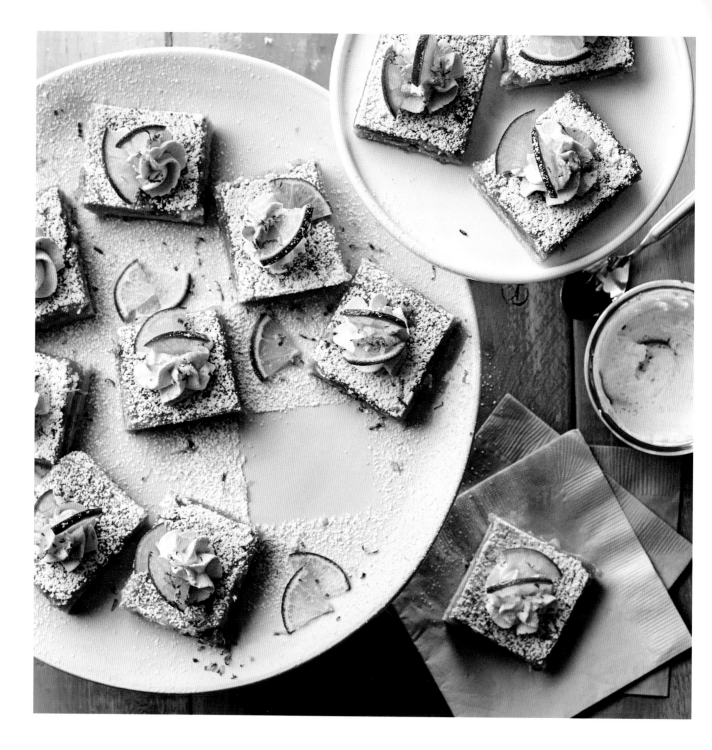

KEY LIME BARS

In this tropical take on traditional lemon squares, fresh Key lime juice takes center stage.

1 cup (8 ounces) butter, softened

2⅓ cups (about 10 ounces) all-purpose flour

½ cup powdered sugar

4 large eggs, lightly beaten

1¾ cups granulated sugar

1 teaspoon baking powder

¼ teaspoon kosher salt

¾ cup Key lime juice

Powdered sugar, for sprinkling

Garnish: lime zest, lime wedges and whipped cream

1. Preheat the oven to 350°F. Lightly grease an aluminum foil-lined 13- x 9-inch baking pan. Beat the butter with a mixer at medium speed until creamy. Gradually add 2 cups of the flour and ½ cup powdered sugar. Beat just until a smooth dough is formed. Press into the prepared baking pan. Bake at 350°F until lightly browned, 20 minutes.

2. Meanwhile, whisk together the eggs, remaining ⅓ cup flour, 1¾ cups sugar, and next 3 ingredients in a large bowl; pour over the baked crust. Bake at 350°F until set, 25 minutes. Let cool completely in pan; chill, if desired. Sprinkle with the powdered sugar, and cut into bars. Garnish as desired.

Cumulus clouds billow above the Golden Gate Bridge and golden hills of the Headlands on a blue sky day over the San Francisco Bay.

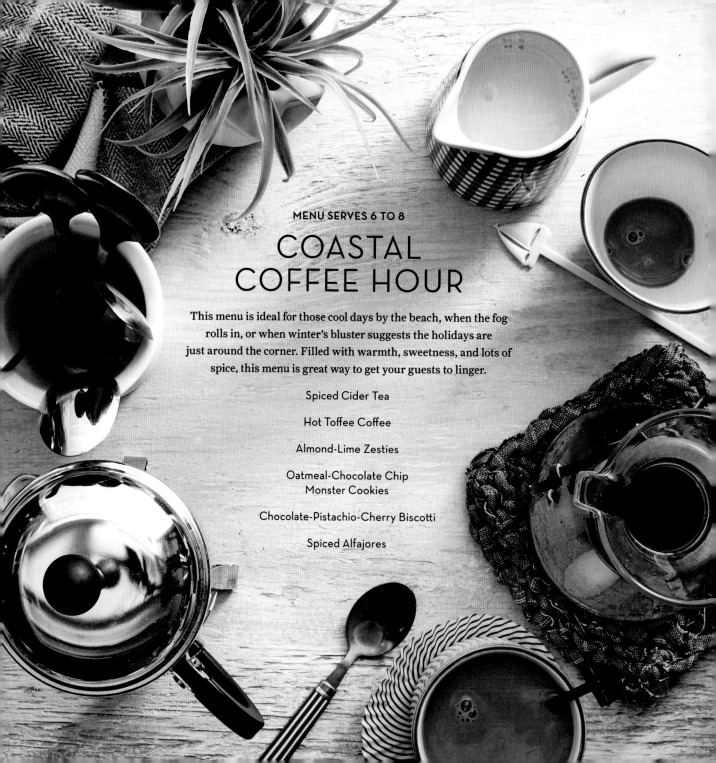

MENU SERVES 6 TO 8

COASTAL COFFEE HOUR

This menu is ideal for those cool days by the beach, when the fog
rolls in, or when winter's bluster suggests the holidays are
just around the corner. Filled with warmth, sweetness, and lots of
spice, this menu is great way to get your guests to linger.

Spiced Cider Tea

Hot Toffee Coffee

Almond-Lime Zesties

Oatmeal-Chocolate Chip
Monster Cookies

Chocolate-Pistachio-Cherry Biscotti

Spiced Alfajores

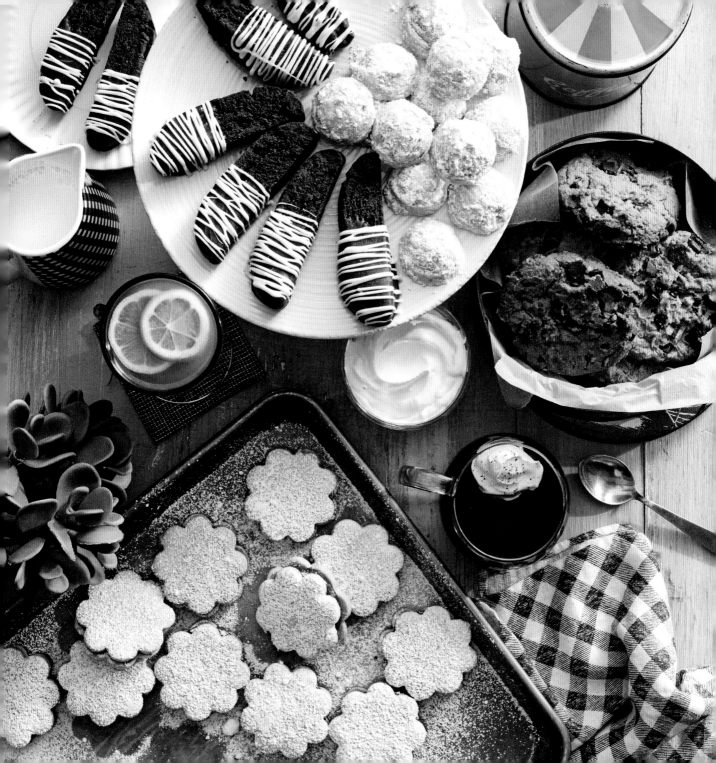

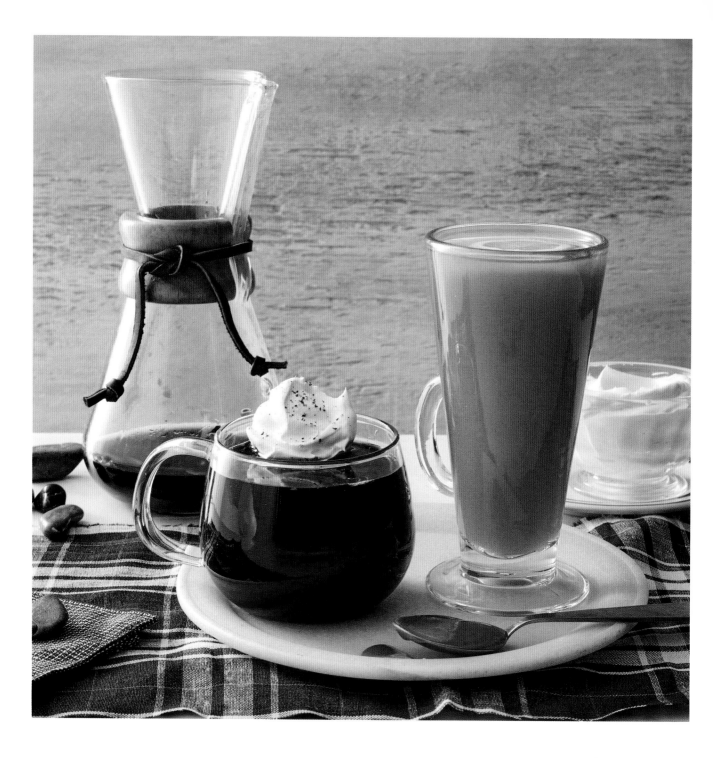

SPICED CIDER TEA

Enjoy sipping warm spiced cider around a crackling fire. Some versions are made with hard cider, but this recipe is family-friendly.

1 orange
1 lemon
2 cinnamon sticks
3 whole cloves
4 cups water

¼ cup packed light brown sugar
4 family-size tea bags
3 cups apple cider

1. Cut several layers of cheesecloth into 8-inch squares and stack them. Cut 3 (1-inch) strips of peel each from orange and lemon and place in the center of the cheesecloth stack. Add the cinnamon sticks and cloves. Wrap and secure with kitchen string.

2. Bring 4 cups water to a boil in a saucepan. Add the spice bundle and brown sugar; reduce heat, and simmer 10 minutes. Remove from the heat, and add the tea bags. Steep 5 minutes. Remove the spice packet and tea bags. Stir in the cider. Juice the orange and the lemon, and pour the juice into the cider mixture. Heat over medium until hot but not boiling. Serve warm.

HOT TOFFEE COFFEE

When Toffee Sauce inspired by a recipe from the Presidio Social Club combines with hot coffee, you end up with a soul-warming mug of absolute deliciousness. Double or triple this recipe depending on your crowd.

14 tablespoons (7 ounces) butter
¾ cup packed brown sugar
¼ teaspoon freshly grated nutmeg
1½ teaspoons ground cinnamon

¼ teaspoon ground cloves
¾ cup heavy cream
Hot brewed coffee
Whipped cream
Garnish: grated nutmeg, ground cinnamon, and ground cloves

1. Combine the butter, brown sugar, nutmeg, cinnamon, and cloves in a medium saucepan over medium and bring to a boil. Boil, stirring constantly, 1 minute. Stir in the cream; return to a boil. Remove from the heat, and strain.

2. Spoon a tablespoon or two of the sauce into mugs of hot coffee to serve. Top with whipped cream and garnish as desired.

MAKES 3 DOZEN HANDS-ON 20 MINUTES
TOTAL 45 MINUTES

ALMOND-LIME ZESTIES

With only five ingredients, these cookies are straightforward and simple to make for a delectable afternoon (or anytime) snack.

1 cup (8 ounces) butter
2 cups powdered sugar
1 tablespoon lime zest

2 cups (8½ ounces) all-purpose flour
½ cup finely ground almonds

1. Preheat the oven to 350°F. Line a baking sheet with parchment paper.

2. Beat the butter and 1 cup of the powdered sugar at low speed with a mixer until smooth. Beat in the lime zest. Add the flour and ground almonds gradually, beating until well blended. Chill 15 minutes.

3. Shape the dough into 1-inch balls; place 1 inch apart on the prepared baking sheet. Bake 350°F until light golden brown on the bottom, 10 minutes. Let stand on the baking sheet 2 minutes.

4. Roll the warm cookies in the remaining 1 cup powdered sugar, coating well. Let cool completely.

MAKES 18 COOKIES HANDS-ON 15 MINUTES
TOTAL 30 MINUTES PER BATCH

OATMEAL-CHOCOLATE CHIP MONSTER COOKIES

For a classic cookie that can't be beat (and that's ready in 30 minutes), this recipe is tops.

1 cup (8 ounces) butter, softened
¾ cup packed light brown sugar
¾ cup granulated sugar
2 large eggs
1 tablespoon vanilla extract
2 cups (8½ ounces) all-purpose flour

1 teaspoon baking soda
½ teaspoon kosher salt
2 cups uncooked quick-cooking oats or old-fashioned oats
1 (11.5-ounce) bag dark or semisweet chocolate chunks or chips

1. Preheat the oven to 325°F. Line 2 baking sheets with parchment paper.

2. Beat the butter and sugars with a mixer at medium speed until creamy. Add the eggs and vanilla, beating well.

3. Combine the flour, baking soda, salt, and oats in a bowl. Mix oat mixture into butter mixture. Add the chocolate.

4. Drop the batter by the ¼-cup, 4 inches apart, onto the baking sheets; flatten slightly. Bake at 325°F until centers are set, 15 minutes. Cool on the baking sheets 3 minutes. Transfer to wire racks to cool completely.

BEACH EATS 232 BOARDWALK BAKERY

CHOCOLATE-PISTACHIO-CHERRY BISCOTTI

Perhaps the most decadent and delicious biscotti you'll ever taste, one dozen of these make an excellent host or holiday gift.

- ½ cup (4 ounces) butter, softened
- 1 cup granulated sugar
- 3 large eggs
- 2 teaspoons vanilla extract
- 2 cups (8½ ounces) all-purpose flour
- ½ cup unsweetened cocoa
- 1 teaspoon baking soda
- ½ teaspoon kosher salt
- 1 cup pistachios, coarsely chopped
- 1 cup dried cherries, coarsely chopped
- 12 ounces semisweet chocolate or dark chocolate, melted
- 4 ounces white chocolate, melted (optional)

1. Preheat the oven to 350°F. Line 2 baking sheets with parchment paper.

2. Beat the butter and sugar with a mixer at medium speed until fluffy. Beat in the eggs and vanilla.

3. Combine the flour and next 3 ingredients in a large bowl. Add the flour mixture to the sugar mixture, beating until blended. Stir in the pistachios and cherries.

4. Place a half of the dough on each prepared baking sheet. Shape each half into a slightly rounded log about 10 x 3 inches using floured hands. (Dough will be very sticky.)

5. Bake at 350°F until the dough is firm to the touch, 25 to 30 minutes. Cool completely on the baking sheets on a wire rack.

6. Transfer the logs to a cutting board, and cut into ½- to ¾-inch-wide slices with a serrated knife. Place the slices, cut sides down, on a baking sheet. Bake until crisp 4 minutes per side. Transfer to wire racks to cool completely.

7. Dip the ends of the biscotti into the dark chocolate, and drizzle with the white chocolate, if desired. Place on wax paper to set. Store in an airtight container up to one week.

SPICED ALFAJORES

Prepared dulce de leche is spooned between these traditional Latin American cornstarch cookies. The result is magical!

2¼ cups cornstarch

1½ cups (about 6.4 ounces) all-purpose flour

2 teaspoons kosher salt

1 teaspoon baking powder

½ teaspoon ground cinnamon

¼ teaspoon cayenne

18 tablespoons (9 ounces) unsalted butter, cut into pieces and softened

10 tablespoons granulated sugar

4 large egg yolks

3 tablespoons orange juice

1 teaspoon vanilla extract

10 tablespoons prepared dulce de leche

3 tablespoons powdered sugar

1. Lightly spoon the cornstarch and flour into dry measuring cups and level with a knife. Whisk together the cornstarch, flour, salt, baking powder, cinnamon, and cayenne in a bowl.

2. Beat the butter and granulated sugar in a mixer at medium-high speed for 3 minutes or until light and fluffy. Reduce the speed to medium. Add the egg yolks, 1 at a time, beating well after each addition. Mix in the orange juice and vanilla. Add the flour mixture; beat at low speed until combined. Turn the dough out onto a lightly floured surface; press into a (1-inch-thick) rectangle. Wrap tightly with plastic wrap; chill 1 hour.

3. Preheat the oven to 350°F. Line 2 baking sheets with parchment paper.

4. Divide the dough in half. Roll half of the dough to ¼-inch thickness on a well-floured surface. Cut into 40 cookies with a 2-inch round, scalloped-edge cookie cutter, rerolling dough scraps as necessary. Arrange the cookies ½ inch apart on the prepared baking sheets. Bake at 350°F until the cookies are set, 10 minutes. (Edges will not brown.) Let cool completely on wire racks. Repeat with the remaining dough.

5. Flip 20 cookies over. Top each with 1½ teaspoons dulce de leche. Top with the remaining cookies, flat side down. Sift the powdered sugar over the sandwiched cookies.

DOUBLE-CHOCOLATE BREAD PUDDING

White chocolate, dark chocolate, French bread, and a Caramel-Coffee Sauce drizzle combine to make one irresistible end to any meal.

1 (16-ounce) French bread
 loaf, cubed
1 cup white chocolate chips
1 cup dark chocolate chips
4 large eggs
3 cups half-and-half

1 cup granulated sugar
1 tablespoon vanilla extract
¼ teaspoon kosher salt
Caramel-Coffee Sauce
 (recipe follows)

1. Combine the first 3 ingredients in a lightly greased 13- × 9-inch baking dish. Whisk together the eggs and next 4 ingredients in a large bowl. Pour the egg mixture over the bread mixture, pressing down to soak all pieces of bread. Let stand 30 minutes, or cover and refrigerate overnight.

2. Preheat the oven to 350°F. Bake the bread puddinguntil the edges are golden brown and center is set, 40 minutes. Let cool at room temperature 10 minutes. Serve warm with the Caramel-Coffee Sauce.

CARAMEL-COFFEE SAUCE

½ cup (4 ounces) butter
½ cup packed light brown
 sugar

1 cup heavy cream
¼ cup coffee liqueur

Combine butter, light brown sugar, and heavy cream in a saucepan. Bring to a boil, and cook 1 minute. Remove the pan from the heat, and stir in the coffee liqueur.
Makes 1½ cups

MEXICAN CHURROS

Pillowy churros dusted in cinnamon and sugar are delicious on their own or with the Smoked Chocolate Ice Cream in the following chapter for an intriguing pairing.

6 cups canola or peanut oil

2 teaspoons ground cinnamon

¾ cup granulated sugar

1 cup water

½ cup (4 ounces) unsalted butter

½ teaspoon kosher salt

1 cup (about 4¼ ounces) all-purpose flour

3 large eggs

Smoked Chocolate Ice Cream (page 251)

1. Heat the oil in a large, wide Dutch oven or cast-iron skillet over medium-high to 360°F.

2. Stir together the cinnamon and ¼ cup of the sugar in a shallow dish, and set aside. Combine the water, butter, salt, and remaining ½ cup sugar in a large saucepan. Cook over medium-high until the butter is melted, 3 to 4 minutes. Add the flour, and stir continuously with a wooden spoon or stiff rubber spatula until very smooth and a ball forms, about 1 minute. Remove from the heat.

3. Add the eggs, 1 at a time, stirring until completely blended after each addition. Transfer the mixture to a pastry bag fitted with a large star tip. Pipe 3- to 4-inch churros into hot oil, using a paring knife to cut to desired length. Fry until golden brown and crispy, 5 to 6 minutes, turning occasionally. Drain well on paper towels. Dredge the churros in the cinnamon mixture while still warm. Serve with the Smoked Chocolate Ice Cream.

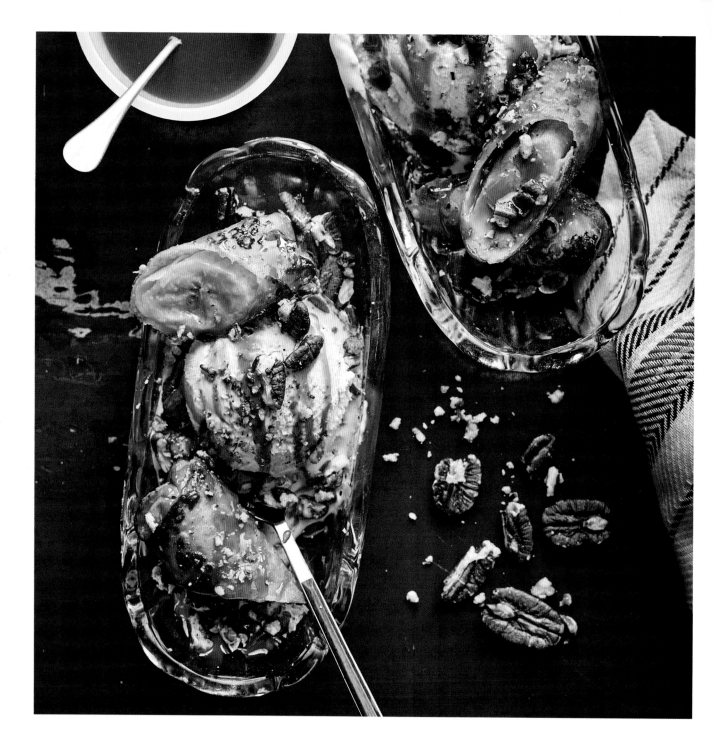

FRIED BANANAS FOSTER

The Big Easy's signature flaming banana and caramel dessert—invented at Brennan's in the French Quarter—gets a sweet and inventive update. Wrap baby bananas, available at Asian and Latin markets, in spring roll pastry wrappers, fry, and serve over ice cream—topping with caramel rum sauce (not optional).

BANANAS
1 cup granulated sugar
8 baby bananas or
 4 medium bananas
 (about 7 ounces each),
 cut into 4-inch lengths
8 (8-inch) square spring roll
 pastry wrappers (such as
 Spring Home)
1 large egg, beaten
3 quarts vegetable oil

SAUCE
1 cup packed dark brown
 sugar
½ cup (4 ounces) salted
 butter
6 tablespoons (3 ounces)
 rum
2 tablespoons heavy cream
2 teaspoons black pepper

ADDITIONAL
INGREDIENTS
½ cup toasted pecan
 halves
Butter-pecan ice cream or
 Homemade Vanilla Ice
 Cream (page 264)

1. PREPARE THE BANANAS: Place the granulated sugar in a shallow pie plate or baking dish. Toss the bananas in the sugar; shake off excess.

2. Place 4 spring roll wrappers on a work surface with 1 point facing you (so that they look like diamonds). Place 1 banana on each wrapper, 1 inch above the bottom point. Carefully begin wrapping the banana from the bottom up, keeping the roll as tight as possible. Fold in the sides of the wrapper (like a burrito). Brush 1 inch of top point with some of the beaten egg, and continue to wrap, pressing to secure roll. Repeat with remaining bananas, wrappers, and egg. Place the rolls in a single layer on a sheet pan lined with a damp paper towel. Freeze 1 hour.

3. Heat oil to 325°F in a large Dutch oven. Fry the banana rolls, 2 or 3 at a time, until golden brown, 6 to 7 minutes. Drain on paper towels.

4. PREPARE THE SAUCE: Cook the brown sugar and butter in a skillet over medium-high, whisking constantly, until melted and bubbly, 3 to 4 minutes. Tilt the pan away from you, and carefully add the rum, whisking until smooth. Remove the pan from the heat, and stir in the cream and pepper.

5. Slice the banana rolls in half diagonally. Spoon the sauce over top, sprinkle with the pecans, and serve with the ice cream.

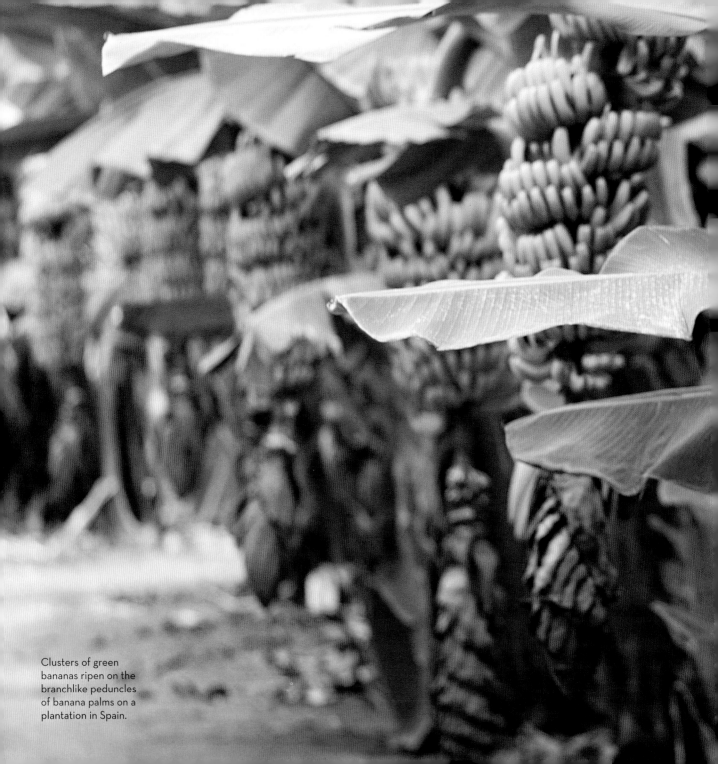

Clusters of green bananas ripen on the branchlike peduncles of banana palms on a plantation in Spain.

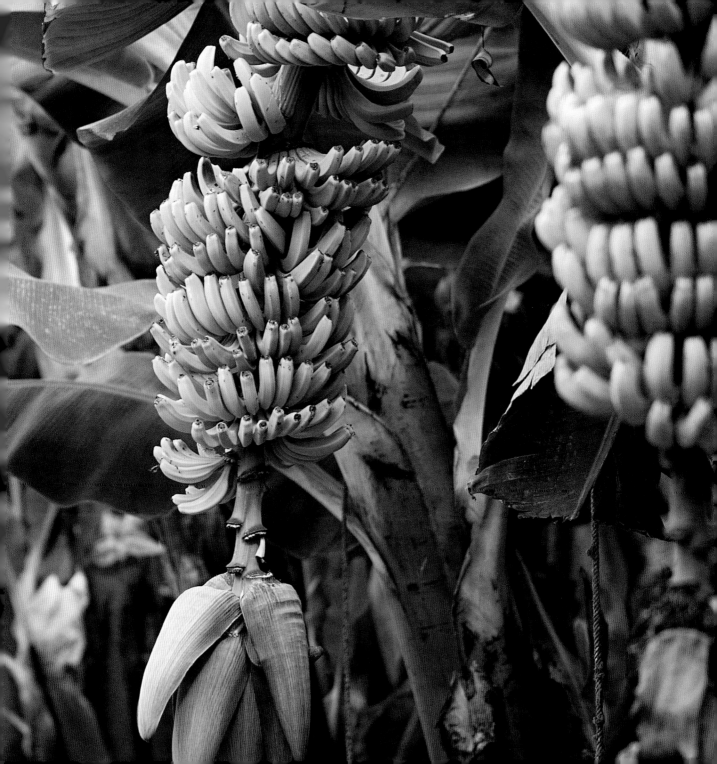

06.
ICE CREAM CART

FROSTY TREATS TO
BANISH THE HEAT
AND SATISFY EVERY
SWEET TOOTH

CONFETTI VANILLA FROZEN CUSTARD

No ice cream machine? No worries. You can also make frozen custard by placing the cooled custard in the freezer for 45 minutes to 1 hour. Remove the custard from the freezer and stir it well, and then return it to the freezer and continue stirring every 30 minutes or so until frozen.

2½ cups whole milk
8 large egg yolks
1¼ cups granulated sugar

1 tablespoon vanilla extract
½ teaspoon kosher salt
2 cups heavy cream

1. Process the milk, yolks, sugar, vanilla, and salt in a blender on high until smooth and thick, about 15 seconds. Transfer to a large saucepan, and stir in the cream. Cook over medium, stirring constantly, just until mixture begins to bubble and has thickened slightly, about 15 minutes. Remove from the heat. Transfer the mixture to a bowl, and place plastic wrap directly on warm custard (to prevent a film from forming). Chill until cold, at least 4 hours or up to 24 hours.

2. Whisk the mixture until smooth. Pour into the freezer container of a 2-quart electric ice-cream maker, and freeze according to the manufacturer's instructions. Transfer the custard to a 9- x 5-inch loaf pan, and return to the freezer until ready to serve.

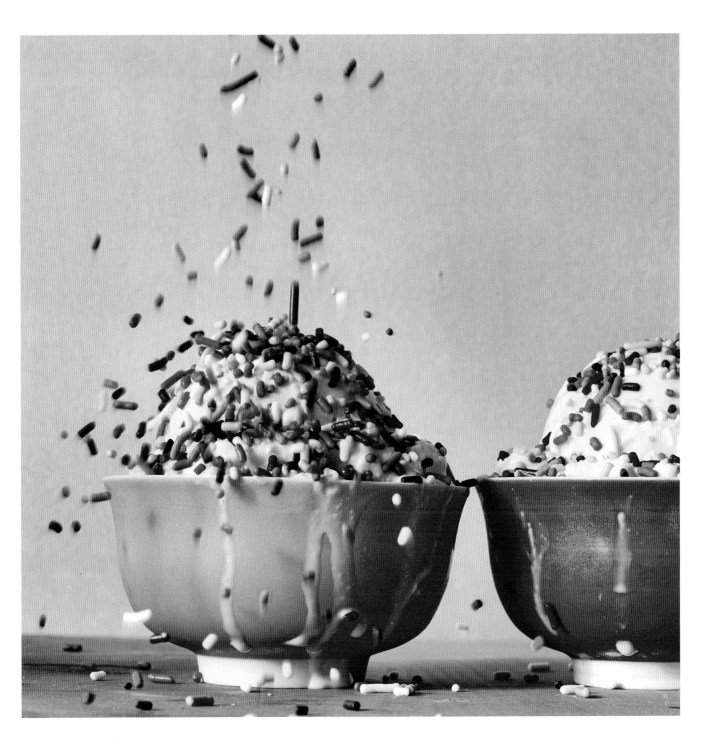

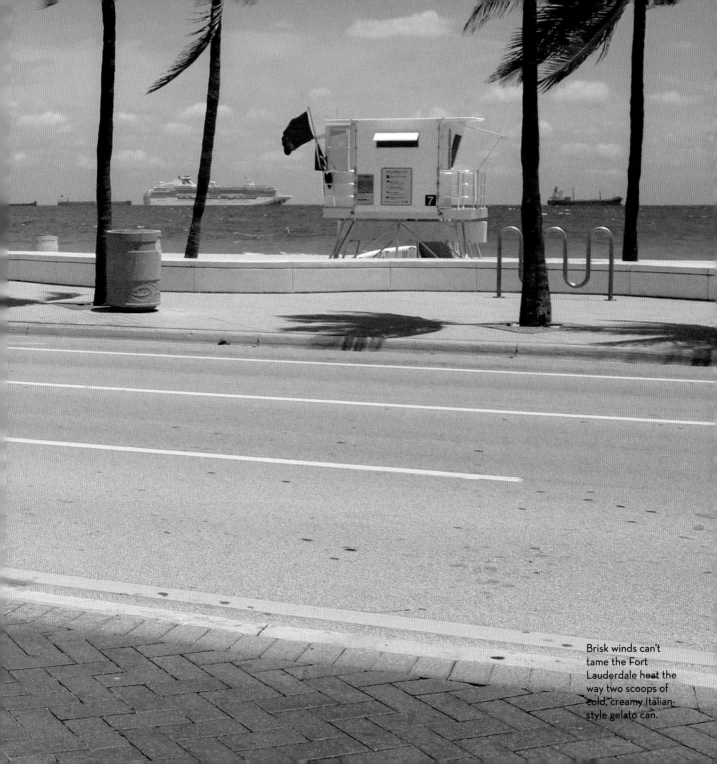

Brisk winds can't tame the Fort Lauderdale heat the way two scoops of cold, creamy Italian-style gelato can.

SMOKED CHOCOLATE ICE CREAM

Whether you spike this rich ice cream with mezcal or not, it pairs perfectly with the Mexican Churros on page 238.

2 cups heavy cream

1 cup whole milk

7½ ounces smoked chocolate (such as Mast Smoke Chocolate), roughly chopped

¾ cup plus 2 tablespoons light corn syrup

¼ teaspoon kosher salt

1 tablespoon mezcal (optional)

1. Stir together the cream and milk in a saucepan. Cook over medium, stirring occasionally, until just steaming, 5 to 6 minutes. Remove from the heat.

2. Pulse the chocolate in a food processor until finely chopped, 4 to 6 times. Add the corn syrup, salt, half of the milk mixture, and, if desired, mezcal to the chocolate; process until smooth, about 1 minute.

3. Place the remaining milk mixture in a large bowl; add the processed chocolate mixture. Whisk until smooth. Chill over an ice bath or in the refrigerator until cold, about 1 hour. Pour the mixture into the freezer container of a 1½-quart ice-cream freezer; freeze according to manufacturer's instructions. Transfer to an airtight, freezer-safe container; freeze until firm, about 2 hours.

MANGO-ORANGE GRANITA

Finish the evening with a sweet, icy dessert that bursts with the flavors of the tropics. For an eye-opening kick, garnish servings with a sprinkle of cayenne.

2 medium-size ripe mangoes (about 1 pound, 10 ounces)

1 cup fresh orange juice

½ cup water

½ cup granulated sugar

2 teaspoons lime zest plus 1 tablespoon fresh lime juice (from about 2 limes)

¼ teaspoon kosher salt

8 teaspoons gold tequila

Cayenne (optional)

1. Peel the mangoes; coarsely chop the fruit. Process the mango, orange juice, water, sugar, lime juice, and salt in a blender until smooth. Pour the mixture into an 8-inch square baking dish. Freeze until firm, about 4 hours, scraping the mixture with a fork every 30 minutes.

2. Divide the mixture among 8 small bowls. Drizzle with the tequila, and sprinkle with the lime zest. Garnish as desired.

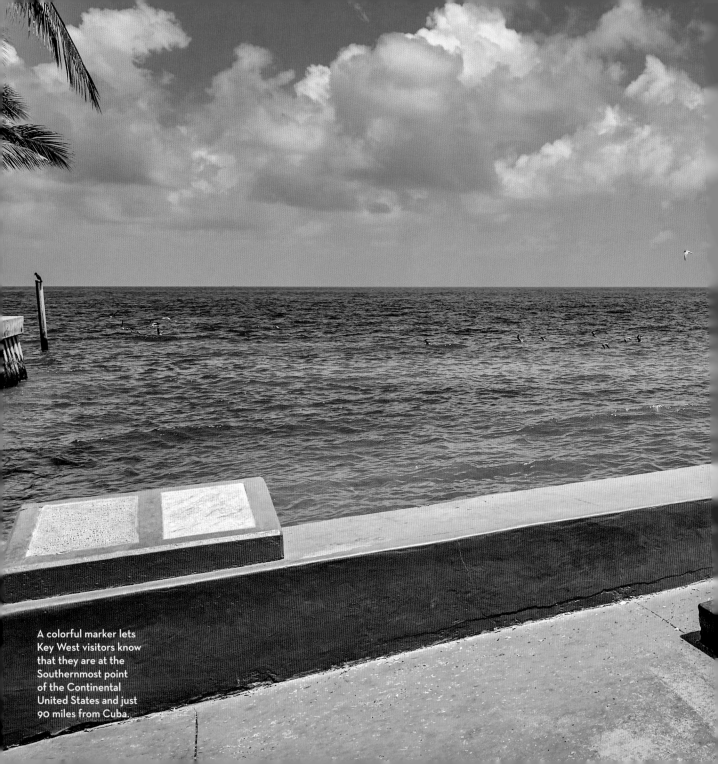

A colorful marker lets Key West visitors know that they are at the Southernmost point of the Continental United States and just 90 miles from Cuba.

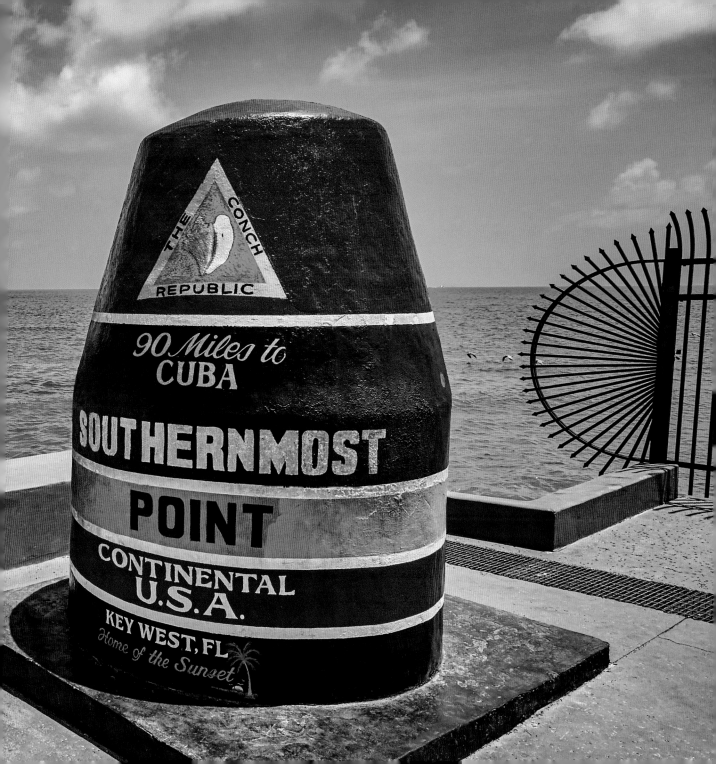

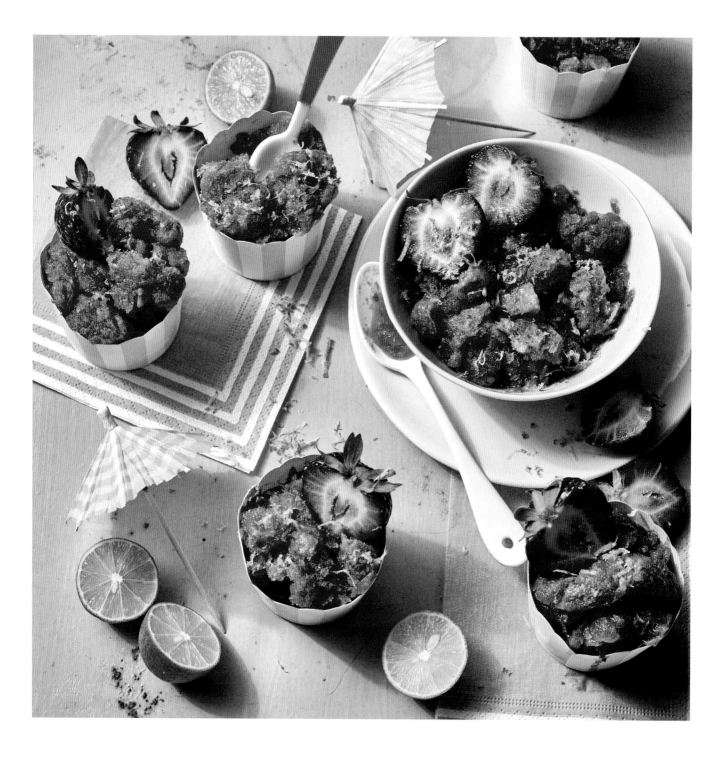

STRAWBERRY-KEY LIME ITALIAN ICE

You're just four ingredients away from unwinding with a refreshingly cool treat that brings delight to kids and adults alike.

1 pound fresh strawberries, quartered

1¼ cups granulated sugar

½ cup fresh Key lime juice (from about 8 Key limes)

2 cups water

Garnish: grated fresh lime zest and strawberry halves

1. Stir together the strawberries, sugar, and lime juice in a large bowl. Coarsely mash the strawberries with a potato masher. Let stand at room temperature 30 minutes.

2. Process the strawberry mixture in a food processor until mostly smooth and liquid, about 30 seconds. Pour into a 13- x 9-inch baking dish; whisk in the water until combined.

3. Freeze the strawberry mixture, stirring with a fork every 30 minutes, just until mixture begins to set, 1 hour to 1½ hours. Once the mixture begins to set, use a fork to scrape and loosen the mixture, evenly distributing the frozen and liquid portions. Continue to freeze and scrape every 30 minutes until the mixture is almost frozen but scoopable, about 2 hours. Scoop into a bowl, garnish as desired. Serve immediately.

HOMEMADE FLUFFY HAWAIIAN SHAVE ICE

Vibrant homemade syrups create flavorful shave ice to beat the heat. Make single flavored cones, a striped sampler of all three, or mix equal parts of each syrup—strawberry + coconut + watermelon—together to create Tiger's Blood. Use your favorite shave-ice machine to finely shave ice into a small bowl. Using a scoop, form 2½ cups packed shave ice (4 to 5 cups fluffy shave ice) into a small mound. Flavor to suit your fancy.

MAKES 2 CUPS HANDS-ON 5 MINUTES
TOTAL 35 MINUTES

COCONUT SYRUP

1 (13.5-ounce) can coconut milk, well shaken

1 cup granulated sugar

1. PREPARE THE COCONUT SYRUP: Whisk together the coconut milk and sugar in a medium saucepan. Bring to a simmer over medium-high; cook, whisking often, until the sugar is dissolved and mixture is emulsified, about 3 minutes. Remove from the heat; cool completely, about 30 minutes. Store in an airtight container in the refrigerator up to 2 weeks.

2. FOR THE HAWAIIAN SHAVE ICE: Drizzle 3 tablespoons of the syrup over 2½ cups packed shave ice in a bowl, coating the mound. Serve immediately.

MAKES 4 CUPS HANDS-ON 10 MINUTES
TOTAL 1 HOUR, 30 MINUTES

STRAWBERRY SYRUP

2 pounds fresh strawberries, hulled and roughly chopped

2 cups granulated sugar
2 cups water

1. PREPARE THE STRAWBERRY SYRUP: Stir together all the ingredients in a medium saucepan; bring to a boil over medium-high, stirring constantly to dissolve the sugar. Reduce the heat to medium-low; simmer until the berries lose their color and the liquid is bright pink, about 20 minutes, skimming any foam that rises to the surface. Pour through a fine wire-mesh strainer into a bowl. (Do not press hard on the solids to remove additional liquid.) Discard the solids. Cool the syrup 1 hour. Store in an airtight container in the refrigerator up to 1 week.

2. FOR THE HAWAIIAN SHAVE ICE: Drizzle 3 tablespoons of the syrup over 2½ cups packed shave ice in a bowl, coating the mound. Serve immediately.

MAKES 2 CUPS HANDS-ON 20 MINUTES
TOTAL 1 HOUR, 30 MINUTES

WATERMELON SYRUP

6 cups cubed seedless watermelon (from 2 small seedless watermelons)

2 cups granulated sugar
1 cup water

1. PREPARE THE WATERMELON SYRUP: Stir together all the ingredients in a medium saucepan. Bring the mixture to a boil over high, stirring constantly to dissolve the sugar. Reduce the heat to medium-low; simmer until the watermelon loses its color and the liquid is light pink, about 30 minutes. Pour through a fine wire-mesh strainer into a bowl. (Do not press hard on solids to remove additional liquid.) Discard the solids. Pour the syrup (about 4 cups) back into the saucepan; bring to a boil over medium-high. Boil until the mixture is reduced by half, 10 to 15 minutes. Remove from the heat, and cool 1 hour. Store in an airtight container in the refrigerator up to 1 week.

2. FOR THE HAWAIIAN SHAVE ICE: Drizzle 3 tablespoons of the syrup over 2½ cups packed shave ice in a bowl, coating the mound. Serve immediately.

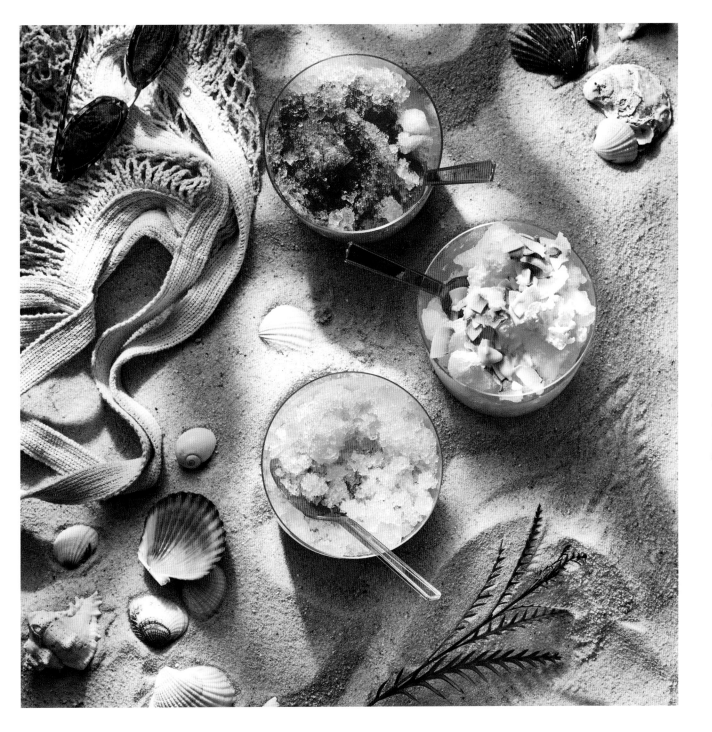

Like synchronized
swimmers, a tidy row of
umbrellas and lounge
chairs draw beachgoers
to take in the white sands
and turquoise waters.

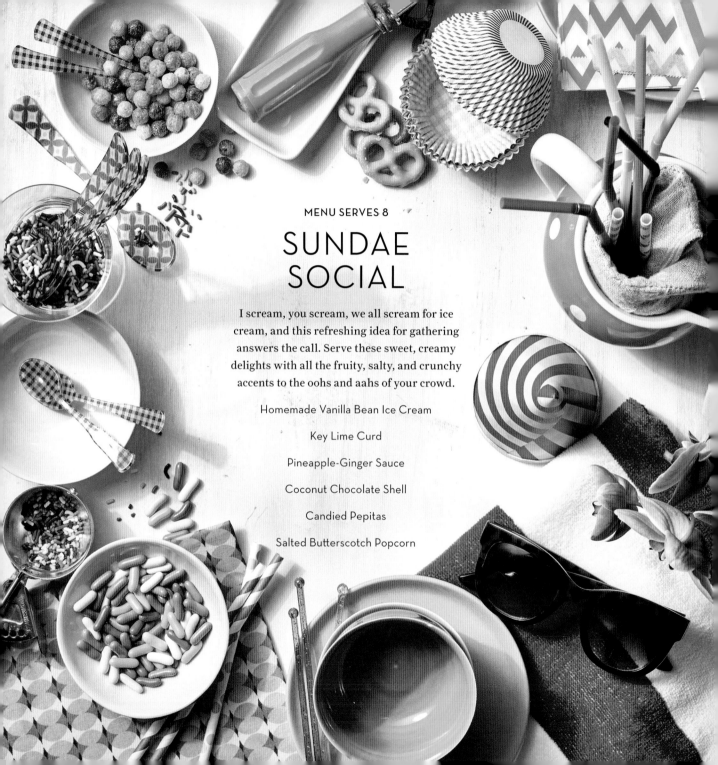

MENU SERVES 8

SUNDAE SOCIAL

I scream, you scream, we all scream for ice cream, and this refreshing idea for gathering answers the call. Serve these sweet, creamy delights with all the fruity, salty, and crunchy accents to the oohs and aahs of your crowd.

Homemade Vanilla Bean Ice Cream

Key Lime Curd

Pineapple-Ginger Sauce

Coconut Chocolate Shell

Candied Pepitas

Salted Butterscotch Popcorn

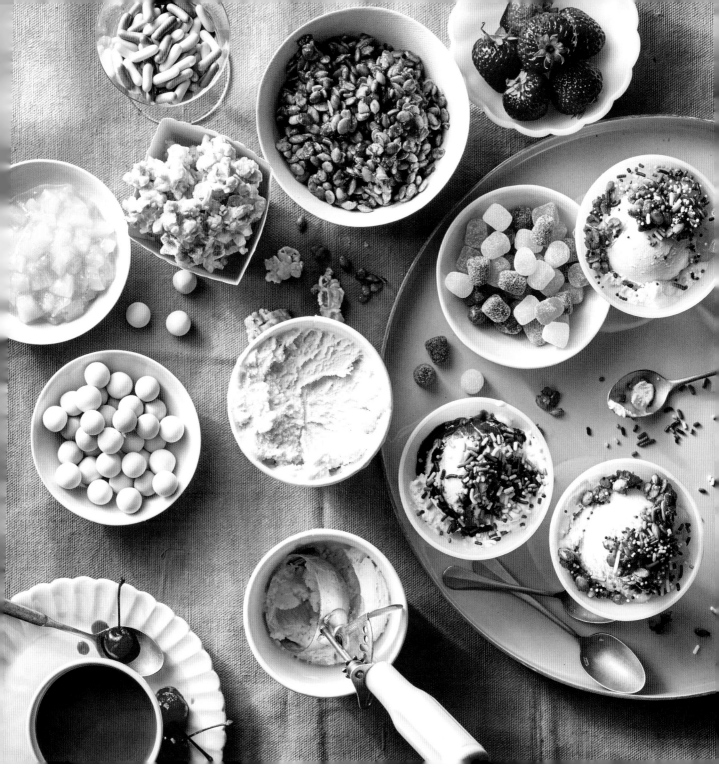

HOMEMADE VANILLA BEAN ICE CREAM

This delicious ice cream is speckled with flecks of vanilla for a rich, frozen treat that's anything but plain. Make two batches of ice cream for this party.

2 cups whipping cream
2 cups whole milk
¼ teaspoon kosher salt
1 cup granulated sugar

1 vanilla bean, split lengthwise
6 large egg yolks, well beaten

1. Combine the first 3 ingredients and ¾ cup of the sugar in a large, heavy saucepan over medium. Scrape the vanilla bean seeds into the mixture; add the pod. Cook, stirring constantly, 7 minutes or until the sugar dissolves. (Do not boil.) Remove from heat, and let stand 15 minutes.

2. Whisk the egg yolks and remaining ¼ cup sugar in a medium bowl. Gradually add 1 cup of the warm cream mixture to the egg mixture, whisking constantly. Add the egg mixture back to remaining warm cream mixture. Cook over medium, stirring constantly, 11 minutes or until the mixture thickens and coats a spoon, and a thermometer registers 160°F. Pour through a wire-mesh strainer into a metal bowl, discarding vanilla pod.

3. Fill a large bowl with ice. Place the bowl containing the cream mixture in ice, and let stand, stirring occasionally, 20 minutes. Cover and chill 4 hours.

4. Pour the mixture into the freezer container of an ice-cream freezer, and freeze according to manufacturer's instructions. Transfer to a container; cover and freeze until firm.

KEY LIME CURD

3 large egg yolks
2 large eggs
1 cup granulated sugar
¾ cup bottled Key lime juice (such as Nellie & Joe's)

2 tablespoons cornstarch
7 tablespoons unsalted butter
½ cup graham cracker crumbs
2 teaspoons lime zest

1. Prepare an ice bath by filling a large bowl with ice; place a medium bowl on top of the ice. Set aside. Whisk together the egg yolks, eggs, sugar, and Key lime juice in a medium saucepan over medium. Cook, whisking constantly, until the sugar is dissolved, about 3 minutes. Whisk in the cornstarch. Increase heat to medium-high, and bring the mixture to a boil, whisking constantly. Boil, whisking constantly, 1 minute. Remove from the heat; whisk in the butter, 1 tablespoon at a time, until melted.

2. Pour the mixture through a fine wire-mesh strainer into a medium bowl over the ice bath. Stir the mixture often, using a rubber spatula, until cooled to room temperature, about 10 minutes. Remove the bowl from the ice bath; place plastic wrap directly on the curd (to prevent a film from forming). Chill completely, about 1½ hours. To serve, spoon over ice cream, and sprinkle with graham cracker crumbs and lime zest.

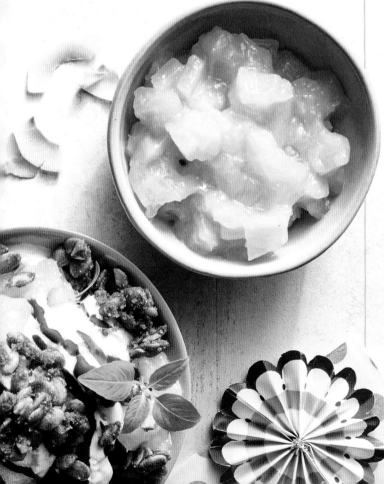

PINEAPPLE-GINGER SAUCE

2 cups finely chopped pineapple (from 1 fresh pineapple, peeled and cored)

3 tablespoons granulated sugar

1 tablespoon cornstarch

2 tablespoons pineapple juice

2 teaspoons grated fresh ginger (from 1 [2-inch] piece fresh ginger)

2 tablespoons torn fresh Thai basil (optional)

Place pineapple, sugar, cornstarch, pineapple juice, and grated ginger in a small saucepan; heat over medium-high, stirring often with a wooden spoon, until the sugar is dissolved, about 2 minutes. Bring the mixture to a boil over medium-high, stirring constantly. Boil, stirring constantly, until the mixture thickens, about 2 minutes. Cool to room temperature, about 1 hour. Stir in Thai basil just before serving, if desired.

CANDIED PEPITAS

1 cup roasted unsalted pumpkin seed kernels (pepitas)

2 tablespoons light brown sugar

2 tablespoons unsalted butter

1 tablespoon pure maple syrup

½ teaspoon ground cinnamon

¼ teaspoon kosher salt

⅛ teaspoon cayenne

Place the pumpkin seed kernels, brown sugar, unsalted butter, maple syrup, ground cinnamon, kosher salt, and cayenne in a medium-size nonstick skillet over medium; stir with a wooden spoon. Cook, stirring often, until the butter melts, mixture is fragrant, and spices coat pepitas, about 3 minutes. Pour the mixture in a single layer onto a baking sheet lined with parchment paper. Let stand at room temperature until completely cool and dry, at least 2 hours. Store in an airtight container up to 2 weeks.

COCONUT CHOCOLATE SHELL

6 ounces chopped
 bittersweet chocolate
2 tablespoons coconut oil
1 tablespoon cornstarch

½ teaspoon coconut extract
Toasted sweetened or
 unsweetened flaked
 coconut

Place the chopped chocolate and coconut oil in a microwavable bowl. Microwave on HIGH, stirring every 30 seconds, until melted, about 90 seconds. Stir in the coconut extract. Spoon over ice cream to harden. Top with the flaked coconut, if desired.

CRAZY FOR COCONUT

The coconut craze is in full swing, so finding this tropical ingredient in virtually every form is no difficult feat. However, if sometimes you feel like a nut and want to prepare a fresh coconut, here's the drill:

SHAKE IT! When shopping for the perfect coconut, shake it to make sure it's full of liquid (coconut water). Empty coconuts will be dry and flavorless or soapy tasting. A ripe coconut is about the size of a softball; look for coconuts that are heavy for their size.

CRACK IT! Hold the coconut in one hand over a sink. Tap firmly with a hammer in the center of the coconut, rotating and tapping along the "equator." Break the coconut into smaller pieces. If it's difficult to pry the meat from the brown shell, bake the pieces at 350°F for 15 to 20 minutes or until the white meat separates. Peel any brown skin from meat, and grate or peel the meat into strips with a vegetable peeler.

STORE IT! Whole brown coconuts will keep in a cool area about one month. Store fresh coconut pieces or fresh grated coconut in an airtight container three or four days in the refrigerator. Grated coconut can be frozen in an airtight container for about three months.

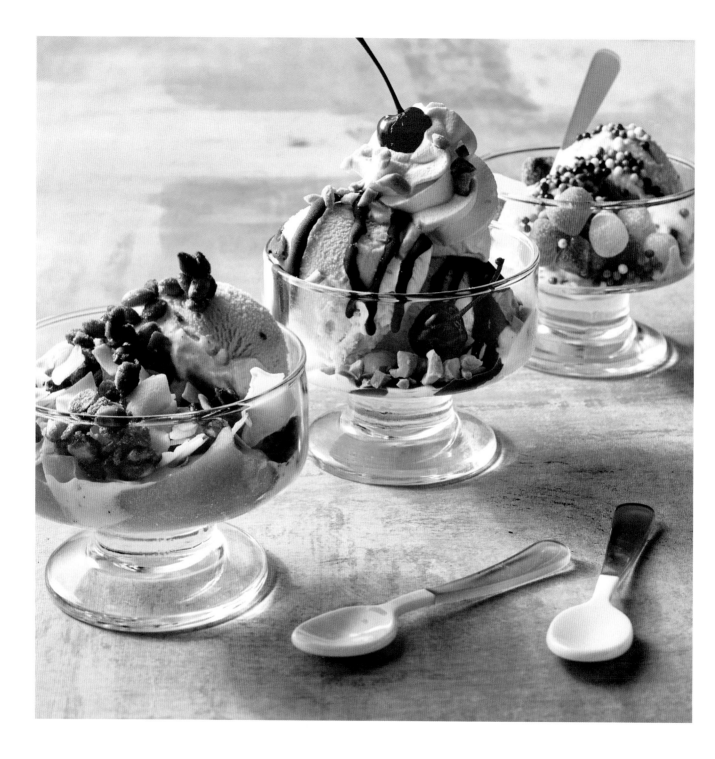

SALTED BUTTERSCOTCH POPCORN

½ cup packed brown sugar

¼ cup light corn syrup

3 tablespoons unsalted
 butter

1 tablespoon sorghum syrup

1½ tablespoons (¾ ounce)
 blended Scotch whisky

¼ teaspoon baking soda

6 cups unsalted popped
 popcorn

2 teaspoons flaky sea salt
 (such as Maldon)

1. Preheat the oven to 275°F. Stir together the brown sugar, corn syrup, butter, and sorghum syrup in a medium saucepan over medium. Cook, stirring occasionally, until the butter is melted and sugar is dissolved, about 5 minutes. Remove from the heat; stir in Scotch whisky and baking soda. (Mixture should lighten significantly in color and begin to bubble.)

2. Place the popped popcorn in a large bowl; pour the brown sugar mixture over the popcorn in a slow, steady stream, stirring to coat completely. Spread the popcorn in a single layer on a baking sheet lined with parchment paper. Sprinkle with sea salt. Bake at 275°F 1 hour, stirring every 15 minutes. Remove from the oven, and let stand at room temperature until completely dry, about 30 minutes.

OVER THE TOP

More creative ways to elevate your ice cream

FRUITY: Raspberries, blackberries, Luxardo cherries, kiwi, banana chips, dragon fruit

NUTTY: Pistachios, sesame crunch (such as Joyva), walnuts, honey-roasted peanuts

CRUNCHY: Pretzels, breakfast cereal (such as Trix), crushed Oreo cookies, chocolate nonpareils

PEANUT BUTTER-BANANA ICE CREAM BITES

Ice-cream bites mean you can treat your sweet tooth to two . . . or three.

½ cup (4 ounces) butter, softened

½ cup creamy or crunchy peanut butter

½ cup granulated sugar

½ cup packed light brown sugar

1 large egg

1½ cups (about 6.4 ounces) all-purpose flour

½ teaspoon baking soda

½ teaspoon baking powder

¼ teaspoon kosher salt

Granulated sugar

1 pint vanilla ice cream, softened

1 banana, chopped

1. Preheat the oven to 350°F. Beat the first 4 ingredients with a mixer at medium speed until blended. Add the egg; beat well.

2. Combine the flour and next 3 ingredients; add to the butter mixture. Shape the dough into 1-inch balls on ungreased baking sheets. Gently flatten with a fork dipped in sugar, making a crisscross pattern on each. Bake at 350°F for 8 minutes. Remove to wire racks to cool.

3. Combine the ice cream and banana until well blended. Scoop 1 rounded tablespoon ice cream onto 1 cookie, and top with another cookie, flat side down, pressing lightly to make a sandwich. Freeze 45 minutes or until firm.

NUT-CRUSTED KEY LIME ICE CREAM CUPCAKES

One bite of these scrumptious treats, and you'll be transported to a tropical place.

½ cup graham cracker crumbs

¼ cup (about 1 ounce) all-purpose flour

⅓ cup slivered almonds

¼ cup packed light brown sugar

¼ teaspoon kosher salt

3 tablespoons (1½ ounces) butter, cut into pieces

3 cups vanilla ice cream, slightly softened

2 teaspoons lime zest

½ cup fresh Key lime or Persian lime juice

Garnishes: whipped cream, lime wedge slice

1. Preheat the oven to 350°F. Line a muffin pan with 12 paper cupcake liners. Combine the first 6 ingredients in a food processor; process until the nuts are ground and the mixture is thoroughly blended. Press into the bottoms and partially up sides of prepared cups. Bake at 350°F for 5 minutes; cool completely.

2. Stir together the ice cream, lime zest, and lime juice in a bowl. Spoon about ¼ cup ice-cream mixture into each crust; freeze until firm. Garnish as desired.

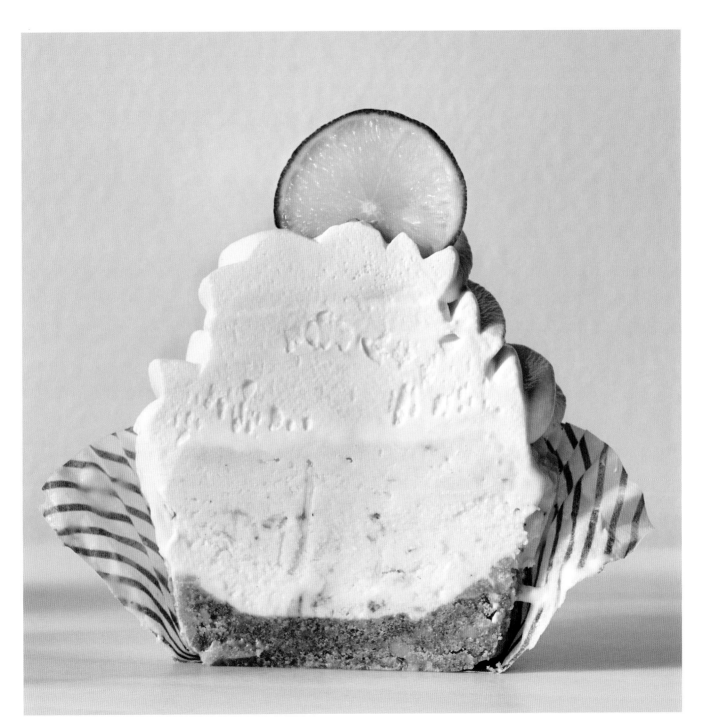

POP STARS: PALETAS

Mexico's hottest frozen treat makes for the chilliest handheld dessert.

SHOWN:

Strawberry-Tamarind Paletas (Pg 274), Avocado-Lime Paletas (Pg 275, Cherry Cream Paletas (Pg 275), Mango-Coconut Paletas (Pg 275), Pineapple-Jalapeño Paletas (Pg 274)

STRAWBERRY-TAMARIND PALETAS

Tamarind paste and a hint of cinnamon add an alluring contrast to all that sweet strawberry flavor.

1 cup granulated sugar
1 cup water
1½ tablespoons tamarind paste

½ teaspoon ground cinnamon
3 cups chopped fresh strawberries

1. Combine the granulated sugar and 1 cup water in a small saucepan. Bring to a boil over high. Reduce the heat to medium, and cook, stirring constantly, until the sugar dissolves, about 5 minutes. Remove from the heat, and cool completely, about 1 hour.

2. Process the tamarind paste and ½ cup of the cooled syrup in a blender on high speed until almost smooth, about 30 seconds. Add the cinnamon, 1½ cups of the strawberries, and remaining syrup, and process on high speed until smooth, about 45 seconds. Finely chop remaining 1½ cups strawberries, and fold into the mixture in blender.

3. Pour the mixture into 10 (2-ounce) plastic ice pop molds. Freeze 1 hour. Insert the pop sticks, and freeze until solid, about 3 more hours.

PINEAPPLE-JALAPEÑO PALETAS

Hawaii's favorite fruit gets its zing on with a dose of jalapeño tempered by the deep freeze.

1 cup granulated sugar
1 cup water
1 small jalapeño chile, stemmed, halved, and seeded

4 cups chopped fresh pineapple

1. Combine the sugar, 1 cup water, and jalapeño in a small saucepan. Bring to a boil over high. Reduce the heat to medium, and cook, stirring constantly, until the sugar dissolves, about 5 minutes. Remove from the heat, and cool completely, about 1 hour. Remove the jalapeño from the syrup, and discard.

2. Process the sugar syrup and 2 cups of the pineapple in a blender on high speed until smooth, about 30 seconds. Finely chop remaining 2 cups of pineapple, and fold into the mixture in blender.

3. Pour the mixture into 10 (2-ounce) plastic ice pop molds. Freeze 1 hour. Insert the pop sticks, and freeze until solid, about 3 more hours.

MANGO-COCONUT PALETAS

Two tropical flavors collide in a rich, dairy-free iced treat.

1 (13.5-ounce) can well-shaken coconut milk
1 cup granulated sugar
¼ cup sweetened flaked coconut
2 tablespoons fresh lime juice (from about 1 lime)
⅛ teaspoon kosher salt
4 cups fresh mango cubes (from about 4 fresh mangoes or 4 cups frozen thawed mango)

1. Whisk together the coconut milk and sugar in a small saucepan. Bring to a boil over medium-high. Reduce the heat to medium-low, and cook, whisking constantly, until the sugar dissolves, about 10 minutes. Remove from the heat, and cool almost completely, about 30 minutes. Chill 1 hour.

2. Process the flaked coconut, lime juice, salt, 3 cups of the mango cubes, and 1 cup of the coconut syrup in a blender until smooth, about 20 seconds. (Store the remaining coconut syrup in an airtight container in refrigerator up to 3 days.) Finely chop the remaining 1 cup mango cubes; fold into the mixture in blender.

3. Pour the mixture into 10 (2-ounce) plastic ice pop molds. Freeze 1 hour. Insert the pop sticks, and freeze until solid, about 3 more hours.

CHERRY CREAM PALETAS

Every kids' favorite ice cream truck menu item is even better made with all-natural ingredients like tart cherries and heavy cream.

1½ cups heavy cream
½ cup granulated sugar
1½ cups coarsely chopped fresh (or frozen, thawed, and drained sweet dark) cherries (10 ounces)

1. Stir together the cream and sugar in a small saucepan; cook over medium, stirring often, until the sugar dissolves, about 5 minutes. Cool completely, about 30 minutes.

2. Divide half of the cherries among 10 (2-ounce) plastic ice pop molds. Pour the cream mixture into molds, and top with remaining cherries. Freeze 1 hour. Insert the pop sticks, and freeze until solid, about 3 more hours.

AVOCADO-LIME PALETAS

Guacamole on stick? Not quite. The lush, buttery fruit lends an ideal creaminess to this icy treat. Lime juice adds a welcome tart note.

1¼ cups granulated sugar
1¼ cups water
2¼ cups mashed ripe avocado (about 4 whole avocados)
½ cup fresh lime juice (from 3 large limes)

1. Combine the sugar and 1¼ cups water in a small saucepan, and bring to a boil over high. Reduce the heat to medium, and cook, stirring constantly, until the sugar dissolves, about 5 minutes. Remove from the heat, and cool completely, about 1 hour.

2. Process the mashed avocado, simple syrup, and lime juice in a food processor or blender until completely smooth, about 20 seconds. (Add up to 2 tablespoons water if needed to achieve a thick but pourable consistency.)

3. Pour the mixture into 10 (2-ounce) plastic ice pop molds. Insert the pop sticks, and freeze until solid, about 4 hours.

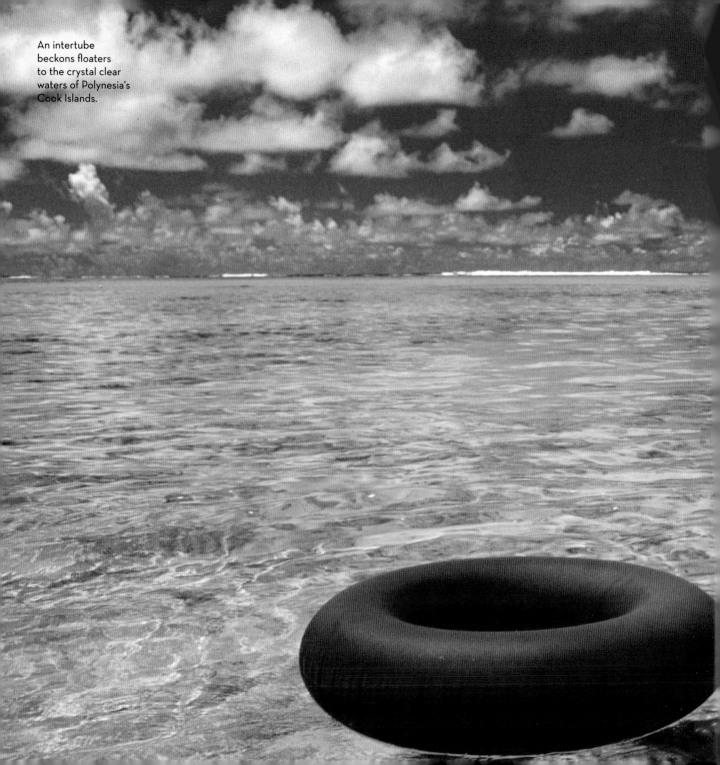

An intertube beckons floaters to the crystal clear waters of Polynesia's Cook Islands.

CHOCOLATE-BLACK CHERRY SODA FLOAT

An iconic delicatessen soda pop gets an upgrade thanks to chocolate-cherry ice cream and a squirt of Hershey's chocolate syrup. Be sure to freeze your glass for at least 10 minutes before serving for an extra frosty dessert.

2 to 3 scoops of chocolate-cherry ice cream

2 tablespoons chocolate syrup (such as Hershey's)

1 (12-ounce) can black cherry soda (such as Dr. Brown's Black Cherry Soda)

2 maraschino cherries

1 tablespoon shaved semisweet chocolate

Freeze 1 (16-ounce) glass 10 minutes. Place the ice cream in the frozen glass, and drizzle with the chocolate syrup. Top with the soda. Garnish with the cherries and shaved chocolate. Serve immediately with a straw and a spoon.

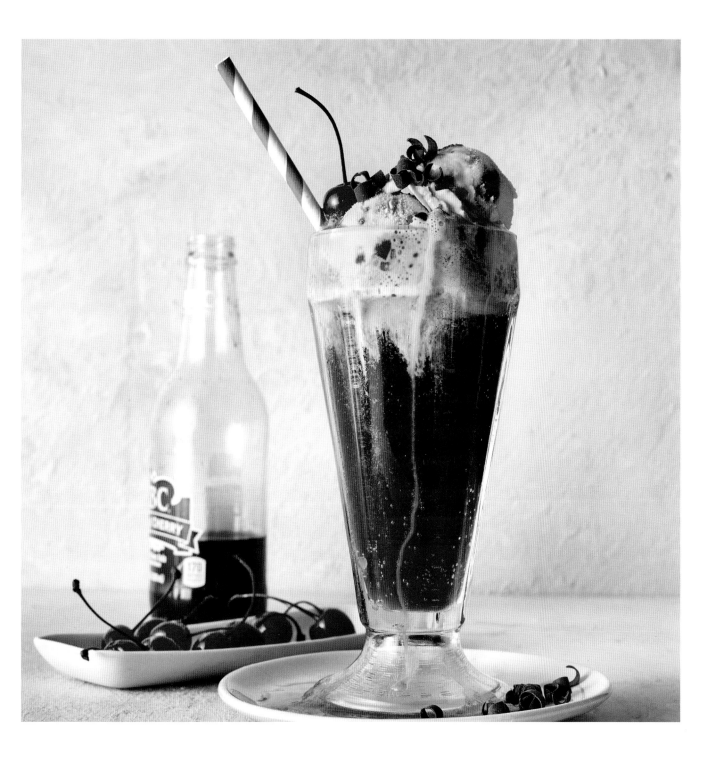

INDEX